Object and Image

Object and Image
An Introduction to Photography

GEORGE M. CRAVEN

De Anza College

Prentice-Hall, Inc. Englewood Cliffs, New Jersey

Library of Congress Cataloging in Publication Data

CRAVEN, GEORGE M
 Object and image.

 Bibliography: p.
 1. Photography. I. Title.
TR145.C89 770 74–9739
ISBN 0–13–628925–8

To Rachel, Clarence, and Peter

Technical drawings by Margaret Jackson

10 9 8 7 6 5 4 3 2

Prentice-Hall International, Inc., London
Prentice-Hall of Australia, Pty. Ltd., Sydney
Prentice-Hall of Canada, Ltd., Toronto
Prentice-Hall of India Private Limited, New Delhi
Prentice-Hall of Japan, Inc., Tokyo

Contents

Preface

Photography is by all odds our most common picture making process. When its effect on the way we see things is considered, it is also quite likely our least understood one. This introductory book is therefore concerned with both the process and the product: it explores how we make black-and-white photographs, how we use them, and how we respond to them.

The text is organized around visual themes because photography is primarily a visual experience. As such, it is perhaps best learned by actually making pictures. The sequence of topics is therefore designed to help you make good photographs quickly, with visual insight as well as technical skill. My aim throughout the book has been to develop each topic just enough to help you progress steadily and confidently toward more advanced skills and ideas, without sidetracking you in nonessentials. Whatever your reasons for exploring photography, your introduction to it should be a stimulating personal adventure.

The first two chapters provide a context for learning and a basis for discussing pictures in verbal terms. They briefly consider what a photograph is, and how it has evolved to its present importance.

Chapters 3 through 6 explain how black-and-white photographs are made. Here the text serves as a guide for a studio or laboratory experience that can be provided by a college or university class, or that you can devise yourself at home.

Chapters 7 through 10 define fundamental styles or approaches to contemporary photographic work. These sections can be used to guide discussion of picture ideas. Other chapters cover topics of frequent interest to new photographers, and the final chapter deals with us as viewers—how we look at and respond to photographs.

Color photography is much too complex for adequate treatment in one or two chapters and is therefore not included; it deserves a book of its own. Motion pictures and how they are made are omitted for similar reasons. What we have, then, is an introduction to the experience of seeing and thinking photographically.

Any such experience must begin with pictures, for they appeal to our senses more directly than words can do. Each photograph in this book has been selected not only to make a specific point at a specific place, but also because it is an outstanding example of a particular photographer's work, or of a superb historical collection. The pictures here may thus be regarded as a guide to many other similar images in books and exhibitions. All can offer us visual experiences that are equally rich and rewarding.

There's more than a grain of truth in the observation that an author

never knows his own book. I hope you will help me discover mine in this respect, and I'll welcome your suggestions for its improvement.

Acknowledgments

I am grateful to a number of friends and colleagues for their interest and assistance. Clarence H. White, Jr., an honored teacher and an exemplary person, has generously shared with me his love for photography and education for more than twenty years. I gladly acknowledge this fundamental debt. I also want to express my gratitude to Henry Holmes Smith and Minor White, whose writings and personal contacts often have sharpened my thinking and provoked me to re-examine familiar positions.

Like anyone else writing today about our photographic heritage, I am indebted to Beaumont Newhall, Helmut and Alison Gernsheim, and Robert Taft for their massive contri-butions to the understanding and documentation of a widely scattered legacy of pictures.

Among those who have shared their insight and counsel with me during preparation of the manuscript, Roger Goettsch and Charles Stephens have been particularly helpful. So has Margaret Jackson, who did the technical drawings.

At Prentice-Hall I had the able assistance of Walter Welch, Joan Lee, and especially Stephen Lux, who quickly caught the spirit of what I was trying to do and translated it into the book's design.

Two great debts remain. One is to my family, who endured this project with patience and understanding. The other is to the photographers and collectors who have permitted me to reproduce their work. All have my admiration and my thanks.

G. M. C.

Cupertino, California

Object and Image

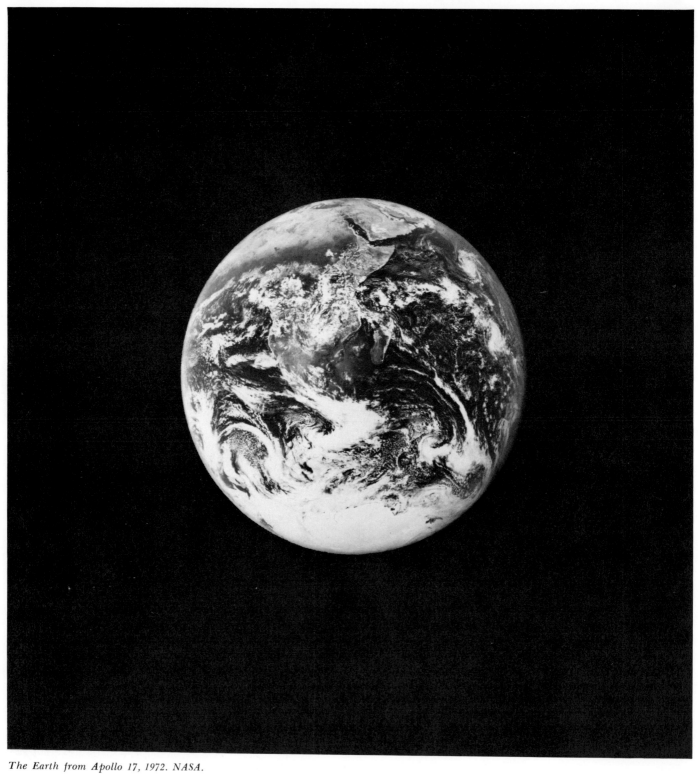

The Earth from Apollo 17, 1972. NASA.

Object and image: what photography is

Why does man make pictures?

A reasonable question, and a deceptively simple one. Yet to examine it seriously is to consider the very nature of man himself. From the beginning, man has been a symbol-making and a tool-making animal, using these devices to perpetuate his existence and to understand his very being. His primary tool, of course, has been language, without a doubt his greatest invention. Each of his many languages is a system of *symbols* that conveys ideas from one person to another through the senses. ┊Symbols help man to simplify his existence by standing for other, more complex ideas and experiences. They make known; they signify. Woven into language, they explain life's complicated reality and form a matrix for man's culture.

Different cultures within the family of man have addressed themselves to the problems of human existence in diverse ways, and language reflects this rich variety. The symbols we call *words* and *pictures* form only two kinds of language; there are many others, and a sensitive man uses all languages at his command to express his ideas and to externalize his thoughts and feelings. Words and pictures, however, are fundamental to man's existence: through them he produces a kind of thinking which can be re-experienced and interchanged with other human beings. Pictures form bridges between cultures; communication and learning depend on them.

Photography is a relatively recent form of picture making devised by man on his long journey from the cave to the moon. The origin of pictures is deeply rooted in prehistoric time and remains obscure, but there is no doubt that these symbols have evolved into a universal language. With the advent of photography in the middle years of the nineteenth century, that evolution became a revolution.

What is photography? Reduced to its simplest dimensions, photography is a means of producing images by the action of light on a substance that is sensitive to that light. But this is a skeletal description that only identifies the tip of the iceberg. It does not begin to describe either the photographic experience or the tremendous impact these pictures have had on nearly every aspect of our life. For it is hardly an exaggeration to suggest that what we know about the world, and the way we have come to understand it, are due in no small measure to the eye of the camera. We know how the earth is shaped, for example, because we have seen photographs of it from outer space, and from those same pictures we have also learned how delicately beautiful our environment is. On a different scale, but no

less remarkable, the Swedish photographer, Lennart Nilsson, has revealed to us the mysterious beginnings of human life in an incredible series of photographs which includes a view of a living embryo in its mother's womb.

No mere tool of science, however, picture making by photography has fascinated people by the millions for more than a century. Today it is a folk art practiced in every country of the world. Photographs had been around for more than sixty years when George Eastman introduced the Kodak in 1888 and made it possible for anyone to take them. So it wasn't their novelty that made them so popular. Rather it was the innate realism of the pictures themselves. Here was something that each individual could identify with. Recognition and response were instantaneous.

Human Vision and Camera Vision

A photograph, however strong its resemblance to actual objects or events, does not accurately mirror the world. Nor does it show things as we see them. These differences between the way things appear to us and to the camera are not imaginary: they are very real, and any serious consideration of picture making by photography must take them into account. But because almost anyone can pick up a camera, make an exposure, and produce a recognizable image, the vast majority of people are led to assume that there is "nothing to" photography. Today millions of people use the camera, and the vast number of resulting photographic images are snapshots; unpretentious and occasionally charming in their simple directness, but too often, like our neighbor's vacation mementos, simply a bore. Photography's inherent simplicity, it appears, is also its inherent weakness.

As in any other visual art, both sight and insight are called for in making a photograph that is anything more than a snapshot. Hence some definitions are in order. First, *seeing*. Seeing is not merely looking at the world, or moving about it without crashing into walls. Seeing involves looking with some effort on our part to understand what we observe. It involves some degree of *empathy*, of feeling our way into whatever we experience, so that we recognize and comprehend it more effectively. At the very least, it demands an *awareness* of what we view. In its rarest and fullest sense it may carry us to revelation and enlightenment. To whatever degree we perform it, seeing requires us to set aside our personal, usually trivial concerns, and concentrate on what is actually there. Such an effort through our various senses we call *perception*. From it we can make some judgments about what we see.

Let's consider for a moment how we see things, and how a camera image is formed. Although the human eye and the camera are both constructed on the same principle, they have different purposes. The retinal image in our eye is not intended to be seen, but to produce a pattern of nervous stimulation in the brain. Cameras used in photography, however, are designed to produce visible images. Our vision is binocular, which enables us to see in three dimensions: we can perceive depth. Most cameras, on the other hand, have only one pic-

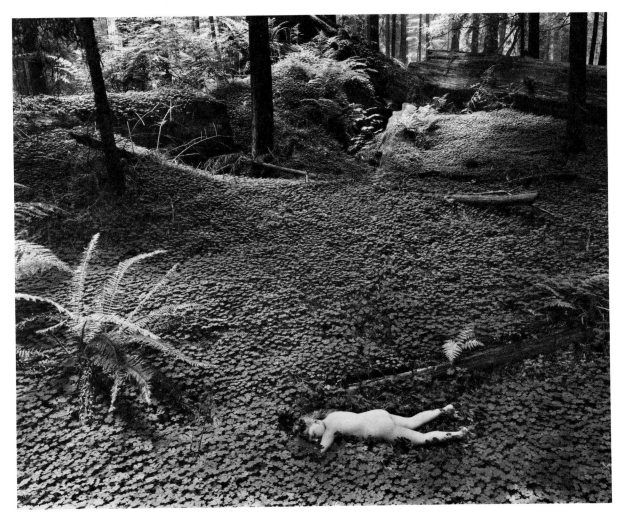

Wynn Bullock: Child in Forest, 1954.

ture-forming lens, and the resulting image has only two actual dimensions. Each of us sees things in some imprecise arrangement of colors, while the camera records in fixed schemes of three colors or in monochrome. It can sometimes approximate, but never duplicate, human color sensation.

Normal human vision takes in a wide field of view, but we see only part of it at any given moment, and then each part only for an instant. Our eyes are continually in motion, even when we stare at something, and there is some indication that such movement is necessary for normal vision. Our total vision establishes the general arrangement of a scene, but our central vision, which is clearer, concentrates on small areas of greater importance to us than the rest. We get a clear, detailed impression of our entire field of view only by moving our eyes to bring each part of that field successively into the area of our central vision.

The camera image usually is an instantaneous one. Generally speaking, all parts of it are produced simultaneously in a very short span of time. Indeed, the process has come to be symbolized by the "click of a shutter." Unlike the eye, the camera can, if necessary, accumulate weak light until

it builds up a developable image; it can, in fact, take photographs in near darkness where the eye can see little or nothing. It can also retain one image or many successive ones, combining them by superimposition into a single impression. Thus a visual world unknown to the eye can be opened through multiple camera exposures.

The camera also is indiscriminate. Left to its own devices, a camera does not order the importance of things within its view. It has no mechanism to pause on the interesting and skip over the trivial, but renders the significant and the trifling with equal accuracy and force. Witness again the snapshot. Selection, it appears, must be made by the photographer.

So our visual perception of the real world is imperfect, and the whole process, it appears, is largely an unconscious one requiring very little willful effort on our part. This, of course, can be a trap, for *seeing is very selective:* we see largely what we want to see, what our mind allows us to see, and even that constantly changes. Here, then, enter our personal concerns, our prejudices, our opinions—in other words, our whole system of human values. These, of course, differ for each one of us. All affect what we see, and therefore no two individuals see the same.

Incidentally, some of the same differences we notice between human vision and camera vision are encountered again, in reverse order, when we look at a photograph. It presents itself all at once—instantly—but we see the image only by degrees, and must often search for what is significant within it. We'll examine this problem in the final chapter of this book.

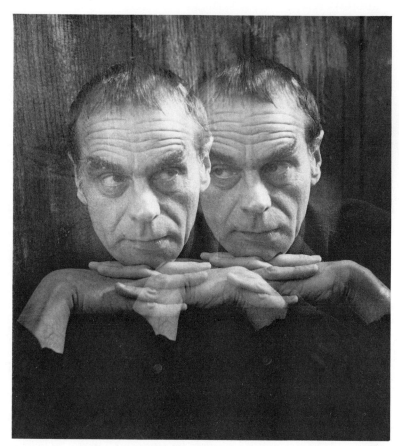

Imogen Cunningham: Poet and His Alter Ego, 1963.

What a Photograph Is

Just as camera vision and human vision differ, the photographic image is unlike every other form of picture and the real world of objects and experiences. We have already considered those differences relating to vision and to the way a camera image is formed. Additional ones, however, are found in the image itself, and perhaps the most important of these concerns *light.*

Photographic images depend on light. The name *photography* itself, which was first used in 1839 by Sir John Herschel, the English scientist, means, literally, writing or marking with light. In photography, the action of light on or through a substance is the central connection between what is presented to the camera and what appears in the picture. Light is the physical force which produces and reproduces the image, and because light-sensitive material must be used, both have a bearing on other image characteristics.

Two of these, continuous tone and infinite detail, serve to identify the photograph among other forms of pictures, although they are not universal characteristics of the medium. *Continuous tone* describes the ability of photography to record changes from light to dark—from white to black—without noticeable steps: in other words, to produce seemingly infinite shades of gray. William Garnett's photograph dramatically reveals this quality. It is due to the manner in which most photosensitive materials respond to light, and is as instantaneous as the image formation itself. No other means of making pictures can approach photography in this respect.

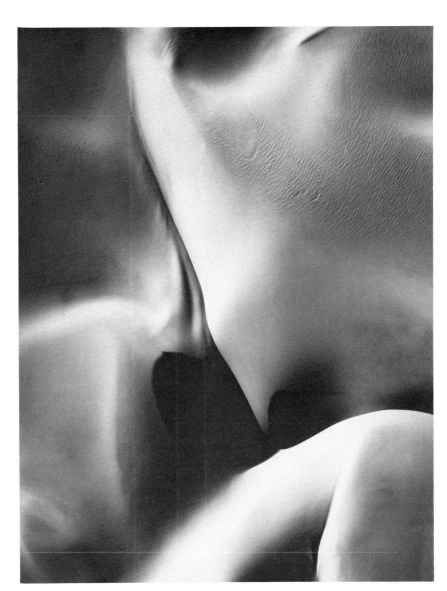

William A. Garnett: Sand Dune, Death Valley, 1954.

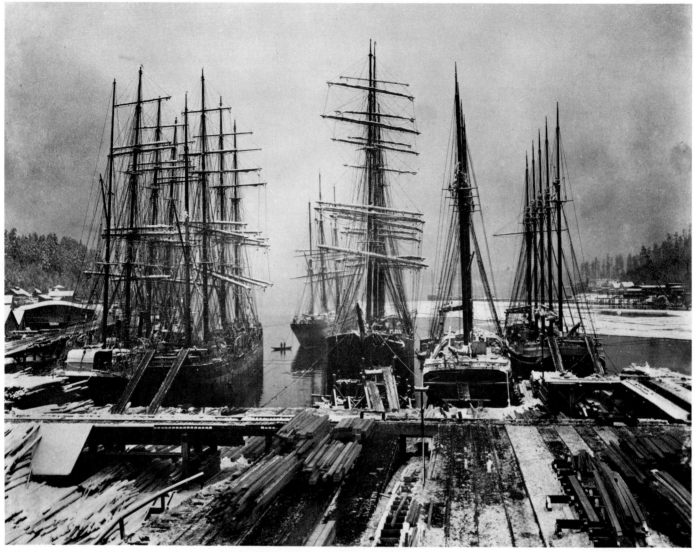

Wilhelm Hester: Barks and Schooners at Port Blakely, Puget Sound, Washington, 1905.
Collection: San Francisco Maritime Museum.

Lenses have long been used to form camera images, making possible acute definition which results in the incisive rendering of *detail*. This aspect of photographs is felt far beyond the medium itself, for it has contributed a term to our verbal language. When we speak of certain drawings or paintings having a "photographic" appearance, for example, or of someone having a "photographic" mind, what we mean is an impression of limitless detail. This, of course, is a valuable feature of the photographic image which makes it an efficient conveyor of information. Such clarity, however, can exaggerate the importance of trivia; overwhelming detail can imply authenticity, or that some new, hidden meaning may await only our patient exploration of the picture. A photographer must use this power wisely and responsibly.

Another far-reaching characteristic of the photographic image which derives from the nature of the process

is its capacity for endless *duplication*. Most forms of the photographic image are produced first as a negative (with tones reversed from their usual order) and, from that negative, as an unlimited number of positives. We may make one positive or any number of exact duplicates without diminishing or destroying the original image. We may also change the size: reproductions can be larger or smaller than the original. And even in those few processes which produce no negative (and are therefore called direct positive processes), the image can be rephotographed and virtual duplication continued. Office copy devices, now a staple tool of modern business, are built around this principle. Likewise the printing craft, for which photography has become its virtual lifeblood.

This capacity for duplication inherent in photography has revolutionized communication and education—in fact, our entire culture. For instance, André Malraux, the eminent French scholar and historian, claims that the study of art history is the study of art that can be photographed. Few students have access to many original works of art; we usually study them, like so many other things, through photographic reproductions. But until recent improvements in color photography became available, the subtle hues and intensities of many originals such as stained glass windows and some Byzantine mosaics could not be adequately reproduced. Much of their message was therefore lost to scholars who knew them only through misleading reproductions or written accounts.

Historian Daniel Boorstin has written lucidly on this substitution of *image* for *object,* which he calls the Graphic Revolution. *The Image* (see bibliography) is his brilliant essay on the art of self-deception in America. In that book Boorstin explains how photography has been a major force in fostering the rapid growth of pseudo-events to replace real ones, and copies of objects and experiences to replace originals. Even more alarming is his keen observation that we have come to value the reproduction more than the original. Evidence of this abounds, for example, in our modern techniques of mass-merchandising goods and services; from network television, everywhere the same, to the nationwide proliferation of franchised restaurants, each serving identical, undistinguished food. Unfortunately such rampant duplication is not limited to postcards and art reproductions—it permeates our culture.

Briefly, then, let us review the most common characteristics of the photographic image:

1 It is a two-dimensional image and it is seen from a single point of view.
2 It requires light and a substance or surface that is light-sensitive.
3 It usually is produced instantly, and all parts of a single image are produced simultaneously: it is born whole.
4 It usually possesses a wealth of detail and is often distinguished by continuous tone.
5 It has the capacity for unlimited duplication: it can, in effect, reproduce itself.

Taken together, these characteristics suggest that the photograph is a unique kind of picture. Indeed it is.

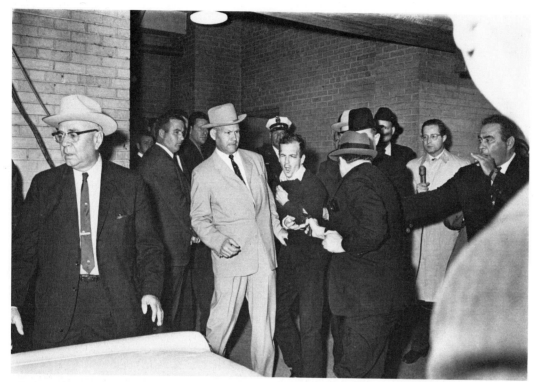

Bob Jackson: Assassination of Lee Harvey Oswald, 1963. © The Dallas Times-Herald. Reproduced by permission.

Rooted in Reality

We do not need to look at a great many photographs to realize that photography, by its nature, is a language rooted in reality. The earliest photographers recognized that fact and it quickly became a working esthetic: for nearly half a century, the degree of likeness between the object and its image was the chief criterion by which the photographer measured his success as an artist. This universal ap-plication of photography—to act as a more convenient substitute for the object itself—remains the principal reason why we make photographs to-day.

The snapshot, mentioned earlier, is only the most obvious and ubiquitous form of this *representational* image; others are equally commonplace. The great bulk of commercial photography —portraits, catalog pictures, photo-graphs for sales and advertising in business and industry—is an extension and application of this basic idea. Pho-tographs for reference, for records of all sorts: we have developed through-out society an indispensable need for such images and it is hard to imagine what contemporary life would be like without them.

Curiously, however, such widespread use of representational photography has spawned its own peculiar prob-lems. People readily believe that the photographic image is indeed a re-creation of the original object, and

Margaret Bourke-White: *At the Time of the Louisville Flood, 1937.* LIFE Magazine © Time Inc.

photographers, on the whole, seem content to let this naive assumption go unchallenged. A photograph signifies the real; thus it becomes a symbol of truth. The fact that a photograph presents only an *illusion* of reality may often go unnoticed.

How often, for example, has our recollection of a momentous event been triggered by a photograph of it? Many of us who witnessed Lee Harvey Oswald's assassination on television may nevertheless feel that the pho-tograph of it is far stronger than our memory of the real event. This apparent contradiction is evident because our memory is not static, and our ways of observing events constantly change. By isolating a moment of time as well as a field of view, the camera records the appearance of objects and events, and thus helps us to remember the transitory. Images of events, then, can be given a new sense of reality just as images of objects can.

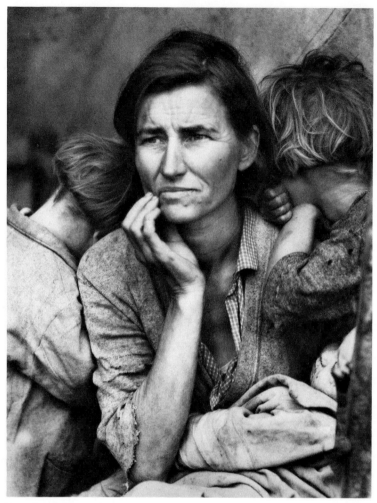

Dorothea Lange: Migrant Mother, Nipomo, California, 1936. Collection: The Oakland Museum.

We use this feature of photography to shape public opinion. Photographers such as Margaret Bourke-White and Dorothea Lange, for example, have shown us that photographs can not only document a period forever gone, but they can be powerful instruments of persuasion—of propaganda—as well. Less controversial, perhaps, but employing the same device, is everyman's restaurant, where we judge the hamburger served up to us by how closely it resembles a color photograph hanging on the wall. In this case, reality becomes true to the extent it resembles its photograph!

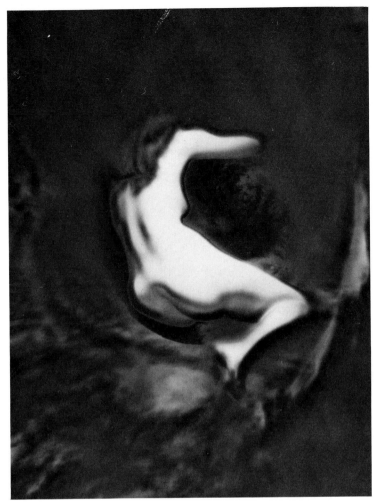

Todd Walker: Nude, 1969. Courtesy Light Gallery, New York.

Creating the Illusion

Because of this interchange of functions, then, it isn't hard for the photographer to fill his picture with illusory truth. For one thing, his camera can record in an instant more than he can perceive. For another, he has all the richness of detail that we associate with the photographic image going for him.

When a painter strives to create an illusion of reality he must draft his image in a precise spatial arrangement and enrich it by rendering sufficient detail. The photographer, on the other hand, faces a different problem: his image is drawn, in effect, by his point of view and his lens; choosing them defines his picture. From that point his task is not how to include enough detail but rather how to eliminate all that is not needed. For the painter builds his image, element by element, adding, revising, elaborating his theme toward its final state. The photographer, however, usually begins with his image whole, and determines it by selective elimination. He limits his view by imposing a frame on reality, then further selects within that frame by using light and shadow to give the objects form and importance, to distill significance out of chaos—in short, to bring order and structure to his picture. His method is *analytic* rather than synthetic: it eliminates the less important so that only the essence of his visual idea remains. The photographer's initial approach, then, is exactly opposite that of the painter, even when both of them have the same end—a representational image—in mind. Indeed, the common man sums it up uncommonly well when he notes that paintings are *made,* and that photographs are *taken.*

Robert E. Brown: [untitled], 1961.

The Picture Is an Experience Itself

A sensitive photographer, however, realizes that a photograph can be *made* as well as taken, that it can represent an inner reality of thought and feeling as well as an external world of objects and events. This idea is important to a photographer because it can free him from any need to make his image a *picture of* something; like any other artist, he may make his image simply *a picture*. By recognizing that his image is based on reality but does not reconstruct it, a photographer opens the door to an enormous range of picture-making possibilities and enjoys virtually all the freedom of image formation which artists in other media traditionally have known. If his image bears a strong resemblance to what was before the camera, it may be termed *representational*. But if it bears little or no apparent relation to its original source, it usually is designated *nonrepresentational*. In that case there is no attempt to illustrate, and the identity of what was before the camera is unimportant. Instead, the photograph is presented as an experience in itself; it invites the viewer to bring his own intuition to it and expand upon the image through his own imagination. What he sees in it, then, may reflect his own feelings as strongly as

Jerry N. Uelsmann: Navigation Without Numbers, 1971.

it reveals those of the photographer. Such a photograph functions more as a mirror than as a window, and usually it will evoke a variety of responses from different viewers.

Regardless of how he wants his picture to function for the viewer, a photographer eventually must conceive his image in terms of what his tools and materials can do. He must extend his perception through the working of photographic materials and processes to *visualize* his picture. Edward Weston, the photographer, summed it up another way: he termed it "seeing photographically." What Weston meant was the entire process by which we concentrate on an object or observe an event, decide what kind of image we want to make from it, and then see the image in our mind *as a picture.* After all, in a photograph, the only reality is its image. The final outcome of that image should not be left to chance or to the camera and film, but every aspect of it should be visualized by the photographer.

Hence the title of this chapter and this book. It implies a major concern for a relationship that is central and vital to the photographic experience. Each of these realities, object and image, is given meaning in terms of the other through the eye of the photographer.

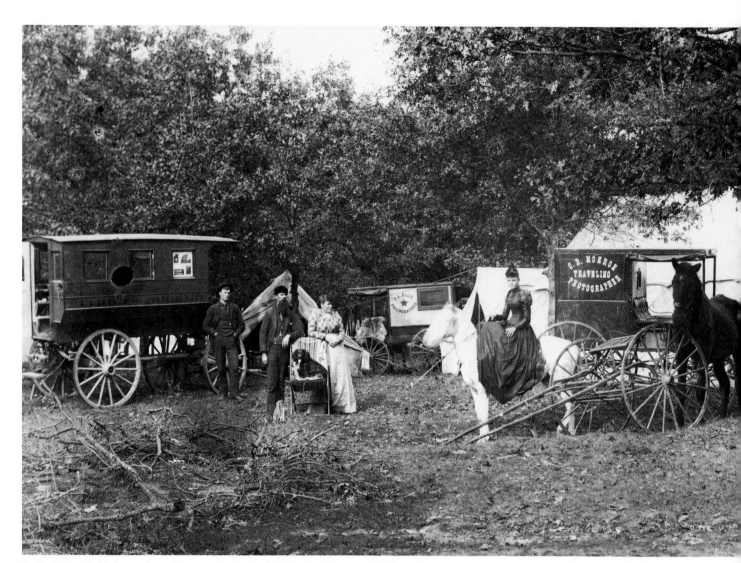

C. R. Monroe: Photographers' Wagons, [n.d.]. State Historical Society of Wisconsin.

Is there anything more familiar to us today than the photographer's image? Everywhere we turn it touches our lives, and has done so for a long, long time. Two decades after its introduction here the American cameraman was no longer a curiosity but a well-established figure in nearly every major city and town. And if the populace was too scattered to go to the photographer, he simply went to them. Because we find him everywhere, perhaps we may be excused if we sometimes forget that the photographer hasn't always been with us. His picture, in fact, is a comparative late-comer to a long and continually evolving list of reproducible images. To consider the impact of this picture on our culture, then, we must go back beyond the events which made photography possible and take a brief look at those pictures that preceded it—not to belabor the past, but to put the origin of the photograph in its proper perspective.

Although the photograph was a unique image, it did not fill a unique need. It merely did a job which for several centuries had been done by something else. But it did that job—representative illustration—much better than it ever had been done before, and thereby created a demand which spurred its rapid improvement and astonishing growth. It led to a revolution in seeing and thinking, in art and communication that is still going on, and which has not yet been fully realized or appreciated.

Our story begins in western Europe with the invention of printing there in the fifteenth century. Reproducible pictures on paper, it appears, were first made at that time, and seem to have served two clear functions from the outset: as playing cards and religious symbols. The former application required duplicated images because cards quickly wore out; the latter met a demand from simple worshippers. Since the church was the center

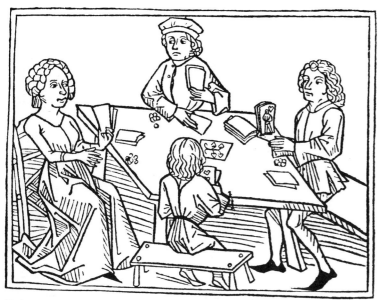

Meister Ingolt: Card Players. Woodcut from Das goldene Spiel. [Augsburg] Günther Zainer, 1 Aug. (an dem 8. Tag S. Jacobs) 1472. Rosenwald Collection, The Library of Congress.

of artistic activity, just as it was the focus of most other aspects of daily life, crudely made reproducible prints enabled the faithful to have common religious symbols at home. Soon thereafter these pictures appeared in books, which up to that time had been illustrated ("illuminated," as it was called) the same way they had been written—by hand.

With the decline of feudalism, life shifted from the countryside to cities. Growth in the cities led to trade, which in turn fostered a rising middle class of merchants, especially in Italy. A rapid expansion of universities accompanied this trend, and books quickly multiplied. Throughout the fifteenth century, then, the collective thinking or faith of the middle ages gave way to individual opinion, which needed facts for comparison and judgment. Artists and writers helped to supply them. They studied the world around them, portrayed man as a dignified human being, and placed him at the center of their universe. The knowledge that developed from this humanistic concern was not categorized: art, mathematics, and nature were all considered as one, and it probably was no accident that the greatest scientist of the fifteenth century was a painter, Leonardo da Vinci.

At this same time, Filippo Brunelleschi and Leon Battista Alberti, the great Florentine architects, gave their people the concept of *linear perspective,* a mathematical basis for rendering space in art. This is important to our story for two reasons. First, because it laid the foundation for a natural realism in pictures, a standard of resemblance to nature, if you'd like to call it that. Second, as more and more unskilled people responded to nature and caught the urge to paint and draw it, a need for mechanical drawing aids grew. Many such contrivances were invented during the sixteenth century, but one of the most successful and widely used ones was a much older device, the *camera obscura.*

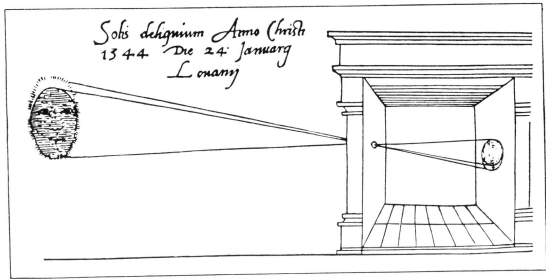

Gemma-Frisius: First published illustration of a camera obscura, 1544. Gernsheim Collection, Humanities Research Center, The University of Texas at Austin.

The Camera Obscura

A camera obscura (literally a darkened room) was described as early as the tenth century by the Arabian scholar, Alhazen, using a principle known to Aristotle in the fourth century B.C. for observing eclipses of the sun. Leonardo discussed it in his notebooks in considerable detail (leading many people to think he had invented it), and Albrecht Dürer, the German artist, knew of it in the early sixteenth century. A tiny hole in one side of a room admitted rays of light in such a way that an inverted image of what was outside the room appeared on the inner wall opposite the hole. About

1550 a lens was added to the opening, making the image brighter and clearer.

All descriptions of it prior to 1572 indicate that the camera obscura was, in fact, a room, but early in the seventeenth century we find mention of a portable device—first a wooden hut, next a tent, then a covered sedan chair, and finally a small box such as Canaletto undoubtedly used to paint his sweeping views of Venice in the early eighteenth century. There is evidence that Antonio Guardi, Jan Vermeer, and other artists used it, but more important is the observation that by 1685 the camera obscura had been developed to a form that was to

remain substantially unchanged for nearly two hundred years.

The continuing growth of the middle class in the eighteenth century created a demand for cheap pictures of all kinds, but especially original portraits. Before that time portraiture had largely been available only to the most distinguished public and religious figures, or to those who could afford to commission an artist. About 1786 a French court musician, Gilles-Louis Chrétien, invented the *physionotrace*, an adaptation of the pantograph to transcribe outlines of the human head to copper plates. It made producing such drawings a quick and relatively easy process which people of

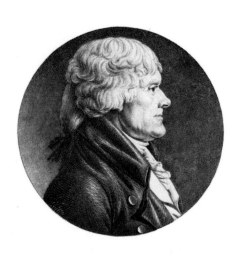

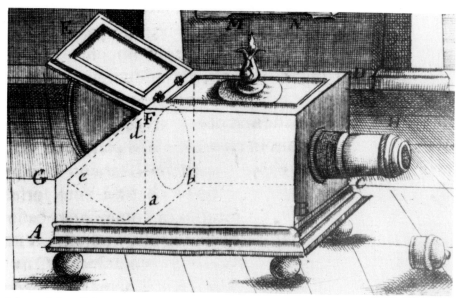

Févret de Saint-Mémin: Profile of Thomas Jefferson. Engraving with physionotrace, 1804. Actual size. Collection: The Metropolitan Museum of Art, Bequest of Charles Allen Munn, 1924.

Johann Zahn: Reflex Camera Obscura, 1685. Gernsheim Collection, Humanities Research Center, The University of Texas at Austin.

moderate means could afford. One master of the device who brought it to America charged $33, we are told, for the original drawing, the copper plate, and twelve impressions.

Throughout the seventeenth and eighteenth centuries, book illustration was dominated by woodcuts and copper engravings. The former were useful for cheap copies but could not convey shading very well. Engravings gave satisfactory reproduction but, because copper is a soft metal, wore out quickly and were used primarily for more costly and limited editions.

Moreover, the visual medium, as Marshall McLuhan was to put it 200 years later, had already become the message, in a subtle manner that went unnoticed by many people in the same way that we blindly accept the "truth" of a photograph today. Consider that all visual information available to the common man in the form of reproducible and therefore inexpensive pictures came to him second or even thirdhand. Master artists prepared the originals, but reproduction in prints was left to other craftsmen who translated those images into the peculiar linear construction of the engraver's medium. What came out in an engraved print, then, often was the result of several nameless people

rather than a single mind or hand. At best it was only an approximation of the original visual statement; too often it turned out to be a stylized mechanical image more descriptive of the process than the source.

The demand for pictures, though, continued unabated. Lithography—printing with greasy ink from the flat surface of a porous, wet stone—was invented around 1797, and at the same time wood engraving was revived. A wood engraving was cut across the grain of a block (as on the end of a board) instead of running parallel to it, as a woodcut was made. It permitted a longer printing run than did copper, while retaining most of the image detail and shading possible with metal plates. Thus popular editions of illustrated books could be printed by this method, and it remained the primary way of reproducing pictures in ink for another hundred years. Not until the end of the nineteenth century, then, did printed picture making come fully of age. What brought it to maturity, of course, was the evolution of photography.

Initial Investigations

Almost everything that makes photography possible has been known since 1725, when Johann Heinrich Schulze, a German scientist, discovered that light darkened silver salts. Although he had no way of knowing it, this was the fundamental reaction on which virtually all photography was to depend. The only missing technical link was a suitable means to preserve the image once light had formed it. Carl Wilhelm Scheele, a Swedish chemist who knew that silver chloride was soluble in ammonia, discovered in 1777 that *blackened* silver chloride (silver metal) was not. In ammonia, then, he had a crude yet workable preservative. But since Scheele was not interested in producing pictures he did not see the application of his discovery, and the world had to wait until the nineteenth century for someone to put it all together.

Wedgwood and Davy

Two fundamental ideas make photography as we know it possible. One is optical, the other chemical. The first person to see the connection between them was Thomas Wedgwood, youngest son of the famed English potter, Josiah Wedgwood. Thomas took note of the earlier work by Schulze and Scheele, and using his father's camera obscura, tried to record images from nature, possibly as early as 1799. But his silver nitrate compound was not sensitive enough to produce a visible picture. He also experimented with white leather that he had sensitized with silver nitrate, exposing the material through leaves and paintings made on glass. Wedgwood's collaborator, Humphry Davy, repeated the camera experiments using silver chloride, which was more sensitive to light. Neither Wedgwood nor Davy produced an image with the camera, but both got impressions of small objects placed on their materials in direct sunlight. All efforts to preserve these images failed, however, as the continued action of light caused the paper and leather to darken after the objects were removed. Ill health forced Wedgwood to abandon the work. In 1805 he died without reaching his goal.

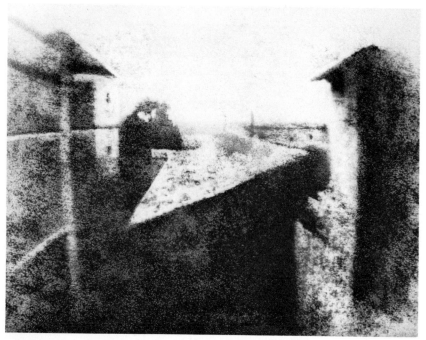

Nicéphore Niépce: View from his window at Gras, near Chalon-sur-Saône. The world's first photograph, 1826–1827. Gernsheim Collection, Humanities Research Center, The University of Texas at Austin.

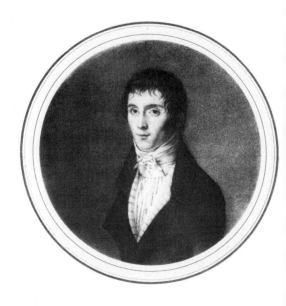

C. Laguiche: Nicéphore Niépce, c. 1795. Pencil and wash drawing. Gernsheim Collection, Humanities Research Center, The University of Texas at Austin.

Heliography

The next attempt was made by a French inventor, Joseph Nicéphore Niépce, of Chalon-sur-Saône, who apparently succeeded in making a paper negative with the camera in 1816. He ran up against the same problem that had baffled Wedgwood and Davy—his image continued to darken when removed from the camera—so he abandoned this line of work and sought a material that would be lightened by exposure instead. This would have resulted in a direct positive image, one in which the tones were not reversed from their usual order. Niépce turned next to plates of polished pewter metal, spreading on them a thin coating of an asphaltic varnish, bi-

tumen of Judea. When sufficient light struck the bitumen it hardened it, but where the exposure was held back by a superimposed image in contact with it (he used an engraved print) or by the reflection of dark objects in the camera, the coating remained soluble in a mixture of oil of lavender and turpentine. Then, after exposure, Niépce used the oil to remove the soluble (unexposed) parts of the coating, revealing a faint, positive image. This he washed with water and dried.

Niépce named his process *heliography,* or sun-writing. Most of his early experiments were copies of engraved prints, but one made in 1826 or 1827, according to historians Helmut and Alison Gernsheim, was a view from the window of his attic

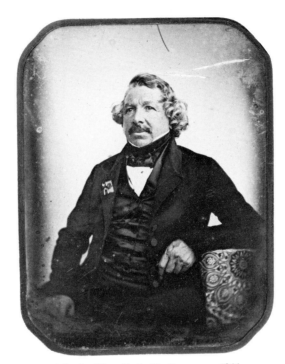

J. B. Sabatier-Blot: L. J. M. Daguerre, 1844. Daguerreotype. Collection: International Museum of Photography.

workroom. Rediscovered by the Gernsheims in 1952 and reproduced here, it is the world's first photograph, and the only surviving example of Niépce's work with the camera.

Niépce's camera was fitted with a prism, which corrected the lateral reversal of the image so that a pigeon loft of the house, which actually was on the left as one would see it from the window, appears there in the image. Other objects are discernible: the long, sloping roof of a barn, a tree beyond that, and another wing of the house on the right. The exposure required by the bitumen coating was about eight hours on a summer day, and since the sun changed position during that time, objects appear to be illuminated from both sides simultaneously. Niépce also made a still-life heliograph with the camera on a bitumen-coated glass plate about 1829, but it and a copy of an engraving obtained on glass in 1822 were later destroyed.

In 1827 Niépce was introduced to another experimenter, Louis Jacques Mandé Daguerre, through their mutual lensmaker, Chevalier. After two years of extremely cautious contacts and exchanges, Niépce and Daguerre formed a partnership to perfect and exploit the former's invention. Four years later, however, Nicéphore Niépce died, leaving Daguerre to carry on the work alone. Although Niépce had made photography possible, it remained for Daguerre and others to make it practical.

The Daguerreotype

L. J. M. Daguerre had earlier achieved fame in Paris as the painter and proprietor of the Diorama, a theatrical presentation wherein large colored pictures could be viewed by changeable combinations of reflected and transmitted light. The illusion of realism was heightened by including actual objects in front of the picture planes, creating a setting similar to three-dimensional displays of wildlife commonly presented today in natural history museums. The Paris Diorama was such a crowd pleaser that Daguerre and his partner in the venture (who does not otherwise figure in the story of photography) opened another in London within a year.

The Dioramas achieved much of their realistic illusion because they had been painted in meticulous perspective, and for that, of course, Daguerre had used a camera obscura when sketching the pictures. Since he therefore knew how laborious it was to *draw* such realistic impressions with the camera, we can imagine his interest upon learning of Niépce's efforts to "fix the image of objects by the action of light," as the latter described his pioneering work.

Seeking to improve his image quality, Niépce in 1828 had switched from pewter to silver-plated copper sheets, and found he could strengthen the contrast of his image by fuming the silvered plate with iodine vapor. Daguerre now tried this, but the resulting silver iodide was still too low in sensitivity for reasonably short exposures. Shortly thereafter, in 1835, he accidentally discovered that by subjecting his underexposed plates to the vapor of

mercury (which had spilled from a broken thermometer), the nearly invisible image could be made to appear much stronger. Two years later Daguerre succeeded in permanently desensitizing, or fixing, the plate, using a solution of table salt in hot water. His earliest successful effort was the still life reproduced here.

By January, 1839, Daguerre was ready to publicize his achievement. Christening it the *daguerreotype*, he prevailed on his friend, François Arago, who was secretary of the French Academy of Sciences, to make the announcement. Later, after a clumsy attempt to discredit Niépce and garner all the honors for himself, Daguerre (with Arago's continued help) persuaded the French government to make the process public and to award him and Isidore Niépce (Nicéphore's son and heir) lifetime pensions. Thus spared the task of seeking financial backing, Daguerre freely shared his discovery with the world. All, that is, except England, where he had secretly patented his process five days before the French government made it free to all.

The daguerreotype, according to Arago, demanded no "manipulation which is not perfectly easy to every person. It requires no knowledge of drawing and does not depend on any manual dexterity." The popular French painter, Paul Delaroche, reacted more directly: "From today," he exclaimed, "painting is dead!"

Well, not quite. But it never was the same again. The public was absolutely fascinated with the new pictures; "daguerreotypomania" swept Paris. Daguerreotypes were favorably compared to Rembrandt's etchings; in

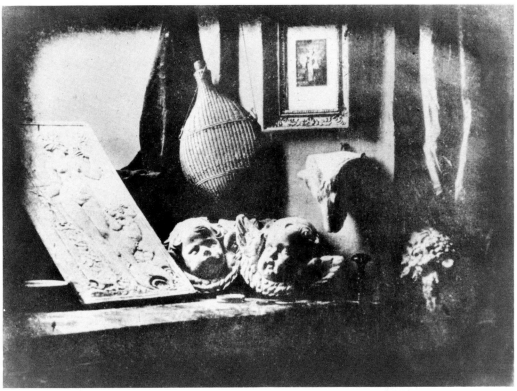

L. J. M. Daguerre: The Artist's Studio. The earliest surviving daguerreotype, 1837. Collection: Société Française de Photographie. Paris.

their revelation of light and shade and in their absence of color, the comparison seems justified even if naively overstated. As a means of recording information, nothing so accurate had ever been seen before. But the pictures had a ghostly quality about them too, especially when made outdoors. While every detail of streets and buildings was clearly etched, no sign of life was apparent. Exposures were too long to record moving objects, but revealed every cobblestone over which they had traveled.

The chief value of the new process was for portraits. Realistic likenesses satisfied most people, and their incredibly beautiful tonal scale rendered the subtle modeling of faces by light with amazing delicacy.

The daguerreotype process was a complex one. To start, the silver side of a silver-plated copper sheet was polished as smooth and bright as possible, and then was inverted over a box containing iodine. This vaporized onto the plate, creating silver iodide which was sensitive to light. Transferred to

Richard Beard: Portrait of an unknown man, London, c. 1842. Daguerreotype. Author's collection.

[Photographer unknown]: Margaret Aurelia Dewing, 1848. Daguerreotype. Collection: Richard Rudisill, Santa Fe, New Mexico.

the camera in a lightproof container, the plate was exposed, again covered, and removed to a darkened room. There it was inverted over a vessel containing heated mercury, which deposited a white amalgam on those parts of the plate that had received light from the exposure in the camera. The silver iodide not exposed was dissolved with common salt or sodium thiosulfate, and rinsed away with water. Then the plate was gently dried over an alcohol lamp.

At first the daguerreotype was not sensitive enough for portraiture; exposures were simply too long. Early operators like Richard Beard, who opened the first portrait studio in London in 1841, overcame this problem by making the plates smaller to take advantage of better camera lenses, and by using chemical accelerators. Being a direct image, the picture was laterally reversed. This was soon corrected by using a prism lens on the camera, as Niépce had done many years before. Since the mercury adhered only lightly to the plate, the picture was easily damaged if anyone touched it. Protective cases were quickly introduced; each contained a paper matte as a spacer and a cover glass to protect the image, all bound up with the plate itself like a sandwich. And of course the image was unique: it could not be duplicated.

None of these limitations, however, delayed the spread of this marvelous French discovery to other countries, particularly England (in spite of the patent) and America, where Oliver Wendell Holmes called it a "mirror with a memory." Daguerre's instruction manual, according to the Gernsheims, went through 29 editions in six languages. He was made an officer of the Legion of Honor, and in 1840, at the age of 52, L. J. M. Daguerre retired from national public life, leaving to others the task of perfecting his discovery.

John Moffat: William Henry Fox Talbot, [n.d.]. Carbon print. Photo. Science Museum, London.

Talbot's experimental cameras, 1835–1839. Crown Copyright. Science Museum.

Photogenic Drawing

Arago's announcement of the daguerreotype in January, 1839 was noted with alarm by William Henry Fox Talbot, an English scientist and scholar who had been honored by election to the august Royal Society in 1832. Several years earlier, Talbot had worked out a method for making images by the direct action of sunlight on paper. The idea for this occurred to him in the fall of 1833, in Italy, while he was trying with considerable difficulty to sketch a view. At that time Talbot was unaware of the work by Niépce and Daguerre, and had himself taken quite a different tack in pursuit of the elusive image. By 1835 he had discovered a way to coat paper with silver chloride. After two hours' exposure through various materials in contact with it, a tonally reversed image appeared on the paper, which he then preserved with a strong solution of salt water. This, of course, was the same contact method first tried by Wedgwood and Davy more than 30 years earlier, but where they had failed to preserve the photographic image, Talbot succeeded.

Next he increased the sensitivity of his paper by repeated applications of chemicals and exposed it in several

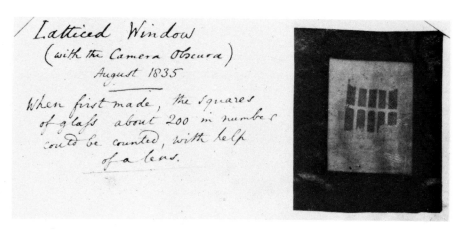

William Henry Fox Talbot: Latticed Window, 1835. The earliest existing negative. Actual size. Science Museum, London.

small cameras—"mousetraps," his wife called them—that were made for him by a local carpenter. One of these camera negatives is now preserved in the Science Museum in London. It is a view through the central oriel window of the south gallery at Laycock Abbey, the Talbot family home near Chippenham in Wiltshire. Only about an inch square, it is the earliest existing negative, and the second oldest surviving photograph in the world.

Over the next four years Talbot turned to other interests, and until the news of Arago's announcement reached him in January, 1839, these early photographic experiments had been all but forgotten. Quickly realizing what was at stake, however, Talbot rushed to claim priority for his discovery before the end of that eventful month. He dispatched brief letters to Arago and others in the French Academy, and a lengthy report to the Royal Society, its English equivalent. Buried within that report was a recognition of great importance:

If the picture so obtained is first *preserved* so as to bear sunshine, it may be afterwards itself employed as an object to be copied, and by means of this second process the lights and shadows are brought back to their original disposition.[*]

With this statement Talbot introduced the negative-positive principle that has been the basis for most photographic processes ever since.

Talbot's paper to the Royal Society was widely reported by the press in February, but his *photogenic drawings* —coarse paper negatives about one inch square—simply failed to capture the imagination of a public clamoring for the daguerreotype abroad and indifferent to new pictorial developments at home. Daguerreotypes were larger (up to 6½ by 8½ in.), direct positives (as normally viewed), and much more brilliant and detailed. Meanwhile, Sir John Herschel, the eminent scientist, had independently conducted his own experiments. He found that hyposulfite of soda was a suitable preserving agent, and in just a few days succeeded in covering the same ground as Daguerre and Talbot. When the latter visited him on February 1, Herschel "explained to him all my processes." Talbot did not reciprocate, and when Herschel suggested that they collaborate their investigations, Talbot refused. On August 19 the secret of Daguerre's process was revealed by the French. Talbot saw it as a challenge, but continued his work alone.

[*] W. H. F. Talbot, *Some Account of the Art of Photogenic Drawing* (London: privately printed, 1839), Sec. 11.

The Calotype

Talbot was bitter at what he considered to be an inadequate response from his own prestigious Royal Society, and annoyed by the public's disinterest in his work and its acclaim of Daguerre's. Securing larger cameras with better lenses, he continued to experiment. Then in September, 1840, while resensitizing a batch of photogenic paper that he had greatly underexposed and thought could be used again, Talbot noticed the former images suddenly appear. In a way remarkably similar to Daguerre's encounter with spilled mercury five years earlier, Talbot discovered a *latent* or hidden image that could be made visible by development. Exposures were thereby reduced from two hours to a minute or less, and these improvements Talbot immediately secured by patent in England and France in 1841, and in America six years later.

The *calotype,* as Talbot called this improved process, was prepared and exposed much like a photogenic drawing. But then it was developed by reapplying a solution of gallic acid and silver nitrate to the sensitive surface of the paper, and heating the sheet to bring out the image. The picture appeared when the reapplied solution deposited additional silver on the latent image, a now obsolete process known as physical development. (It has since been replaced by chemical development, in which silver is produced by a reaction *within* the latent image rather than by an external deposit.) Once developed, Talbot's calotypes were preserved by Herschel's method—hypo—which Talbot cavalierly patented along with his own discoveries.

Because it was made on paper rather than metal or glass, the calotype was better suited to record masses of tone than fine detail. The best examples are characterized by vigorous use of light and dark areas in the picture. Many are landscapes and architectural views.

Calotypes (also called talbotypes) were largely ignored by English photographers because of Talbot's vigilant enforcement of his patents. Some amateurs' worked the process privately—paper, after all, was cheaper than silver-plated copper—but the pictures often had a tendency to fade within months. Many of Talbot's own negatives are preserved at the Science Museum, and most of these are still strong and clear today. One source of good quality work was Talbot's firm at Reading, west of London, shown in the photograph here. The photographer in the center, uncapping his lens to make a portrait, is probably Talbot himself. This is undoubtedly the first photofinishing laboratory in the world. Here in 1844 a thousand prints were made for Talbot's *Pencil of Nature,* the world's first photographically illustrated book.

Another source of excellent calotypes was the studio of David Octavius Hill, a painter, and Robert Adamson, a chemist, in Edinburgh. Talbot's process was free from patent restrictions in Scotland, and Hill was one of the first people to realize the artistic potential of the material. For five years from 1843, Hill and Adamson produced a remarkable collection of early Victorian portraits before Adamson's death ended the association.

Calotypes were also made in France, where Talbot had taken out a patent but failed to enforce it. In 1851, Louis

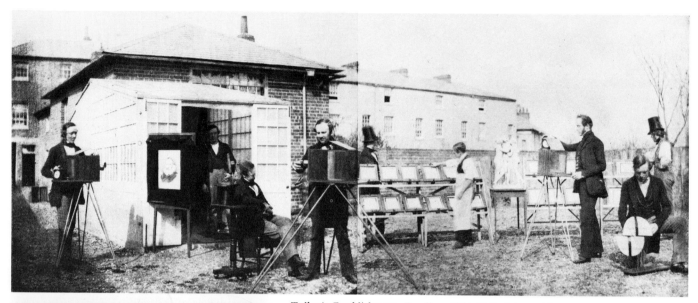

Talbot's Establishment, Reading, 1844–1847. Science Museum, London.

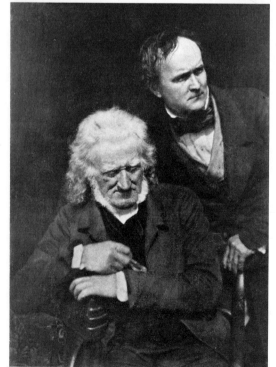

Hill and Adamson: John Henning and Alexander Ritchie, c. 1845. Calotype. Collection: International Museum of Photography.

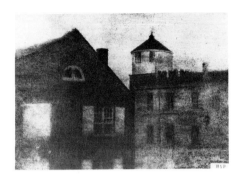

Joseph Saxton: Old Central High School, Philadelphia, 1839. The oldest surviving daguerreotype in America. Actual size. Collection: The Historical Society of Pennsylvania.

Desiré Blanquart-Evrard opened at Lille a photographic printing shop similar to Talbot's at Reading. Talbot, as we have seen, had developed a latent image to make his calotype negatives, but was printing his positives from them by the older principle using the direct action of light, that is, by *printing out.* Blanquart-Evrard's prints, on the other hand, were produced like his negatives, by a much shorter exposure and *developing out* the image, the basic method we still use today. He also introduced *albumen paper,* in which the sensitive salts were dispersed in the whites of eggs. This produced a clear, glossy coating capable of retaining more detail from the negative than silver chloride paper could. Albumen paper remained in general use for more than 40 years.

Photography Comes to America

The first photograph made in America has always been an elusive image for historians. Most accounts credit one D. W. Seager of New York City, who successfully made a daguerreotype in September, 1839, but none of his pictures are known to have survived. The oldest existing American daguerreotype seems to have been made a month later in Philadelphia by Joseph Saxton, an employee of the United States Mint, from which the view was taken. It is reproduced here in its actual size.

Undoubtedly the most famous pioneer American daguerreotypist was Samuel F. B. Morse, a professional portrait painter, professor at New York University, and inventor of the telegraph. Morse had seen Daguerre and his work in Paris during March of 1839. With his New York colleague, chemistry professor John W. Draper, Morse also began to experiment that same September, but his most important contribution to American photography was not as a cameraman but as a teacher of others.

America learned of the daguerreotype when the steamer *British Queen* docked at New York on September 20, 1839, carrying European newspapers that detailed the process. It was a favorable time for such news to arrive. The United States was in the midst of a depression that had begun in 1837, when five years of rampant land speculation fed by unregulated banking practices caused a wave of financial panic and closed every bank in the country. With unemployment high, any new idea that promised business opportunity and jobs was eagerly grasped. Daguerreotyping required little capital investment and the needed proficiency could be learned with moderate effort. Thus Morse found himself sought by others wishing to acquire the necessary skill. Among his students were Mathew Brady, a boy from rural New York State, Edward Anthony, an unemployed civil engineer, and Albert Southworth, a Bostonian. Within a few years these enterprising men had established a new American industry.

The new craft of daguerreotyping also attracted many speculators and few of them had any talent. Dentists, blacksmiths, cobblers, and shopkeepers could be found making daguerreotype portraits as a sideline, and results often were poor. Other operators in small towns posed as magicians, making the practice of photography little more than a con game.

Some, however, built reputations on the quality of their work. There was John Plumbe, Jr., the first to advocate a transcontinental railroad in 1837, and owner of a chain of 14 daguerreotype studios in eastern and midwestern cities. Plumbe was careful to staff his establishments with competent employees, and his growing reputation aided his political cause.

Edward Anthony arrived in Washington in 1843. With his partner, J. M. Edwards, he began photographing members of Congress and publicly exhibited these pictures as a National

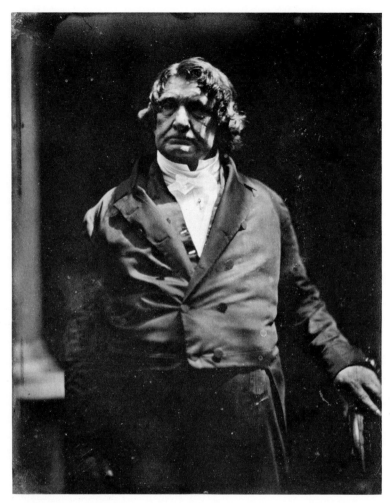

Southworth and Hawes: Lemuel Shaw, 1851. Daguerreotype, actual size. Collection: The Metropolitan Museum of Art, Gift of Edward S. Hawes, Alice Mary Hawes, and Marion A. Hawes, 1938.

Daguerrean Gallery in New York City. Fire destroyed this collection in 1852, and Anthony, who had earlier sold his gallery interest, then formed a new partnership with his older brother, Henry, to sell daguerreotype supplies. Their firm of E. and H. T. Anthony and Company remained the major American supplier of photographic materials for half a century.

Albert Southworth and Josiah Hawes of Boston produced remarkably natural daguerreotypes, like that of Chief Justice Lemuel Shaw of the Massachusetts Supreme Court, reproduced here. They claimed that they exposed all plates themselves, never using "operators," and since they took many poses at each sitting, they were able to assemble a major collection of portraits and views. It is now preserved in three museums.

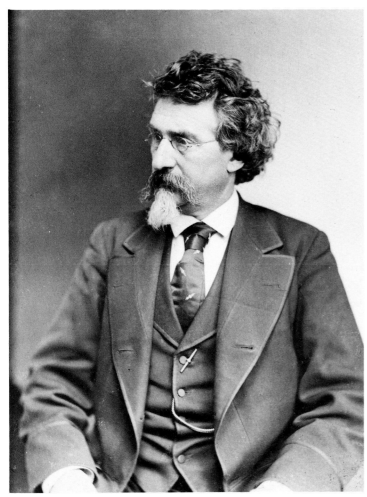

Levin C. Handy: Mathew B. Brady, c. 1875. Daguerreotype. The Library of Congress.

Mathew Brady

By far the most famous of all early American photographers was Mathew B. Brady. His studios in New York and Washington daguerreotyped the great and near great of a prosperous but deeply troubled era. The Mexican War of 1846–1847 had given the United States vast territorial gains, and these in turn produced a westward outlook and migration that were dramatically stimulated by the discovery of gold in California in 1848. The trouble, of course, was that peculiar institution—slavery—which supported a southern economy based almost entirely on cotton, and which reared its ugly head as each new western territory came up for inclusion in the union.

More than any other early American photographer, Brady sensed the usefulness of photographs as historical records of a changing time. By 1850 he had organized his business so that he could afford to photograph people and events because he felt they were important. Brady's publication of a *Gallery of Illustrious Americans,* 12 lithographs skillfully copied from daguerreotypes he made of John J. Audubon, John Calhoun, John Charles Fremont, Zachary Taylor, Daniel Webster, and others, was conceived and heavily subsidized by the photographer himself. Undoubtedly he realized the social and historical value of the reproducible photographic image before it became widely available. When the first major skirmish of the Civil War erupted at Bull Run in 1861, Brady was there.

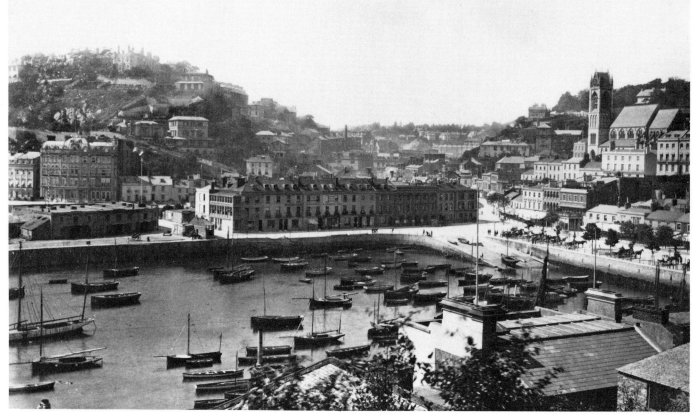

Francis Bedford: Torquay, England, c. 1860. Albumen print. Author's collection.

The Collodion Era

English photography, effectively stifled by Talbot with his patents, languished for a decade before two unsung heroes changed the course of its history. One was a gentle and unassuming sculptor and photographer, Frederick Scott Archer, who in 1851 introduced the *collodion* process for making negatives on glass. This was not only a significant improvement over both paper and metal, but also the first workable process not restricted anywhere through patents by its inventor. Talbot, however, claimed that collodion was merely a variation of his calotype, and prosecuted those who used it without paying his fee. One such defendant was Silvester Laroche, a London studio operator. Laroche threatened countersuit, and moved to block the upcoming renewal of Talbot's calotype patent. A jury found Laroche not guilty of infringement, and with collodion thus beyond his legal grip, Talbot let the calotype patent expire. Meanwhile Daguerre's English patent had run out, so by 1855 photography in England could be practiced by anyone.

Collodion was made by treating cotton with nitric acid to form nitrocellulose, and then dissolving that in a mixture of ether and alcohol to form a clear, viscous liquid. When spread on glass and allowed to dry, it became a tough film. Archer added potassium iodide to his collodion and, before the coating had dried, dipped the plate into a silver nitrate bath. This formed a suspension of silver iodide all over the collodion surface. Then he exposed the plate *while it*

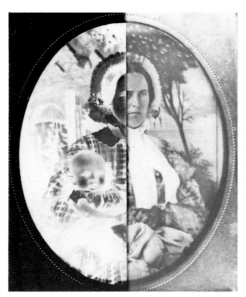

C. R. Moffett: Woman and Child, Mineral Point, Wisconsin, 1858. Ambrotype showing negative and positive aspects. Actual size. Author's collection.

was still wet, before its sensitivity diminished. Development was by pyrogallic acid with subsequent processing by conventional means.

Collodion was easier to work than the daguerreotype, and much more sensitive than the calotype. It yielded a negative image on glass, from which unlimited numbers of high quality paper prints could be made. Photographers everywhere eagerly adopted the collodion process, or *wet plate,* as it was popularly known. It became the universal negative material from about 1855 to 1880, and was printed on albumen paper. Francis Bedford's view of Torquay, an English holiday town, shows the excellent tonal quality possible with this process. In 1857, Archer died prematurely, unrewarded and virtually unrecognized for his discovery and his generosity.

American daguerreotypists, too, were quick to adopt the wet process. Archer's invention was patented here in 1854 by James Ambrose Cutting of Boston. It was a weak collodion negative on glass; when placed on a black cloth it appeared to be a positive, and in this form it thus became a cheaper substitute for the daguerreotype. Most were no larger than 3¼ by 4¼ in. (8.3 by 10.8 cm) and were matted and cased just as daguerreotypes were. In America these small collodion positives were called *ambrotypes.* The portrait by C. R. Moffett, of Mineral Point, Wisconsin, shows the negative-positive effect (here the left half is seen by transmitted light; the right half is backed by black paper).

The immensely popular *tintype* was a modification of the same process,

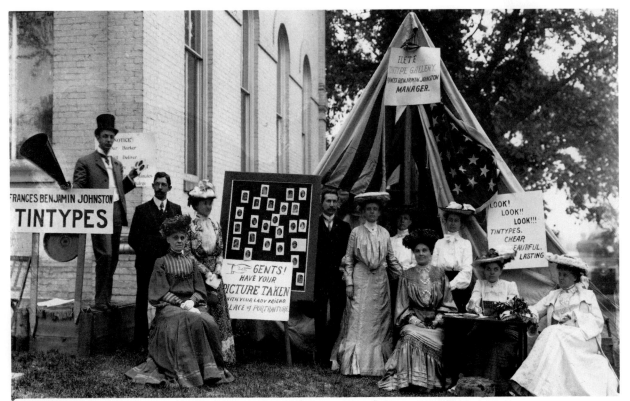

Frances Benjamin Johnston: Her Tintype Gallery and "Studio" at a County Fair in Virginia, 1903. The Library of Congress.

with the collodion poured over a piece of metal that first had been lacquered with a dark-colored varnish. Tintypes were not as fragile as glass and could easily be mailed. They could not be reproduced, though, so were similar to daguerreotypes in their appeal, but much cheaper to produce. Most were portraits, casually and quickly made. Tens of thousands of them still survive.

It was still another form of the collodion image, however, that finally rendered the daguerreotype obsolete. In 1854, Adolphe-Eugène Disdéri in France patented the *carte-de-visite*, or visiting card photograph, so named because the print was pasted on a card mount 4 by 2½ in. (10.1 by 6.4 cm) similar to what we now call a business card. Multi-lens cameras equipped with devices to reposition the 6½ by 8½ in. (16.5 by 21.6 cm) collodion plate between exposures enabled studio operators to quickly take eight pictures and process them as one. The resulting albumen print was cut up and mounted.

Most of the early card photographs were full-length portraits, and the

T. Partridge: Unknown Girl, South Devon, England, [n.d.]. Carte-de-visite. Author's collection.

Adolphe-Eugène Disdéri: Uncut print from carte-de-visite negative, c. 1860. Collection: The International Museum of Photography.

style remained popular for decades. People left them as calling cards; they became "the social currency, the sentimental 'greenbacks' of civilization," as Oliver Wendell Holmes put it. Photograph albums, introduced in 1861 expressly for collecting and storing such cards, soon became a fixture in nearly every American parlor. A larger card style, the *cabinet photograph,* appeared in England in 1866. At first it was used for publicity pictures of royalty and theatrical people, but soon it, too, swept the world. The example here is from Finland.

Augustus Schuffert: Group of eight men, Turku, Finland, [n.d.]. Cabinet photograph. Author's collection.

The Emergence of Style

From heliography through the early collodion era, the images made by each method were largely determined by the nature of the process itself. Thus while the daguerreotype was capable of recording events that changed very slowly in time, it was used primarily for unique portraits. Calotypes, rich in tone but poor in detail, seemed best suited to landscapes and architectural views. Albumen was too slow for the camera but was ideal for contact printing. Ambrotypes and tintypes, inexpensive collodion positives, were sold like the daguerreotypes they replaced. Collodion negatives with their short ex-posures were taken of everything that could be exposed to light. Such negatives were ideal for *published* photographs, that is, for multiple prints of a single image. With collodion, a universal technique was established; photographs thereafter differed largely because the people who made them were not all cut from the same cloth.

Having described each vintage process and its typical pictures, we may now consider photographs made from the collodion era to the present day primarily as personal statements, as pictures made by people. In the main, *who* made them and *why* they were made are far more important than *how*. And what they tell us today can be a richly rewarding experience.

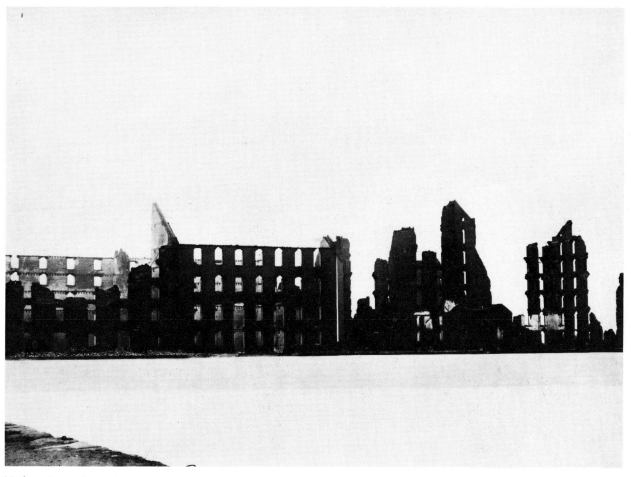

Mathew B. Brady: Ruins of the Gallego Flour Mills, Richmond, Virginia, 1865. Albumen print, 6½ by 8¼ in. (16.5 by 21 cm). Collection: The Museum of Modern Art, New York.

Take Mathew Brady and his Washington studio manager, Alexander Gardner, for example. Between them they photographed nearly every President and other government officer of cabinet rank or above, from John Quincy Adams to William McKinley.* This sense of history, mentioned earlier, also compelled Brady to photograph the preparation for battle and its inevitable aftermath during the Civil War. Brady's photograph of the

gutted Gallego Mills at Richmond, burned by retreating Confederate troops in April, 1865, speaks simply and directly of the ultimate futility of war. There are few more eloquent pictorial expressions of this theme from any conflict, before or since.

Brady and his staff, incidentally, were not the first cameramen to photograph warfare. A few daguerreotypes survive from the Mexican War (*c.* 1847) but they show no combat. Roger Fenton, sent to the Crimean War in 1855 by an English publisher, returned to London with more than 300 photographs of military encampments and other details, but his pictures are not combat views either, although some probably were made under fire.

* William Henry Harrison died in 1841, a month after his election and before Brady had established his business. Many notables were photographed after their terms of office had expired.

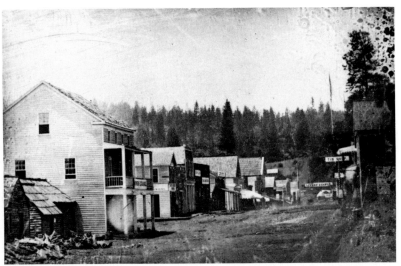

Isaac W. Baker: Murphy's Camp, California, 1853. Daguerreotype. Collection: The Oakland Museum.

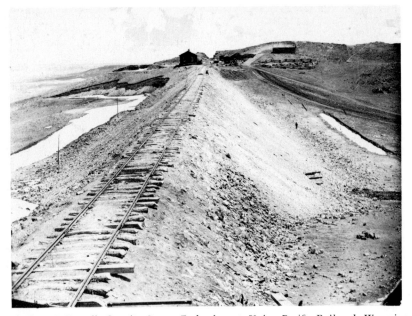

Andrew J. Russell: Granite Canon Embankment, Union Pacific Railroad, Wyoming, 1869. The Oakland Museum, Andrew J. Russell Collection.

The American West

A decade before the Civil War, daguerreotypists had accompanied geographic expeditions as they charted rivers and mountains across the unsettled land. Most of the images made by these pioneer cameramen are known only from sketchy mention in government reports; few plates have survived. Other photographers worked eastward from the Pacific coast. R. H. Vance and Isaac W. Baker joined the forty-niners in the California goldfields, and Carleton E. Watkins was among the first to photograph Yosemite Valley in 1860.

After 1865 America again turned its attention westward. Expeditionary teams now surveyed for mineral resources, ethnological knowledge, and other specific purposes. Alexander Gardner and Captain Andrew J. Russell, fresh from the war, hired on with the Union Pacific Railroad to document its route survey and construction that had been brought to a standstill by wartime shortages of men and iron. Russell's view of the Granite Canyon fill west of Cheyenne, Wyoming, clearly shows how quickly and poorly some parts of the first transcontinental line were rushed to completion. Many miles of the line were rebuilt after the historic meeting of the rails at Promontory, Utah, on May 10, 1869. Russell and two other photographers, A. A. Hart from Sacramento and Charles Savage from Salt Lake City, recorded that dramatic event.

Timothy O'Sullivan, who like Gardner had worked for Brady in wartime, went to California in 1867 with the Clarence King survey party. They headed eastward from the massive granite wall of the Sierra Nevada,

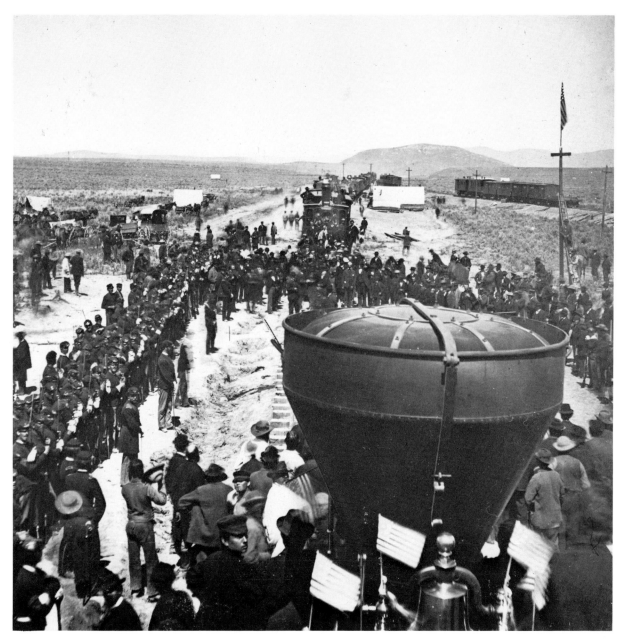

Andrew J. Russell: Meeting of the Rails at Promontory, Utah, 1869. The Oakland Museum,
Andrew J. Russell Collection.

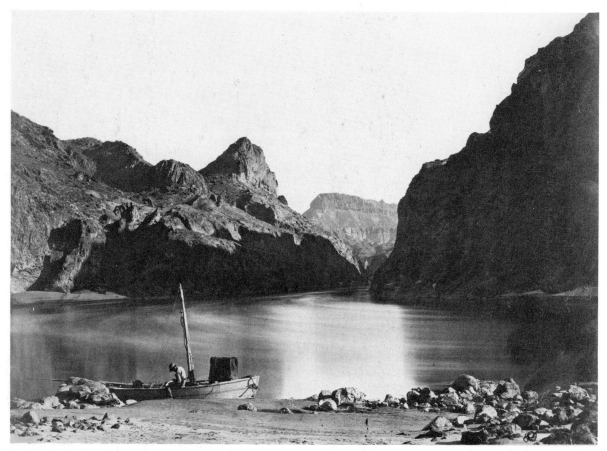

T. H. O'Sullivan: Black Cañon of the Colorado, 1871. The Library of Congress.

across the great basin of Nevada and Idaho. In 1871, after a few months in Panama with a survey team seeking routes for a canal, O'Sullivan joined Lt. George M. Wheeler's expedition in the Southwest. The party crossed Death Valley and tried to explore the Grand Canyon of the Colorado by boat (O'Sullivan's tiny darkroom is seen here aboard one of the craft). Two years later, O'Sullivan again accompanied Wheeler through Arizona and New Mexico; this trip yielded him some of the most strikingly beautiful images of the American West. Cañon de Chelly represents O'Sullivan at his best.

There were dozens of other territorial and frontier photographers whose work survives. J. C. H. Grabill of Deadwood, Dakota Territory, for instance, made remarkable views of the Plains Indians. The Sioux encampment near Brule, reproduced

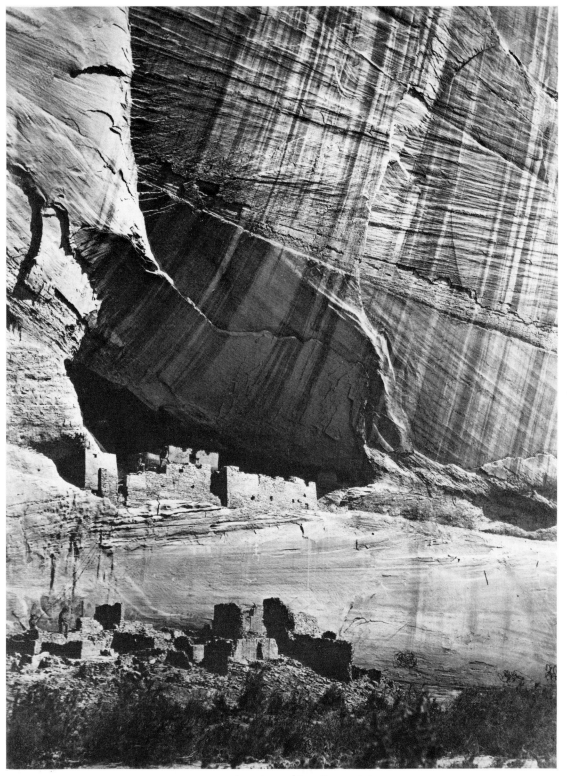

T. H. O'Sullivan: Cañon de Chelly Cliff Dwellings, 1873. The Library of Congress.

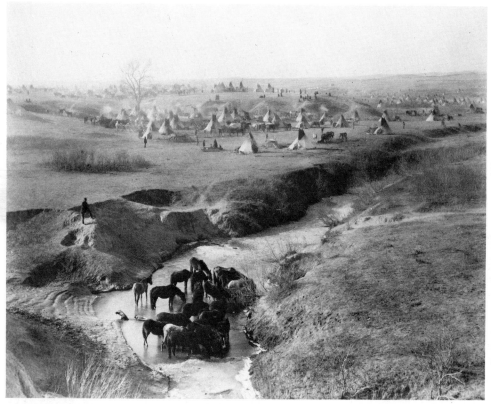

J. C. H. Grabill: Sioux Encampment near Brule, Dakota Territory, 1891. The Library of Congress.

here from Grabill's print, was probably photographed soon after the Battle of Wounded Knee.

But the best known of all the frontier cameramen was William Henry Jackson, who worked his way west from Omaha and was the official photographer to the Hayden Surveys from 1870 to 1879. The 1871 trek explored the natural wonders of the Yellowstone region, and Jackson's photographs, displayed to the Congress in Washington, were instrumental the next year in creating Yellowstone National Park. For several years after 1875, Jackson, headquartered in Denver, photographed the Rocky Mountain region. Occasionally he used a 20 by 24 in. (50.8 by 61 cm) wet plate camera, enduring the trials of working with such messy and cumbersome apparatus to produce a collection of superb views. After 1860, however, most western photographers made paired stereoscopic negatives, since the three-dimensional pictures were the height of fashion in more settled areas of the country, and an important source of income for cameramen on the frontier.

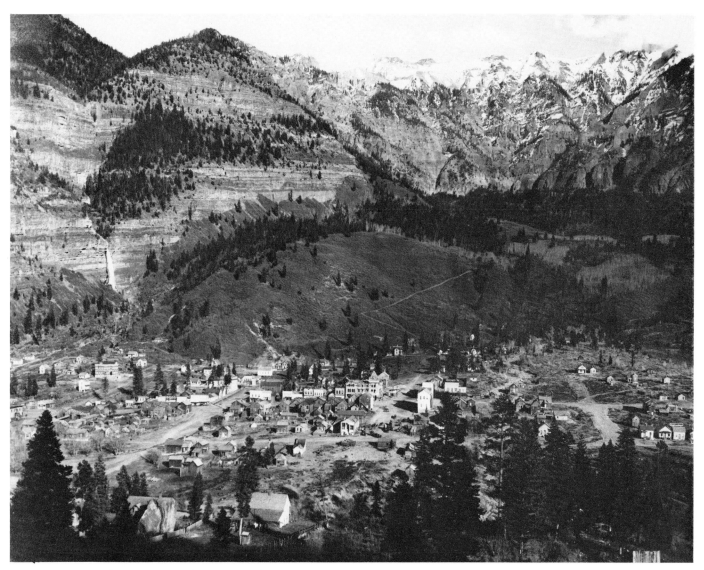

William Henry Jackson: Ouray, Colorado, c. 1885. Collection: The International Museum of Photography.

The Gelatin Period

Looking at these early western photographs today does not readily reveal that the photographer's lot was a difficult one. Pictures by Gardner and O'Sullivan reproduced here and in Chapters 5 and 8 give us clues: everywhere the cameraman went, his darkroom had to go too, for collodion plates had to be sensitized, exposed, and developed on the spot. This problem had plagued photographers everywhere for nearly two decades.

Once again the solution came from England. In 1871, Dr. Richard L. Maddox, a physician and amateur photographer, found that when he replaced collodion with *gelatin,* he had an equally clear but *dry* vehicle for the silver salts. Seven years later, another Englishman, Charles Bennett, discovered how to increase their sensitivity a hundred times or more, and gelatin plates were enthusiastically received the world over.

Three advantages were immediately realized. First, photographers were freed from the mess and inconvenience of wet collodion. Second, the tremendously higher sensitivity of gelatin emulsions for the first time made photography of action feasible.* Third, because dry plates did not require coating just before exposure or developing immediately thereafter, they could be made and sensitized at a central factory and shipped to the user. Thus an industry was born. All that now remained was to replace the frag-

ile glass plate with a flexible, nonbreakable support. A decade later it came along, and it revolutionized photography again.

In May of 1887, Rev. Hannibal Goodwin of Newark, New Jersey, applied for a patent on a flexible, transparent rollfilm made of nitrocellulose. More than two years elapsed before the patent was granted, and in the meantime Henry Reichenbach, a chemist employed by George Eastman, patented a similar product. Eastman began making the film, and in 1888 a camera, the *Kodak,* to use it. Noting the success of Eastman's new products, Goodwin's heirs (he died in 1900) and the owners of his patent sued Eastman charging infringement. After 12 years of legal proceedings that eventually went against him, Eastman settled the matter. The inventor of the Kodak, however, could well afford the decision. His combination of a small, hand camera and dry rollfilm was simple to use and made photography practical for everyone. The tools and materials we use in photography today stem directly from that epochal achievement.

Up through the introduction of gelatin and the hand camera, the photographic process, as we have seen, changed several times. What we did with that process—the photographs we made—evolved more slowly. For half a century after 1900 the basic method remained pretty much the same. A few improvements were significant: panchromatic films (explained in Chapter 5), more sensitive materials, instant processing, and most notable of all, practical color photography. The styles and uses of photographic

* The multiple role of gelatin is further explained in Chapter 5, and the photography of action in Chapter 8.

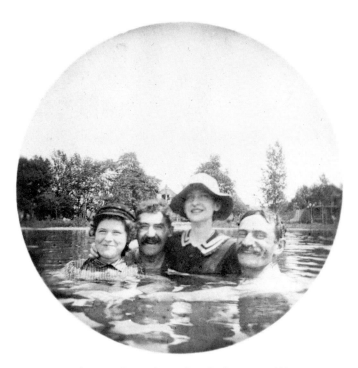

[Photographer unknown]: Bathers, c. 1888. Snapshot taken with No. 2 Kodak. Collection: The International Museum of Photography.

pictures also were redefined, but for the most part these changes continued to lag behind technical improvements, usually occurring as belated responses to them.

Since 1960, however, rapid and numerous improvements in the technology of photography have given image makers the means to explore many new directions and to cover more familiar territory with unparalleled ease. Photographers themselves have not been complacent; more than ever before, they are seeking new ways to make pictures. They will readily adapt a long-obsolete material or process to their needs where the new technology does not keep pace with their vision, and their restless search is already demanding some fundamental redefinition of the photographic language. The more significant developments in contemporary photography, and their importance to us as image makers, will be considered in other chapters of this book.

One final note of caution about the various vintage processes that are an integral part of our photographic heritage. In recent years there has been a sporadic renewal of interest in using them, especially by students. The daguerreotype and collodion processes, in particular, employ chemicals that are dangerous to human health (mercury), highly flammable (collodion), or deadly poison (potassium cyanide). They should not be casually handled under any circumstances, and attempts to recreate these obsolete materials are therefore not recommended.

Astronaut Edwin E. Aldrin, Jr. on the Moon. Apollo 11, 1969. NASA.

Every camera, no matter how simple or complex it may be, has four vital parts. The most important of these are the lens, which forms the image, and the film, which records it. A third part, the shutter, times the passage of light to the film, and a fourth essential part, the lightproof chamber or box, connects the other three.

To be sure, most cameras have more parts than these. Their number, design, and complexity have a direct bearing on a camera's usefulness and are unavoidably reflected in its cost. Most of these additional parts relate to things we must do when we make a picture with a camera. Usually there are three operations: framing, focusing, and exposing; they are fundamental to all camerawork.

What makes one camera preferable to another? If they all are essentially similar, what accounts for the vast differences in cost which are obvious to the beginner and veteran photographer alike? Generally speaking, ex-pensive cameras are built better than cheaper ones are. They may therefore be expected to give longer, more dependable service for their added cost. But they will not, by themselves, produce better pictures; that is largely up to the photographer who uses them. Beyond this, most camera differences relate to their fundamental design. Basically, all cameras are one of three types: view cameras, rangefinder cameras, or reflex cameras. Recognizing these types is the key to understanding them.

View Cameras

The view camera is directly descended from the *camera obscura* of Renaissance times, and its modern form is a flexible yet precise photographic tool. It requires a stand or tripod for rigid support, and an opaque cloth to cover the adjustable chamber, or bellows, together with the photographer's head,

Calumet 4 x 5 View Camera. Courtesy Calumet Photographic, Inc.

Leica M5 Rangefinder Camera. Courtesy E. Leitz, Inc.

in order to exclude light that would render the dim ground-glass image invisible. With a view camera, the photograph must be composed and its elements assembled within the frame of the ground glass to produce the recorded image. Because the photographer can view the ground-glass image under the dark cloth with both eyes and can examine it in detail, the view camera, more than any other type, tends to make the photographer aware of the image as a two-dimensional picture. This, of course, is the vital element of seeing photographically. The view camera is designed to use film in single flat sheets that permit exposures to be processed individually and immediately if necessary. Using this camera is a slow process, but it can be rewarding to a patient worker. It encourages discovery, builds discipline, and effectively separates the image of a photograph from its subject in the real world. It is the classic photographic tool.

Rangefinder Cameras

In the rangefinder camera, a brilliant, optical *viewfinder* is used to frame the image as the photographer holds the camera up to his eye. This design invites one to use the camera as an extension of the eye, which in turn encourages careful and continuous observation of the subject—even interaction with it—but at the expense of readily sensing the two-dimensional or graphic qualities of the picture. This phenomenon may be disadvantageous to the artist but it is an asset to the reporter who must constantly and visually seek the significance of a changing situation. The viewfinder image does not focus, so this type of camera often includes a *rangefinder*. In its simplest form, this is a pair of small mirrors or prisms placed about three inches apart within the camera. One mirror is transparent (the eye can see the subject through it) and is stationary; the other pivots as the

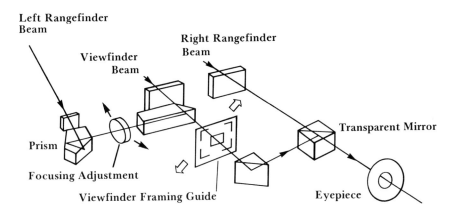

How a rangefinder works.

Yashica D Twin-lens Reflex Camera. Courtesy Yashica, Inc.

lens is moved to focus it, resulting in two images of the subject which coincide to form one when the lens is focused on that distance (see diagram). Without a rangefinder in this type of camera, the distance to the subject must be estimated and the lens then set accordingly. With a rangefinder, however, focusing is quick and accurate, although the added number of moving parts and any adjustment required by them are usually reflected in the camera's cost and reliability. The rangefinder often is conveniently incorporated within the frame of the viewfinder.

The rangefinder camera, nonetheless, has one serious flaw: its viewfinder and its taking lens, being in different places, do not frame exactly the same area of the subject. This discrepancy, known as *parallax,* is serious at close working distances (less than three feet from the subject). Such cameras are unsuited to copying and similar close-order applications,

unless expensive accessories are added. Most rangefinder cameras today are designed around the popular 35 mm and 16 mm formats. They are compact, lightweight, rapid working, and relatively quiet. Many have automatic exposure systems built into them.

Reflex Cameras

Reflex cameras combine many of the best features of view and rangefinder cameras and are therefore a popular compromise between these other basic types. There are two kinds: the twin-lens reflex (TLR) and the single-lens reflex (SLR).

Twin-lens reflexes have separate lenses of identical focal length for viewing and recording, placed one above the other and mounted so that they focus together. Most yield 12 pictures, $2\frac{1}{4}$ in. square (6 by 6 cm), on a roll of 120 film. The Rolleiflex is the most famous; many others are patterned after it.

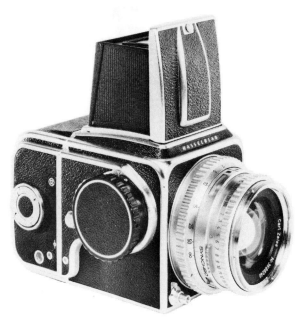

Hasselblad Single-lens Reflex Camera. Courtesy Hasselblad/Paillard.

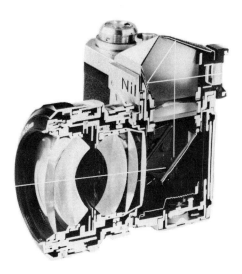

Single-lens Reflex Camera, cutaway view showing light path to eyepiece. Courtesy Nikon, Inc.

Like the view camera, the TLR produces a viewing image the same size as the one projected on the film—a distinct advantage—but like the rangefinder type, it suffers from parallax: the viewing lens and taking lens are in different places and frame slightly different areas of the subject. In some models, parallax is reduced by a mask on the ground glass which moves with the focusing mechanism or by a similar movement built into the reflecting mirror under the ground glass. Nevertheless, the twin-lens reflex camera is small enough to be managed easily in the hands, yet it produces an image large enough to be studied with the unaided eye and to be useful for most applications. It is a good choice for general work where neither the greatest precision nor the most rapid-acting tool is required. The TLR is an excellent "first camera" for the student.

Single-lens reflex cameras eliminate many drawbacks of the twin-lens version. The same lens is used for both viewing and taking, thus eliminating parallax, but this combination of functions in one optical system requires a movable mirror behind the lens. In such cameras the shutter usually is located at the rear of the chamber, near the film. Since the shutter is not located within the lens, as with most other types heretofore described, different types of lenses can be interchanged on the same camera body without the necessity of a separate shutter in each. A through-the-lens exposure metering system, the most accurate in principle, can readily be built into the SLR design, and an erecting prism above the mirror is generally used to revert the viewing image to its correct lateral and vertical orientation. Some models also incorporate a system of small reversed prisms or microprism grids to assist in focusing. These devices work like a rangefinder, but since they utilize peripheral light rays from the lens, rather than central ones, they are not critically accurate: they tend

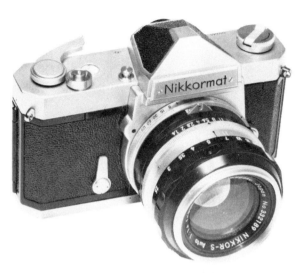

Nikkormat Single-lens Reflex Camera. Courtesy Nikon, Inc.

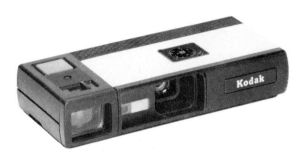

Kodak Pocket Instamatic 40 Camera. Courtesy Eastman Kodak Company.

to be least accurate when most needed (at low illumination levels and at close distances). Most SLR cameras use either 2¼ in. square (6 by 6 cm) or 35 mm formats. The former size tends to be expensive, but usually is of excellent quality. There is an endless variety of 35 mm SLR cameras on the market, and if a single one well-suited to both black-and-white prints and color slides is desired, this group should be looked over with care.

Popular Combinations

To sum up, then, it should be apparent that there is no such thing as a universal camera, but that each design has advantages and drawbacks which must be considered by each photographer in light of his own needs. Most general-purpose still cameras are basically of reflex, rangefinder, or view design. For many years, three film sizes—4 by 5 in. (10.2 by 12.7 cm), 2¼

in. square (6 by 6 cm), and 35 mm (about 1 by 1½ in.)—have formed a classic trinity, with the 4 by 5 in. view camera, 2¼ in. square TLR, and 35 mm SLR outnumbering all others among serious photographers. In addition to these, about one out of every seven Americans has a camera of the Instamatic or Pocket Instamatic type. These use 35 mm or 16 mm film in sealed cartridges that can be conveniently loaded without threading.

Some cameras, particularly older models which often can be obtained *used,* incorporate two or more basic designs and features previously mentioned into workable combinations. Another important point: cameras depreciate in value just as automobiles do; a used camera purchased from a reputable dealer can be an outstanding value for the beginning photographer. Check the camera thoroughly (see Appendix A) and be sure you have the option to return it to the dealer if it proves unsatisfactory.

Adolphe Braun: Countess Castiglione Holding a Frame as a Mask, c. 1870. Collection: The Metropolitan Museum of Art, Gift of George Davis, 1948.

Framing and Focusing

Framing the picture with most cameras is simple and straightforward. In a view camera, the process is obvious: the ground glass says it all. Likewise with the twin-lens reflex: the ground glass is the most accurate framing device and it should be used whenever possible, although in poor light conditions it may be necessary to use the eye-level finder (open frame finder) that is built into the hood of most such cameras. With single-lens reflex and rangefinder cameras, *fill the viewfinder completely*. If your resulting pictures show too much foreground and background around your subject, you're simply not getting close enough.

Focusing usually can be combined with framing. Focusing, of course, has to do with the way the lens forms an image. This will be discussed at length in Chapter 8, but suffice it to say here that the way in which an image is focused will bear directly on the meaning of the picture and on its visual impact. The best general advice that can be given at this point is to *focus on the most important object in the frame*. If you are photographing a person, for example, focus on his eyes.

Exposure

Once we have framed and focused our image, we must retain it. Photography's name is derived from two Greek terms meaning, literally, "to write with light." In the camera, light "writes," of course, by striking the film. Controlling this is a matter of correct exposure.

Every photographic exposure must deal with four variable elements. These are:

1 The intensity of light on the subject, or the brightness of that subject's reflection to the camera.
2 The sensitivity of the film to this light.
3 The length of time light reaches the film.
4 The amount of light that reaches the film.

Let's consider each of these elements in turn.

Light Intensity

In the early days of photography, calculating an exposure was a simple matter. Exposure times were long because plates were not very sensitive. Most photographs were therefore made only in bright daylight, and it was considered a mark of superior craftsmanship and ability if, as many a tintype studio claimed on their mattes, "good pictures can be made in cloudy and rainy weather." Today, of course, we make photographs in a tremendous variety of light conditions, and a more precise means to measure the intensity of that light, or how much of it is reflected to the camera by the subject, is needed.

The most dependable tool for this purpose, once its use is mastered, is a good photoelectric exposure meter. As we'll explain later in this chapter, a meter is a complex device, and is easily misinterpreted. It is not essential for general photography *outdoors by daylight,* where most of our pictures probably will be made. On a typical, clear, sunny day, the intensity of daylight will not vary much from place to place; nor will it change much from one such day to the next. Thus it should be possible to estimate this intensity under various weather conditions with some degree of accuracy, and to do it closely enough to be useful for exposure calculations, yet arbitrarily enough to be simple. The essential point to grasp here is that *daylight varies in intensity* according to a number of factors, but that many of these factors are common enough to be easily quantified. Whether we use a meter to measure the light or depend on a simple, empirical method, we have to judge the intensity of that light because it affects our exposure.

Film Sensitivity

Films differ from one another in many ways, the most important of which is their sensitivity to light. When photographers want to describe how sensitive to light a film is, they generally use the term *film speed.* In the United States this speed or sensitivity is expressed as a designation on a rating scale approved by the American National Standards Institute, formerly known as the American Standards Association. The film speed, therefore, is known as an *ASA rating.* One film may be rated 50 and another film rated 400; this means that the 400 film is eight times faster (eight times more sensitive to light) than the film rated 50 is. Most black-and-white snapshot films are rated 125, but a few are rated 400. The film rated ASA 125 is therefore about one-third as sensitive to light as the other type. Stated conversely, the ASA 400 film is about three times more sensitive to light than the ASA 125 film is. Again, the essential point here is that *all films are not the same, and their response to light must be known.* The ASA rating, or film speed, is supplied by the manufacturer and usually can be found on the film carton. Incidentally, there are other rating systems used in other countries, but all film of foreign manufacture sold in America will contain the ASA rating.

Shutter Time

Once we know the intensity of light on the subject and the film sensitivity, only two questions remain: how much light should reach the film, and for how long. Let's consider the latter element next: the question of *time.*

We control the length of time we expose the film by the camera's shutter. Most shutters are located either within the lens of a camera or just in front of the film. The former generally are known as *leaf shutters* (or between-the-lens shutters); the latter are *focal-plane shutters.* Each name is descriptive of its general location within the camera. On modern cameras, the shutter may be a very complex mechanism, but its function is a simple one. By opening and closing, it permits light to reach the film and record the image on it. Thus it exposes the picture.

Single-lens reflex cameras usually contain a focal-plane shutter. This

consists of a two-section or slotted curtain moving across the plane of the film. The width of the slot, or the distance between the two sections, can be varied, as can the speed of their travel. These variations result in different times of exposure to the film.

Leaf shutters consist essentially of a set of overlapping metal blades or leaves, arranged to open in a few thousandths of a second when actuated by the release button. Usually a rather intricate gear train is set in motion to control the length of time the leaves stay open, variable from one second to a mere $\frac{1}{500}$ or even $\frac{1}{1000}$ of a second before the blades close. The more time settings a shutter provides, the more complex (and expensive) it will be.

On some newer cameras intended for snapshots and containing automatic exposure systems, the shutter may be electronic. The action of this type is similar to that described above, except that the leaves are held open by an electronic light-sensing device rather than a gear train. When the sensor has absorbed enough light for proper exposure, the circuit releases the blades and the shutter closes. *With an electronic shutter, it is important to hold the camera very still during exposures in dim light, for the shutter may automatically remain open as long as ten seconds.* Exposures in bright light, of course, are relatively instantaneous.

The scale of times for which the shutter may be set is marked in *fractions of one second*. The most common designations are 1, 2, 4, 8, 15, 30, 60, 125, 250, 500, and occasionally 1000. Remember: these numbers represent fractions. 1 is one second, 2 is a half second, 4 is a fourth of a second, 500 is $\frac{1}{500}$ of a second, and so forth. Some older cameras may have slightly different markings, but the idea is the same: *each setting provides half or double the time of adjacent ones.* Stated another way, moving the shutter one setting will change the exposure time by *a factor of two.* Remember, however, that we are dealing with *fractions of one second:* thus, changing from 125 to 250 cuts the exposure time in half; changing from 60 to 15 increases the exposure four times. The important concept here is the *factor of two.* It's the key to understanding how exposure times are set on the camera.

The shutter scale may also include B and T settings. When set at B the shutter will remain open as long as the release button is held down.* Thus the B setting is useful for exposures lasting longer than one second. The T setting (time) is similarly used, but it requires two actions of the exposure release—one to open the shutter and another to close it. A flexible *cable release* is strongly recommended to avoid jarring the camera while the shutter is open. Screw one end of the cable into the shutter release on the camera, and press the plunger on the other end to make the exposure.

The Aperture

To review for a moment, once the intensity of light on the subject and the film sensitivity are known, the exposure is simply a matter of the brightness of light reaching the film multiplied by time. Time, as we have seen, is controlled by the shutter; light is controlled by the lens aperture.

The *aperture* (also known as the *diaphragm, stop,* or *f/ stop*) is an opening formed by a series of pivoting metal leaves in or near the lens. These leaves change the size of that opening as they move; they form a mechanical imitation, and quite a remarkable one, of the iris diaphragm in our own eye. The camera aperture performs the same function: by opening—getting larger—it admits more light to the camera. By closing—getting smaller—it reduces the amount of light reaching the film. The aperture leaves are mechanically independent from the shutter blades, although they often are similar in appearance and are located close to each other.

Apertures are marked in *f/ numbers,* those mysterious figures found on lenses which undoubtedly are the most confusing element of basic photography. To understand f/ numbers clearly, we must first have an acquaintance with another term: focal length.

Let's see what the term *focal length* means. When parallel rays of light, which come from very far away, pass through a camera lens, they are bent inward and come to a point, or focus, some distance behind the lens. The focal length of a lens is the distance from its optical center to this point (see diagram). More simply stated, *focal length is the distance from the lens to the film when that lens is focused on infinity,* that is, on a very distant object. This focal length is characteristic of each particular lens and is constant; it does not change even though the lens may be moved farther away from the film to focus on objects closer to the camera. We'll explain focal length

* The initial B stands for *bulb* and is a throwback to the days when nearly all camera shutters were operated by squeezing a rubber bulb at the end of a long air tube. The name survives to designate a similar action on modern cameras.

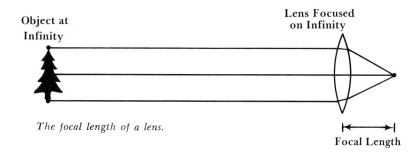

Object at
Infinity

Lens Focused
on Infinity

The focal length of a lens.

Focal Length

more fully in Chapter 11, but for now let's return to the aperture.

Most cameras use what is known as the *ratio system* to designate relative aperture settings. The symbol for this is the *f/ number,* and it expresses *the diameter of the opening as a fraction of the focal length.* For example, an f/4 lens has an opening whose diameter is one-fourth its focal length; an f/2 lens has an opening whose diameter is half its focal length; an f/16 lens, a diameter one-sixteenth its focal length. While the focal length of a lens remains constant—does not change—the diameter or size of the aperture can be easily changed by the adjustable diaphragm. We can take an f/4 lens and move its aperture control to f/5.6, or f/8, or f/11, or even to positions in between these numbers. All we do is change the diameter of the lens opening in relation to its constant focal length.

The f/ numbers usually found on modern lenses read like this: 2, 2.8, 4, 5.6, 8, 11, 16, 22, 32, etc. Obviously this is not a simple progression, so let's consider it a moment. Each f/ number (or f/ stop) in this series represents a diameter of the aperture as a fraction of the focal length. From our earlier discussion we will recall that at f/2, for example, the diameter is half the focal length; at f/8, one-eighth the focal length, and so on. While we are

actually measuring the diameter of the lens opening, we must remember that we're really concerned with *how much light* comes through the opening, not merely how wide it is. When light enters a window, it comes through the entire window, not just the width. So it is that light comes through the entire opening of the lens: it comes through the *area* of the aperture rather than its diameter.

If we set a lens at f/4 (diameter one-fourth its focal length), a certain amount of light will come through the rather large opening provided. Now let's close down the aperture setting to f/5.6. The diameter is now smaller (it will divide into the focal length 5.6 times), but if we compute the *area* of this smaller circle (using the formula $A = \pi r^2$, we'll discover that this area is half that of the f/4 opening. Stated again, by moving the aperture setting from f/4 to f/5.6, we've cut the *area* of the opening in half. And by cutting the area in half, of course, we've also cut in half the amount of light that can enter. Make the window only half as large and only half as much light can get in—it's as simple as that.

Now, back to our f/ number progression we looked at a few moments ago. The usual sequence found on cameras is: 2, 2.8, 4, 5.6, 8, 11, 16, 22, 32. As we move the diaphragm to each higher number in this series, we cut

the amount of light passing through the lens in half; as we move to each lower number, we double the amount of light that can pass through. This is because each f/ number is a fraction of the focal length; smaller aperture diameters are smaller fractions, which have larger denominators. Hence f/8 is a smaller opening than f/5.6, and admits half as much light; f/11 passes one-fourth the light of f/5.6 ($\frac{1}{2} \times \frac{1}{2}$) and f/16 passes one-eighth the light of f/5.6 ($\frac{1}{2} \times \frac{1}{2} \times \frac{1}{2}$). All other apertures are similarly related.

As a rule, only a portion of the f/ stop progression is found on any single camera. The lens may not close down all the way to f/32, nor open as far as f/2. The maximum aperture of any lens depends on its design, and sometimes that maximum falls in between the more familiar numbers. Hence many reflex camera lenses have a maximum aperture of f/3.5; maximum apertures of f/4.5, 4.7, and 6.3 are also found occasionally on older lenses.*

* The "speed" of a lens is designated by its maximum aperture: this and its focal length usually are marked on the lens mount. Thus a lens designated f=1:2.8/80mm is described as an eighty millimeter, f/2.8 lens. Note, however, that *lens speed* is different from *shutter speed:* the speed of a lens refers *only* to its largest aperture, which admits the most light.

John T. Daniels: Wright Brothers' First Flight from Kitty Hawk, N. C., 1903. The Library of Congress.

Relating the Shutter and Aperture

We can now see that the normal aperture scale, like the shutter scale, varies by a *factor of two*. Moving the aperture setting one number (one position) halves or doubles the amount of light reaching the film; moving the shutter setting one position halves or doubles the length of time light reaches the film. Earlier we noted that once the intensity of light on the subject and the sensitivity of the film were known, the exposure became the product of intensity and time: $E = I \times T$. Now the relationship between shutter time and f/stops becomes clear.

Some of the creative options in photography are possible because the photographer has a choice of several shutter and aperture combinations. If exposure equals light multiplied by time, and a correct exposure for a situation is $\frac{1}{125}$ second at f/16, $\frac{1}{250}$ at f/11 would also be correct, as would $\frac{1}{60}$ at f/22 or $\frac{1}{500}$ at f/8. This relationship between *equivalent* exposure combinations may be more apparent when they are arranged like this:

$\frac{1}{1000}$	$\frac{1}{500}$	$\frac{1}{250}$	$\frac{1}{125}$	$\frac{1}{60}$	$\frac{1}{30}$	etc.
f/5.6	f/8	f/11	f/16	f/22	f/32	

Notice that as the time is increased, the aperture is decreased (in area) *by the same factor of two,* thus maintaining a constant exposure. Therefore if one of the above combinations is found to be the correct exposure for a situation, any of them will give correct exposure. The image created by one of these combinations of settings, say $\frac{1}{500}$ at f/8, however, will not be the same as the image created by another across the scale, say, $\frac{1}{30}$ at f/32. While the exposure given the film is the same, the lens affects light rays differently at smaller apertures than at larger ones, and the shutter records moving objects differently at longer times than at shorter settings. These changes in the image resulting from equivalent exposures will be further explained in Chapter 8 in connection with depth of field and movement—in short, with space and time.

Exposures for Average Subjects in Daylight

Now we can construct a workable system for average exposures in daylight, based on the idea that every exposure calculation contains four elements. To repeat, these are:

1 The intensity of light on the subject (light conditions);
2 The sensitivity of the film to light (ASA rating);
3 The length of time light reaches the film (shutter setting);
4 The amount of light which reaches the film (aperture).

The table below relates these four elements over a wide range of daylight conditions that are fairly predictable.

Most mistakes in exposure are due to ignoring one of its four basic elements, rather than from miscalculating. The exposure given in the table, of course, is only one of several correct choices available for any given situation. *Once a combination of shutter time and f/ stop is chosen from the table, any equivalent combination may be used.* Applied in this manner with reasonable care, the exposure table is a workable guide which should serve you well until you master a photoelectric exposure meter. And it's simple enough that its main features can be memorized.

Bracketing

If you're still uncertain about the correct exposure to give a situation, try *bracketing*. This requires three exposures of the subject on separate frames. Give the first frame the exposure indicated by the table, the other frames half and double the first. For instance, if an exposure of $\frac{1}{125}$ at f/8 is indicated, expose one frame at those settings. Expose a second frame for $\frac{1}{125}$ at f/11, and a third for $\frac{1}{125}$ at f/5.6. (Alternatively, the aperture may be

Daylight Exposure Table for Average Subjects

Set the shutter time equal to 1/ASA rating (example: for ASA 125 film, set the shutter at $\frac{1}{125}$ second). Then use the following apertures for the light conditions described.

Bright or somewhat hazy sun: strong shadows f/16
Hazy sunshine: weak, poorly defined shadows f/11
Overcast but bright: no shadows visible f/8
Overcast but dark: high fog, light rain, gray sky f/5.6
Heavy overcast: thick fog, heavy rain, dark sky f/4
Open shade on sunny day (subject entirely in shade under open sky) f/5.6

This table is usable from about an hour after sunrise until about an hour before sunset, and is only a guide: it must be modified for subjects that are darker or lighter than average, for backlighted subjects (where light comes directly toward the camera from behind the subject), and for extreme North and South latitudes. For example:

For average subjects in light sand or snow, use one f/ stop smaller.
For light-colored subjects, use one f/ stop smaller.
For darker-than-average subjects, use one f/ stop larger.
For backlighted subjects, use two f/ stops larger.
For extreme North and South latitudes, use one f/ stop larger.

held constant and the shutter time similarly varied.) Choose the resulting negative that has the best range of tones; avoid using bracketed frames that have clear shadows (caused by too little exposure) or very dense, gray highlights (caused by too much).

Exposure Meters

One of the best investments a serious photographer can make is the purchase of his own photoelectric exposure meter. A good meter can be a photographer's most trusted tool. It is more accurate than the daylight table given in these pages and is useful in a much greater variety of photographic situations. A reliable exposure meter can help make your technique systematic and your results repeatable. Some meters can even be used directly to help visualize the final print. But an exposure meter is very fragile. It can easily be abused and rendered inaccurate, and for most people a good one represents a considerable investment. Perhaps the ideal time to turn to one is when a new camera is acquired for your own use; many new cameras, in fact, have meters built in. In any case, using a meter that must circulate among many people, such as a student sometimes finds in school situations, should be avoided in the interest of reliability as well as convenience. You're better off having your own.

Meter Types

Photoelectric exposure meters available today are of two types: *photogenerative* and *photoconductive*. In the first type, light is focused on a selenium cell, which generates a tiny flow of electricity in proportion to the intensity of the light. This current is measured by a highly sensitive galvanometer, or electric meter, which is connected to a pointer or scale. The scale converts light intensities measured by the meter into exposure information that can be applied directly to the camera.

The selenium cell used in these meters may be as large as a silver dollar, making them more suitable for hand-held designs than for building into cameras. Because this type of meter generates its own electrical energy, it is simple, and can be made reliable. Selenium meters, however, are limited by their relative insensitivity at low levels of illumination. They are moderate in cost.

Photoconductive meters generally use a photoresistive element that requires a separate source of electrical energy, and that acts as a valve to control the flow of current in a circuit. Increased light striking the element increases the flow of current, which again is measured by a sensitive galvanometer as in the other type. Photoconductive elements usually are made of cadmium sulfide and tend to be smaller than selenium cells. Therefore they lend themselves well to meters that are built into cameras, but are also available in hand-held models.

The photoconductive meter requires a power source or battery, often a dime-sized mercury cell that has a long working life, but the cell must periodically be checked for strength or readings will be unreliable. These meters are prone to other problems too: lengthy storage in total darkness or brief exposure to very bright light change the cadmium sulfide cell's sensitivity; accidental exposure to direct sunlight usually will desensitize the meter for several hours. When first turned on, readings from these meters tend to be erratic; a few minutes are needed for them to "settle down." Cadmium sulfide (CdS) meters generally are much more sensitive than selenium types to low levels of illumination (some may be used in moonlight), but they cost more than selenium meters with similar features.

In spite of these problems, meters small enough to be built into cameras have obvious advantages, especially for routine work. But they have limitations too, particularly if wide-angle or telephoto lenses are used. In these cases the instruction manual for the specific camera should be consulted. And if a built-in meter breaks down, the entire camera must be taken out of service to get it repaired.

Meters are designed to measure light in two ways. Most read light *reflected* to them from the subject, just as it is reflected to the lens of a camera. Some, however, are made to measure the intensity of *incident* light—light coming from its source—as it falls on the subject. Incident light meters are popular with motion-picture filmmakers and with others in studio situations where the ratio of highlight brightness to shadow brightness can be controlled. Indoors or out, however, most still photographers work more with light as they find it, and the *reflected* light meter is therefore more useful to them.

Each electrical type—selenium and CdS—is made in each measuring mode —incident and reflected; all four combinations are available. Furthermore, most reflected meters that are not built into cameras can be converted to read incident light by a simple attachment

Weston Master 6 Exposure Meter. Courtesy Weston Instruments.

usually supplied with them. To make a choice, then, perhaps the most useful and reliable meter for a beginning still photographer is the selenium cell type designed for reflected light. There are a number of these on the market, but the Weston Master exposure meter, illustrated here, is one of the best and over the years has been extremely popular. It is highly recommended.

Using the Meter

Exposure determines how much detail will record in the darker shadow areas of the subject, as seen in the print. Development of the negative, on the other hand, will determine how clearly the light gray tones in the print are produced. Of the two steps, *exposure* is the more critical because it records the image on the film; what isn't recorded can't be developed. Exposure, therefore, more than any other single factor, determines the technical quality of the photographic image.

Meters seem so sophisticated that it is easy to forget that they cannot think.

They can't tell what they're pointed at. *Meters are designed to "see" everything as medium gray.* Most problems with their use are caused by our failure to realize this fact. *For any value other than medium gray, meter readings must be interpreted by the photographer.* If the meter is aimed at a white wall, for example, it will yield exposure information that will result in a medium gray wall in the print. If the meter is pointed at a dull, black object, again it will give exposure data resulting in a medium gray photograph. The meter cannot distinguish between white and black; it reacts only to the light reflected to it.

It is important for reflected light meters to measure the same angle of view as the camera lens does. Therefore they usually should be aimed at the subject from the camera position. Some newer meters have optical viewing frames built into them to help make aiming more accurate. Meters differ considerably in this respect, however, and the manufacturer's instructions for each type should be carefully followed.

Actual operating procedures will vary somewhat with each different type of meter; again, you should follow the manufacturer's instructions with care, or consult your instructor for specific advice. A few procedures, however, seem to be in common use with most meters, so they are listed here:

1 Before using the meter, and occasionally thereafter, check the zero setting. When no light strikes the cell, the meter *must* read zero.

2 Next, set the calculator for the ASA rating of your film. Like a computer, the meter must be properly "programmed" to give you valid information.

3 Aim the meter at the subject,* and note the reading on the scale. Set this reading on the exposure calculator.

4 Read the various equivalent shutter and aperture combinations now indicated by the meter, and set one of them on your camera.

There are several ways to take readings with reflected light meters. One way is to take a single reading from the camera position. The meter integrates the light reflected from all objects within its field of view, and averages these reflected readings to a medium gray value. This method is simple, quick, and generally satisfactory. Another way is to take separate, close-up readings of the lightest important object and the darkest important object in the frame of view. The

meter is then set halfway between these two readings so that it averages them. Known as the *brightness range method,* this also generally gives good results.

If the subject is not easily accessible for close readings, more convenient objects may be substituted. Nearby trees, for example, can be metered in place of more distant ones. A white handkerchief will conveniently substitute for anything visualized as white in the final print. Black cardboard, often supplied as photographic paper packaging, similarly can be substituted for deep shadow areas.

For more uniform measurement, some photographers prefer to use an 18% gray card as a substitute for average reflectances in the actual subject. This card, supplied as a "Neutral Test Card" by Kodak and also available in some of their Dataguides, offers a convenient photometric "middle gray" tone on one side and a 90% white on the other. It is called an 18% gray card because although it *appears* medium gray, halfway between white and black, it actually reflects only 18% of the light striking it. Its white side similarly reflects 90% of the incident light.

Meter readings can also be taken from the palm of one's hand. Normal Caucasian skin reflects about twice the light of an 18% gray card, so if close-up readings are taken from such skin, about twice the indicated exposure should be given. (The Weston Meter makes this correction automatically if the "C" position on the dial is used instead of the normal red index.) Negro skin averages about the same as middle gray, and no such adjustment is required.

* Incident light meters should be held near the subject and aimed at the light source.

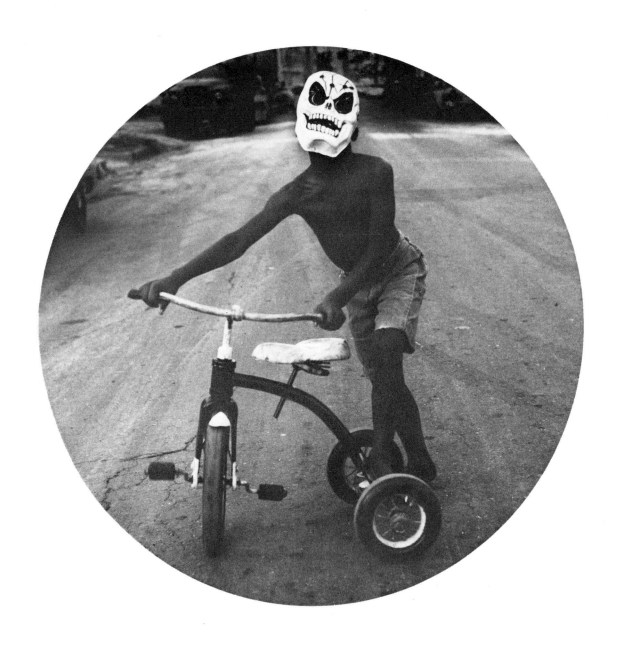

Joanne Leonard: Masked Boy, West Oakland, California, 1967.

Manual or Automatic Cameras?

Some cameras, like the ones we have been discussing, require the exposure to be set manually. Others are automatic, sensing the light and timing the exposure to correctly match the preset aperture and film speed. The latter type is becoming increasingly popular for snapshooting, but automated exposure controls, since they require preset conditions, limit the responses a photographer can choose to the situation before his camera. An automatic shutter, for example, cannot distinguish between a moving subject and a still one, and cannot select the time that will best "freeze" the motion to give a clear picture. Only a manual shutter, set by a photographer, can do that. Thus while an automatic camera is convenient for snapshots and useful for simple recording, a fully adjustable camera, with its greater variety of lens and shutter settings, is preferred for creative work and for its ability to handle a greater number of situations. Some cameras provide both systems, usually permitting the photographer to overrule the automatic one when he wishes. To do this, of course, he must understand the shutter time, aperture, and film speed relationship.

A Working Sequence

We have discussed three camera operations that must be performed to make a photograph: framing, focusing, and exposing. To these we must now add a fourth: advancing the film! Forgetting this will result in double or multiple exposures unless the camera is designed to prevent such occurrences. Multiple exposures, when conceived with forethought and deliberately done, can open new creative possibilities for the photographer. When one is made accidentally, however, the result usually is meaningless and disappointing.

Some cameras have their shutter and film advance interlocked to prevent accidental double exposure, but many do not. If yours does not, a simple sequence of camera handling should avoid the pitfall. Try to think of the routine like this:

1 Having perceived an idea for your picture, try to visualize your desired photograph.
2 Frame your subject or idea in the viewfinder, focusing on the most important object within the frame.
3 Cock the shutter (on some cameras, advancing the film does this automatically).
4 Release the shutter, exposing the picture.
5 *Immediately* advance the film to the next frame.

Additional Tips

Clear pictures require a clean lens. First, remove any dust by lightly whisking the lens with a sable brush or a wad of lens cleaning tissue. Most grease found on lenses comes from fingers; this should be removed with a sheet of lens cleaning tissue moistened with a drop or two of lens cleaning solution. These inexpensive materials are available at any photo shop. Wipe the lens with a gentle, circular motion, and let the fluid dissolve the grease as it slowly evaporates. *Caution: clean only the front and rear sur-*

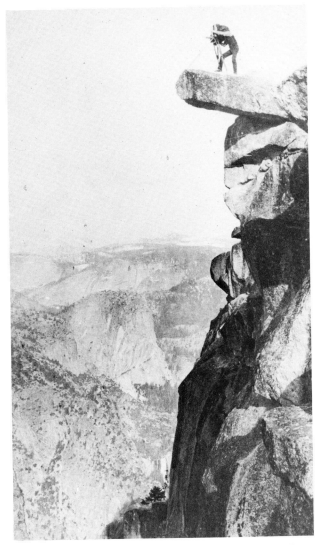

William Henry Jackson: Glacier Point, Yosemite, c. 1895. Western History Department, Denver Public Library.

faces of a lens; taking it apart is a job for a trained technician with proper tools.

Before loading your camera with film, check for dust in the film chamber and bellows. This is best removed with a little dry, compressed air. Dust that settles on the film in your camera will produce tiny, black specks in your prints. Load your camera in subdued light, indoors or in the shade; avoid bright sunlight. Be sure that rollfilm is properly positioned (some cameras have starting marks) and tensioned *before closing the camera back.*

In very cold weather, cameras, like eyeglasses, steam up when taken from the cold into a warm room. Allow time for this condensation, which also forms inside the camera, to evaporate before you use it. Finally, avoid hot storage places for your camera, such as glove compartments or window ledges of automobiles. Cameras are best stored in cool, dry, dark places, with shutters left uncocked.

George M. Craven: Watchmaker's Fence, Turku, Finland, 1970.

Photography, as we noted earlier, depends on light, so photographers usually deal with objects and events that can be illuminated. Although this custom can help us understand light as a basic element, it can also limit our photographic vision. Illuminated objects and occurrences are not the only sources of photographic images: the light itself is a form of language as well as a form of energy, and any idea that can be expressed through an image composed of dark and light values can form the basis of a photographic statement. That is why a skilled and sensitive photographer is always keenly aware of what light can do for him.

Light, of course, is one of the most variable elements that a photographer can use. It occurs in two general forms, natural and artificial, in a spectrum of wavelengths that we see as colors, and in various other qualities of intensity, clarity, and direction.

Natural Light

The first photographs were made in natural light and we still perceive most things as if they were in that kind of illumination. Natural light, of course, comes from the sun, and daylight, which is a combination of direct sunlight and its reflection from the atmosphere, is its most common form. The sense of daylight "falling" on objects is so firmly fixed in our minds that we may have to make a mental adjustment for light from other directions to be considered natural. Leland Rice's photograph on p. 68 was made by natural light, although at first glance this may not appear to be the case. Most artificial light tries to simulate the natural kind because the latter is basic to reality as we sense it.

Natural light has a certain range of colors. Direct sunlight is rich in red and yellow; we tend to think of it

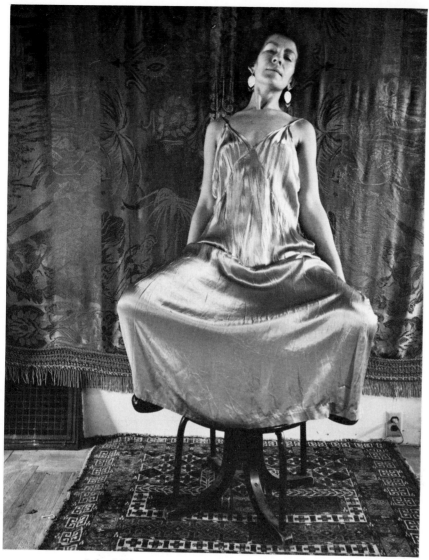

Leland Rice: [untitled], 1970.

as "warm." Light reflected from a clear, overhead sky is much stronger in blue and violet than in red or yellow; thus we regard it as "cool." Daylight contains different mixtures of sunlight and skylight at different times of day. Its dominant color, therefore, can vary from warm to cool hues. This quality of light is very important in color photography, for although the color of light varies, the response of film to it does not. In black-and-white work the actual color of the exposing light is much less critical but still of some concern, particularly when using filters (see Chapter 11), and because not every black-and-white film responds to the whole spectrum of colors in the same manner.

Our eyes, on the other hand, respond to daylight of all types in much the same way. We tend to think of sunlight and skylight, whatever the actual mixture, as *white* light, when in fact it is quite bluish if overcast or yellowish if the direct rays of the sun are dominant. Our eyes adapt them-

selves quickly and automatically to these differences in daylight and to similar variations in artificial light.

A simple demonstration will prove the point. Place a black-and-white TV set in a darkened room with no daylight or other light sources. Watch the TV picture for about five minutes under these conditions, and then step into a room illuminated by ordinary tungsten (not fluorescent) light bulbs. These lights will have a distinct reddish glow that will disappear as our eyes adjust to them and we perceive them, as we did the TV picture, to be "white light." Film cannot adapt its response to different colors of light as our eyes do, so the response of our eyes and that of our film may not be the same. This is especially true of artificial light, where different kinds of light sources produce mixed colors of illumination that are not easily detected by the untrained eye.

Brightness Range

Natural light varies tremendously in intensity. Objects differ in the degree to which they reflect and absorb light. Taken together, these two facts account for a great range of brightnesses in the light that is reflected to the camera, and *that* light, of course, is what exposes our picture.* Again, a

* *Intensity* is a quality of light coming from a source and *falling on* an object. *Brightness* describes a similar quality of light *reflected by* an object to the eye, camera, and film.

simple demonstration is useful. Take two pieces of construction paper or similar material, one white and the other mat (dull) black. Place them both in direct sunlight. One should reflect about 20 times more light than the other. If measured under skylight only, without direct sunlight, the range will be about the same, although the actual levels of reflected illumination will be lower than they were in the sun. Now place the white paper in deep shade and the black piece in the sunlight; the white one will reflect only about twice the light of the other. Next, reverse the papers so that the white one is sunlit and the black one is in shadow: the brightness *range,* or difference between the illumination levels they reflect, might now be as great as 1:200.

Because of this tremendous range of brightnesses exhibited by objects in natural light, then, it is important to know the actual range of these reflections so that our film may be properly exposed for those specific conditions. Exposure tables such as the one in the preceding chapter deal with average brightness ranges. Whenever actual situations are not average in this respect, a good exposure meter, properly interpreted, will give better results. Such conditions are also frequently encountered with artificial light, that is, with light that a photographer can control at its source. Artificial light occurs in a greater variety of colors and intensities than natural light does. Its use in photography is more fully discussed in Chapter 12.

Charles Sheeler: Bucks County Barn, 1915. Collection: The International Museum of Photography.

Light and Form

We have reviewed these characteristics of light because they affect its use in photographic work; light is useful in designing our pictures because it is a variable element. In representational work, the photographer's usual aim is to reveal the form of his object or the significance of his event through *isolation* and effective graphic presentation. Because light shapes the appearance of objects, it can reveal the *essence of form* and thus separate an object from its surroundings. John Marin, whose watercolors of his be-loved New England coast enriched the vision of an earlier generation, admonished draftsmen to follow *line,* and painters to follow *paint.* Photographers, he might have added, should follow *light.* To Charles Sheeler, Marin's younger contemporary, light was "the great designer." Sheeler was primarily a painter who often used the camera as a notebook for his highly structured, clean-edged images on canvas, but in his early years he made his living by photography and valued camera work throughout his life for images that painting could not produce.

Image Unity

Light itself, and the brightness it conveys, can function as a powerful magnet to draw the eye to particular parts of a picture. We see this in Eugène Atget's street musicians. Our eye tends to find brighter values more quickly than darker ones, and to study them longer. Only when the size and shape, or mass, of darker values dominates a picture does this observation of brighter dominance fail. Arranging the light and dark areas within a photograph to take advantage of this phenomenon, then, can strengthen whatever impression our pictures make. For example, if an object and its immediate surroundings (or even a complex subject) can be framed so that dark areas occupy the corners of the picture, the impression conveyed by the photograph is one wherein the center is more revealing than the corners, because it is well within the frame and because it is brighter. A certain visual sense of completeness, of unity, is thereby achieved.

The same effect can be introduced by the photographer if it does not occur naturally: the corners can be slightly darkened when the print is exposed. Whether the effect is natural or otherwise, it avoids bright spots that pull a viewer's eye away from more important areas of the picture, and if done carefully and sparingly (especially in the printing stage) the technique will not call attention to itself. The viewer thus may continue his exploration within the frame, undiverted by corner tensions, and the essential unity of the image is preserved.

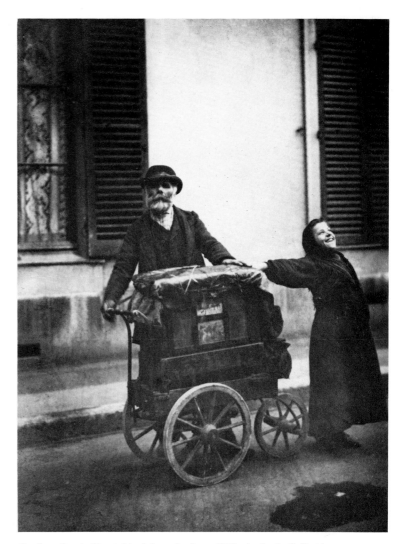

Eugène Atget: Street Musicians, Paris, c. 1910. Author's Collection.

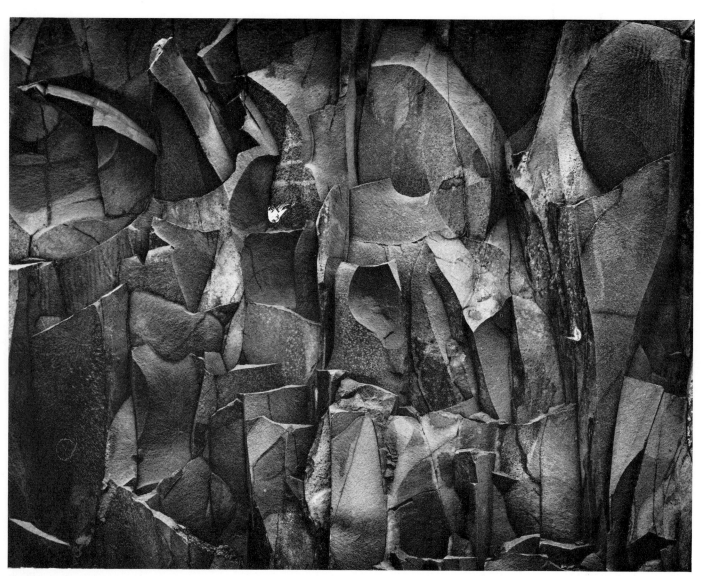

Paul Caponigro: Rock Wall No. 2, W. Hartford, Connecticut, 1959.

Texture

Sunlight, when not diffused by haze or clouds, is strongly directional. The shadows it causes are proof of that. The focused beam from a studio spotlight has similar attributes. Strongly directional light is often helpful to the photographer: he can use it to emphasize surface qualities of an object or material and thus more accurately define his subject. Surfaces often tell us much about what lies beyond and beneath them, and of all the ways to render them graphically, photography is unsurpassed.

Point any directional light source— a flashlight will do nicely—at a board fence or a brick wall. The light illuminates the surface evenly within its circle, just as car headlights appear on a closed garage door. We can see the surface, its color, and perhaps the pattern of its makeup, but we cannot see its structure—its tactile quality: we can only imagine how it *feels*. Now move the light close to the wall surface and aim it nearly parallel to that plane. Instantly the light picks out the raised portions; the third dimension of that surface, however slight it is, becomes vividly apparent. Seen very close, the light appears to bathe higher spots, while their intervening valleys lie in shadow. From farther back, however, highlights and shadows resolve into a revelation of *texture,* that quality of a surface which gives it a richness of character and a stronger identity, and its viewer a heightened sense of awareness.

Whether created on a grand scale in nature or on a more intimate one by the hand of man, textured surfaces are revealed by light in exactly the

Morley Baer: Barndoors, Jalama Beach, 1951.

Ed Cismondi: Mykonos, Greece, 1969.

same way. Light must come from one direction, preferably the side or rear (in relation to the subject), and must rake or skim across the surface rather than strike it directly. Focus, of course, must be needle sharp. That all-important sense of being able to visibly "feel" the textured surface is lost in an unsharp image because the bits of light and shadow that make up texture are very small. And finally there is the tonal scale that shades the surface to complete the illusion of reality. This tone must be properly recorded, and that requires a reasonably correct exposure.

Strong, directional light, so necessary to fully reveal textured surfaces, can emphasize other qualities for the photographer. Ed Cismondi's study from Greece, for example, shows how light can impart a feeling of *presence* to an otherwise monotoned image. Or it can eloquently dramatize landscape, as Ansel Adams shows us in his classic *Refugio Beach*. Additional similar uses, including the effect of soft, diffused light, are discussed in Chapter 7.

Ansel Adams: Refugio Beach, California, 1947. Collection: International Museum of Photography.

László Moholy-Nagy: Photogram, c. 1926. Shadowgraph, 13⅜ by 10½ in. (34 by 26.7 cm). Collection: The Museum of Modern Art, New York.

The Photogram

When we consider how light may be used to shape the impression of a photograph, we must not overlook the most fundamental way and that, of course, involves its own mark-making potential. Talbot was the first to experiment with this. In 1835 he produced tonally reversed reproductions of botanical specimens and lace, calling them "photogenic drawings." In the early 1920s, the Hungarian painter László Moholy-Nagy and the American painter Man Ray pursued the technique for its non-representational image possibilities. Many others have since experimented with it. Moholy-Nagy named his pictures *photograms,* and the term generally has been applied ever since to describe similar cameraless images.

The photogram requires nothing more than those two indispensable photographic elements: light and a substance sensitive to it. Customarily, though, we place in the path of the light various objects or substances that will selectively absorb some of it before it strikes the sensitive film or paper. Anything will do: the range of creative possibilities is endless. Henry Holmes Smith's *Giant,* for instance, demonstrates that the process can be purely photographic, even though the result may appear to be closer to painting than to traditional camera imagery. Photograms, now often combined with other types of images, are enjoying renewed popularity (see the section on negative images in Chapter 10).

Man Ray: Rayograph, 1943. Collection: The Oakland Museum.

Henry Holmes Smith: Giant, 1949. Refraction print in positive. From Portfolio II, 1973, Center for Photographic Studies, Louisville, Kentucky.

Wave motion.

The electromagnetic spectrum.

Light as Energy

The behavior of light in photography can be explained by two theories that describe its physical action in terms of things we can see or measure.

We may think of light as a form of energy that moves outward in all directions from its source, much like ripples or waves on a pond, but in a three-dimensional sense—that is, in all directions rather than in a single plane. In this respect, light behaves very much like television signals, radio waves, X rays, and other forms of radiation; they are all thought to be part of the same great span of radiant energy known as the *electromagnetic spectrum.* Our concept of

such a spectrum, first set forth by the Scottish physicist, James Clerk-Maxwell, is based on our ability to detect these waves, or sense them, and to distinguish one kind of wave from another. Radio and TV receivers are two familiar kinds of detectors. Our eye, of course, is a third, and the radiant energy that it can detect is what we call *light.*

Now, if we represent a light wave as an oscillating line like the diagram, the distance from one crest to the next is called its *wavelength,* and by this measure we can sense how vast the electromagnetic spectrum appears to be. At one extreme are certain radio waves, whose crests are several miles apart. X rays, on the other hand, may

vibrate a billion times in the space of a single millimeter.*

Light waves occupy a very small part of the spectrum between about 4000 and 7000 angstroms in wavelength. Beyond that section in the direction of longer waves lie infrared or heat rays, microwaves, TV and radio signals. Radiation with wavelengths shorter than light includes ultraviolet rays (that cause sunburn), X rays, and radiation associated with nuclear reactions.

* To measure such short wavelengths, nanometers and angstroms are more convenient units. A *nanometer* (nm) is one millionth of a millimeter (.000001 mm). An *angstrom* (Å) is one tenth of a nanometer (.0000001 mm).

We perceive various wavelengths within the narrow band of light as different colors. The shortest wavelengths we call violet, the longest ones red; all other colors of light lie between these two on the spectrum. When all wavelengths of light are mixed together in sufficient intensity, we see the result as *white* light. At lesser intensities the same mixture appears gray. When the intensity is too low for the eye to detect, when all of the light falling on a surface is absorbed and none reflected, or when light is not present, we see nothing: that, of course, we call black.

Photography as we will practice it makes use of five basic physical properties of light. We've mentioned some of them before, but let's review them:

1 Light radiates from a luminous point-source in *straight lines,* spreading outward in all directions.
2 Light can be *reflected.* A mat, white surface reflects most wavelengths striking it, but scatters those reflections in many directions. A mirror reflects light the same way but does not scatter it.
3 Light falling on a black surface will be *absorbed.* Because almost none is reflected to our eye, that surface appears black.
4 When light passes from one material such as air, to another such as a triangular piece of glass (a prism), its waves are bent. This bending is called *refraction,* and is the basis for designing and using lenses.
5 Light can be *filtered.* In any mixture of two or more wavelengths such as white light, certain waves can be absorbed by a substance while others are allowed to pass freely through it.

The wave theory can explain these actions of light, and demonstrate most of its properties.

Earlier we spoke of energy detectors such as television and radio receivers and, of course, our own eyes. Photographic film provides yet another group of sensors of special interest to us. What happens when a ray of light, traveling as a wave, strikes the film in our camera? It causes a small but significant change in the light-sensitive coating, a change that cannot be satisfactorily explained as a wave effect.

If we think of light as a stream of particles, however, its action in film is much easier to understand. Our basis for this idea comes from Max Planck, the German physicist, who proposed a quantum, or particle theory to explain the movement of energy, and from Albert Einstein, who adapted that theory to the behavior of light. Light particles or *photons,* as Einstein called them, act more like matter than like waves of energy. When a photon of light (which, incidentally, is an incredibly small amount) strikes sensitive molecules in photographic film, it begins a complex chain of events that only recently has begun to yield its secrets to scientists through the probing eye of the electron microscope. This basic phenomenon, in fact, is still being investigated. From what is known, though, it appears that light behaves like a series of waves to form the image in a camera, but like a stream of particles to record it on film. But before we can explain how light affects film to produce a picture, we need to consider the film itself. Let's do that next.

Barbara Morgan: Samadhi, 1940. Light Drawing.

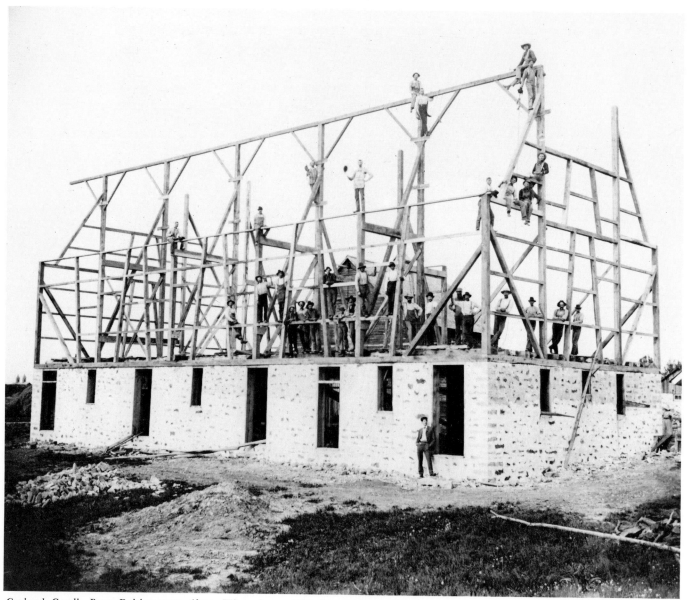

Gerhard Gesell: Barn Raising near Alma, Wisconsin, c. 1895. State Historical Society of Wisconsin.

Film and its processing 5

"You press the button, we do the rest." With that famous advertising slogan, George Eastman introduced the roll-film camera to the world nearly a century ago. Today, simple, reliable cameras and the convenience of automated exposure systems have made it easy for us to concentrate on the visual aspects of picture making. Furthermore, with the rapid popular growth of color photography that we have seen in recent years, more of us than ever before have been content to follow Eastman's advice and leave photographic processing to others. Doing this, however, trades a measure of creativity for convenience, for even after the picture has been recorded we can still exercise a great deal of control over its outcome. In photography, the opportunity to be creative doesn't end with exposure but carries through every step to the final print.

If a good deal of mystique still seems to surround the photographic process, perhaps it is because what actually happens when light strikes our film could not be seen, and was not completely known, until just a few years ago. Results, of course, were thoroughly studied, but how they were produced remained to some extent a mystery.

Modern photographic film, like the reaction that light produces within it, is both simple and complex. Taken out of the camera, it looks simple enough—a piece of shiny plastic material, dark on one side, light gray on the other, and moderately curly. Even a microscopic cross-section gives few clues to its remarkable nature. Most of that thickness is film base: a flexible support for the thin, light-sensitive emulsion where the image is formed. Film base must also be optically transparent and tough, yet unaffected by water and the chemicals used in processing. Two materials meet these requirements well: cellulose triacetate and polyethylene terephthalate. The former is made from wood pulp, the latter from ethylene glycol and other organic chemicals. Both are now used worldwide in film manufacturing.

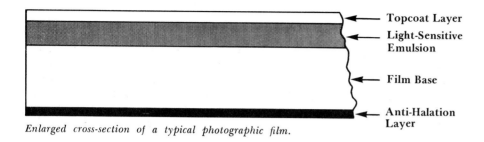

Topcoat Layer

Light-Sensitive
Emulsion

Film Base

Anti-Halation
Layer

Enlarged cross-section of a typical photographic film.

The Sensitive Emulsion

Many compounds of silver are photo-sensitive. They tend to break down or decompose under the influence of light, and virtually all photographic processes depend on this effect. The most useful of these compounds are the *silver halides*—combinations of silver with chlorine, iodine, or bromine. The last mentioned, silver bromide, is the most important. Silver bromide crystals are extremely small—about 500 to 4000 nanometers (.0005 to .004 mm) wide. For this use they are held in a suspension of *gelatin*, which keeps them separated from one another and disperses them evenly across the film surface.

Gelatin, in fact, plays a very special role in the manufacture of modern photographic materials. Made from the hides, hooves, and bones of calves and cows, gelatin is a remarkable material. Liquid when hot, it cools and dries to a hard, smooth layer that freely permits light to pass through it. Gelatin controls the size and dispersion of silver bromide crystals when the emulsion is made, and it holds these crystals and the image that results from them firmly in place. In cold water gelatin swells but does not dissolve, thereby permitting other dissolved chemicals, such as developers, to pass through it and get to deeply situated crystals as well as those near the surface. Since 1878 gelatin has been a universal emulsion material.

Gelatin is also used for the thin, topcoat layer that protects the emulsion from mechanical damage such as scratching in the camera. Another application for it is found in a thin, colored, anti-halation layer on the back of the film base. When a bright source of light is included in the picture area, rays from that source striking the film at an angle (as they will everywhere except in the center of the frame) might travel through the base and reflect off its far side, re-exposing the emulsion in a wider area than a direct ray would. This effect is called *halation;* it produces fuzzy highlights in a print and reduces image sharpness. The dyed gelatin coating on the back of the film absorbs such stray light and prevents it from reflecting back to cause halation.

Film Characteristics

Earlier in Chapter 3 we stressed that all film was not the same. Black-and-white films differ from one another in four important ways: *speed,* or basic sensitivity to light; *color sensitivity,* or how a film records different hues of color as gray values; *contrast,* which is the difference between the lightest and darkest silver deposits obtained with average exposure and processing conditions; and *graininess,* or how readily a film's image tends to break up into a sandpaper-like structure with enlargement.

Film Speed

Speed, or sensitivity to light, is the most important difference between various black-and-white films. A film rated ASA 400, we noted earlier, is about three times more sensitive to light than one rated 125. Speed is governed by the size of silver bromide crystals in the emulsion and by the presence and concentration of other chemicals. Sometimes a small amount of silver iodide is added to the bromide to increase sensitivity. Fewer but larger crystals mean a higher film speed and relatively lower contrast. A dispersion of many small crystals, on the other hand, will yield a less sensitive emulsion with greater contrast. As film speed increases, inherent contrast generally decreases.

From a practical standpoint, photographers usually divide general-purpose films into three speed groups: fast, medium, and slow. Fast films are those with ASA ratings of 400 or more. Because of their higher sensitivity they need less light for exposure. That should be the primary reason for using them, since their higher speed usually is obtained at some loss in image quality. Medium-speed films range from ASA 64 to 250, and are recommended for general photographic work. They are more tolerant of variations in exposure and development than the other types are, and are therefore more useful in average working conditions. Slow films are those with ASA ratings below 50; they require more exposure than the other types, but their long tonal scales, finer grain, and moderately high contrast make them well suited to recording highly detailed images. All of these divisions are somewhat arbitrary and mainly serve as convenient labels; ASA ratings are the most useful measurement of basic sensitivity.

Color Sensitivity

Silver bromide, by its chemical nature, is sensitive to ultraviolet, violet, and blue light, but not to green or red. Early photographers like T. H. O'Sullivan had to contend with this fact when working outdoors. Their plates would properly record brown and green landscape hues only with long exposures, during which blues became relatively overexposed. Skies, therefore, came out uniformly white in early prints and clouds rarely were captured. Today such emulsions are used only for printing papers and a few special-purpose films. They are classified *orthonon,* or color-blind.

By adding certain dyes to the emulsion when it is made, its spectral sensitivity can be extended to green and

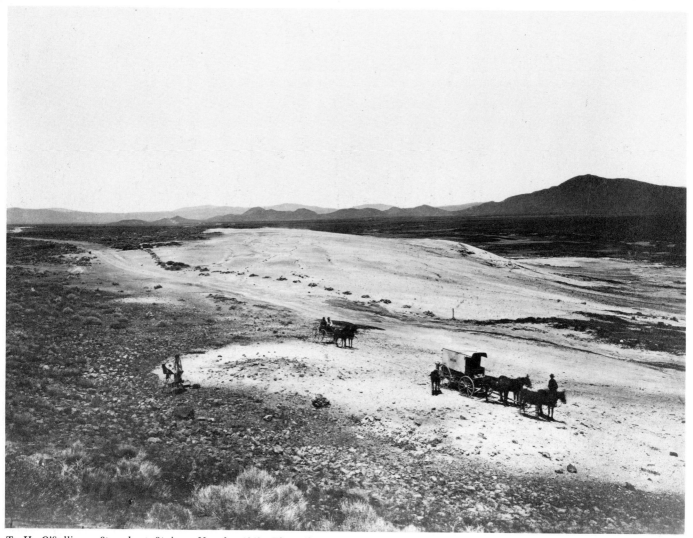

T. H. O'Sullivan: Steamboat Springs, Nevada, 1868. The Library of Congress.

red wavelengths of light. *Orthochromatic* emulsions are sensitive to violet, blue, and green light. They are not sensitive to red, however, and thus can be handled and developed under red safelights. Like the color-blind type, orthochromatic emulsions (called simply ortho) are used in printing papers and special-purpose films.

When an emulsion is sensitized to red as well as green light, it is designated *panchromatic* (or simply pan). This gives it a balanced response to all colors, with gray tones closely corresponding to the value of similar colors seen by the eye. Most of our films are panchromatic, and therefore must be handled and developed in total darkness.

This same sensitizing process can extend the spectral response of film beyond light wavelengths into the infrared region of the electromagnetic spectrum up to about 1350 nanometers, making photography by invisible infrared radiation possible.

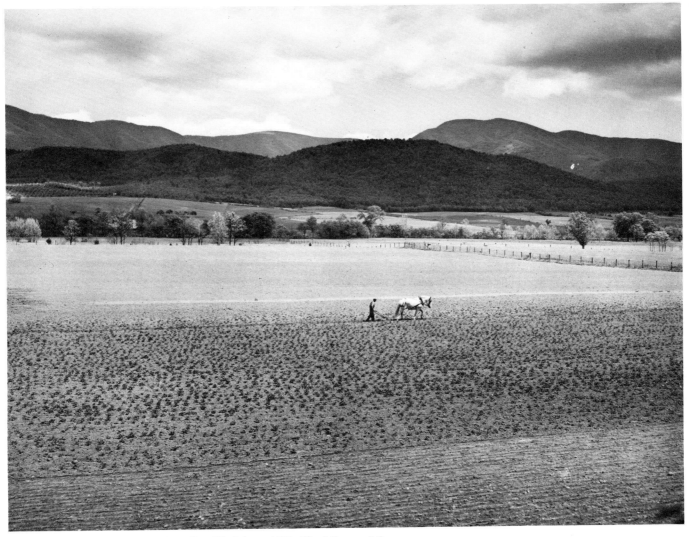

Marion Post Wolcott: Shenandoah Valley, Virginia, c. 1941. The Library of Congress.

X-ray Sensitivity

Films are also sensitive to X radiation, and security measures now employed at airports have made this sensitivity a major concern for photographers. The human body can tolerate X-ray doses that would ruin photographic film, so any screening unit that is considered safe for humans should *not* be so regarded for undeveloped films. Fogging (non-image exposure) from X rays is most noticeable on color films and high-speed black-and-white materials, but any film can be ruined if the unit is powerful enough. Doses are cumulative; multiple screening increases the hazard.

The best way to minimize this risk is to carry your film with you when traveling by air. Avoid shipping film in baggage or suitcases that will be checked, and if more than five X-ray inspections must be tolerated, place the film in protective, X-ray shielding bags.

Harry Callahan: Eleanor, 1948. Courtesy Light Gallery, New York.

Contrast and Grain

The other two major characteristics, contrast and graininess, are related to speed. Some films are made expressly to produce high-contrast images—those where black and white tones are more evident than shades of gray. These films are used for reproduction, microfilming, and many applications in the printing industry. A few are freely used in photographic design work, and some of these applications are outlined later in the book. High-contrast films have relatively low speeds, from ASA 64 down to 3 or less.

Except for a few special-purpose types, films are not designed to produce low-contrast results. This feature more often is a result of the large, silver bromide crystal formation needed for high speed. What we commonly call graininess likewise results from the further grouping or clumping of large crystals in faster emulsions. This effect often is accentuated by the development necessary to obtain maximum light-sensitivity. In medium-speed films, however, it sometimes can be minimized by using a fine-grain developer. Graininess is seldom a problem with slow films, whose smaller silver bromide crystals make a more homogeneous emulsion.

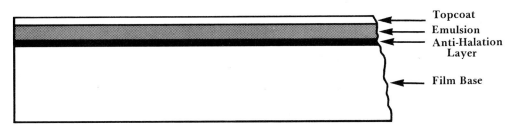

Enlarged cross-section of a thin-emulsion film.

Thin-Emulsion Films

Some low-speed films are not typical of the type diagramed earlier but have emulsions thinner than normal. The main advantage of such films is their ability to record a sharper image with greater capacity to resolve fine detail. Such an image can withstand a higher degree of enlargement before it becomes noticeably fuzzy.

This greater sharpness is obtained in two ways. First, the thinner emulsion produces an image with less actual depth than regular film can do. Second, the anti-halation layer often is a dye coated on top of the film base but under the emulsion, where it effectively prevents any halation from occurring in either the emulsion or the base. This dye becomes transparent and colorless during development. If fine-quality lenses are used on the camera and enlarger, and other aspects of technique are directed to produce a high-quality image, the advantage to a photographer can be dramatic.

These films, however, have their drawbacks. Thinner emulsions contain fewer silver halide crystals, resulting in lower film speed and very little tolerance for error in either exposure or development. Special compensating developers are required with some of them to realize their inherent advantage. Some manufacturers specify particular developers, and those recommendations should be carefully followed.

Polaroid Materials

One other family of films should be mentioned here, and that is the line of Polaroid-Land materials that produce their images in 10 to 20 seconds. Because they are fundamentally different from other black-and-white photographic materials, they are discussed briefly in Appendix B.

Choosing Your Films

Which film, then, is the best? Most of us would be well-advised to use medium-speed, general-purpose pan films for all of our work unless we have a good reason to try something else. Let's get to know what one type of film will do before experimenting with others. High-speed films, as a rule, should be used only when their extra sensitivity is needed; medium-speed films will most often give better results in general use. Slow films are useful when extreme enlargement is planned, when maximum tonal quality in the print is wanted, and when the inherent advantages of such films can be exploited. To realize their benefits they require more careful exposure and development than medium-speed films do.

With practice, however, many photographers find that they can bridge the medium-speed group altogether, using a slow film for general work and a fast film only when its extra speed is needed. Such a working method requires care and skill in all aspects of film and camera handling. It is particularly useful to the 35 mm cameraman, who may find it advantageous to travel lightly, but there's no reason why you can't use the same rationale with other formats.

The Latent Image

We noted earlier that when light strikes a photographic film it behaves more like a stream of particles than a wave. With that in mind, now, let's look at the film emulsion. From a microscopic viewpoint, it is a deep layer of gelatin in which are scattered millions of silver bromide crystals. Each of these crystals, if greatly magnified, would appear to be a cubic arrangement of alternate silver and bromine particles called *ions*—electrically charged atoms—and the whole crystal structure would look something like a jungle gym.

When a photon of light strikes one of these crystals, it sets off a sequence of events that results in the formation of tiny particles of silver metal. These silver particles, invisible even in an optical microscope, do not form everywhere in the crystal but apparently only at certain locations called *sensitivity specks*.

The whole sequence may be roughly visualized if we compare the silver bromide crystal to a billiard table where we find ourselves behind the eight ball. Let the black eight ball represent a silver ion, the white cue ball a charge of energy from a bromine ion, and our cue the exposing light particle. We shoot: our cue (photon of light) taps the white cue ball (energy charge) into the black eight ball (silver ion). Both balls together roll into a pocket, where they are trapped. Now extend your imagination to allow the cue ball and the eight ball to fuse together into a single gray one, still trapped in the pocket. This would represent an atom of silver metal held in place at a sensitivity speck. Repeat the preceding sequence many times within the same crystal (by additional photons of light), and you form an invisible silver pattern.

This formation of submicroscopic silver particles in exposed crystals is known as the *latent image*. *Latent* means lying hidden and undeveloped, which describes this silver pattern perfectly. Subsequent development of the picture will begin in this same pattern, for that small but significant change made in silver bromide crystals by light permits the developer to amplify that change many times, forming a visible image.

Film Processing

Our exposed film contains the pictures we recorded earlier in the camera, but if we were to look at it now, we would see nothing. Our next step, then, is to make those images visible and permanent: that's what processing does. This involves some elementary chemistry, so let's first consider *what* happens during processing and *why,* then how it can easily be done.

It may be helpful to think of the film at this point as having two kinds of areas, namely, the parts which contain a latent image that can be developed (we'll call these the *exposed* areas), and those parts which have not received sufficient light to be developed, or no light at all (the *unexposed* areas). The former parts will be the main image areas on the film, representing all highlights and middle tones of our pictures. The latter unexposed areas will include the deepest shadows of our subject (that will be black in the finished picture) and those parts of the film which never were exposed in the camera: the borders, spaces between pictures, and an inch or two at each end of the roll. We shall refer, then, to these two parts —exposed and unexposed areas—as we describe what takes place in the film during each step of the process.

Development

The first step is to make the latent image visible, and this is known as *development*. The developer is a solution usually containing five or more chemicals dissolved in water. Its most important ingredients are called *developing agents,* and their task is to reduce the exposed silver bromide crystals to silver metal. As usual, the reaction is a complex one but it may be simply described: the developer causes exposed crystals of silver bromide to disassociate their ions, or split apart, by giving up some of the developing agents' energy to the silver ions in those crystals, producing silver metal. This process must discriminate between those crystals that were exposed by light and those that were not, for failure to do this would result in all of the crystals being reduced to silver, and that would give us a totally black film with no visible image.

Development, it appears, begins at the sensitivity specks in each exposed crystal. Like most chemical reactions, it proceeds faster as the temperature is raised. The longer the developer works on our film, the more it breaks down the exposed crystals to produce silver metal. As we noted earlier, most of our films are panchromatic and their development must therefore take place in total darkness. While we cannot watch its progress, we can determine our results by controlling both *time* and *temperature*. The relationship of these factors to each other and to the picture was pointed out by Ferdinand Hurter and Vero C. Driffield, two scientists working in England from 1876 to 1890. "The production of a perfect picture by means of photography," they wrote, "is an art; the production of a technically perfect negative is a science." Their report that followed this statement showed photographers how to control the developing process; today we call this way of developing the *time-temperature method.*

In exposed silver bromide crystals, then, the developer proceeds to separate ions of bromine and silver until the entire crystal is reduced to metallic silver, which is opaque and looks black suspended in the gelatin emulsion. The bromine ions diffuse out of the gelatin and are collected by the used developer solution, eventually being discarded with it.

When development has produced a dense enough image, it must be stopped. In most cases a simple water rinse suffices, effectively diluting what developer remains in the gelatin emulsion. In the *exposed areas* of our film we now have a visible silver image. In *unexposed areas*, however, our emulsion is still full of *light-sensitive* silver bromide, and if light strikes our film at this point it will ruin it. We must remove this light-sensitivity, then, so that the negative image on our film will no longer be changed, but will be usable to make a positive image, or print.

Fixing

Removing this unused light-sensitivity after development is called *fixing*. Silver halides are not soluble in water, so they must be changed to different compounds that are. Another chemical solution, *fixer,* is now applied to the film. Fixer contains sodium or ammonium thiosulfate, chemicals that dissolve silver halides without significantly affecting silver metal (the

image).* The dissolved silver halides can then be removed by washing the film with water.

The gelatin by now has become quite soft and fragile. It has freely permitted water and developer to flow in and out of it, and this swells and softens it, even at normal temperatures. Touching it at this point might damage the film surface and with it, the picture, so we *harden* the gelatin to make our image tough enough to be handled with reasonable care.

Hardening the gelatin emulsion is a two-step process. The first stage is a *chemical* action by potassium alum that occurs in the fixer. The second stage is a *physical* hardening that takes place as the emulsion dries, and film is not tough enough to endure casual handling until it has dried completely.

Washing

After fixing is completed, our film is transparent except for its image, which is more or less opaque according to the amount of silver produced at any given point. It contains dissolved silver compounds produced by the fixer, however, and also the residual fixer itself. All of these dissolved chemicals must be completely removed from the fixed emulsion in order to make the image permanent. Any substantial traces of them remaining in the emulsion will cause the image to ultimately break down into other silver compounds, discolor, and fade.

Washing removes fixer and dissolved silver compounds, leaving only the pure silver image in clean gelatin. The rate at which effective washing takes place depends to some extent on the temperature, but is largely governed by the molecular structure of the gelatin emulsion. As long as fresh, clean water is supplied to the film surface at a steady rate, washing proceeds until the concentration of fixer and dissolved silver salts is virtually nil.

Increasing the flow faster than the gelatin can absorb clean water will not improve the washing or reduce the time required for it. Certain chemical washing aids may be used to speed up the process, but these are more valuable for washing paper prints, for which times are much longer. These washing aids will be discussed in the next chapter. Completely washing the gelatin emulsion requires only a few minutes in running water. Then the film is dried.

How to Process Rollfilm

Now let's outline a working procedure to do all this. A *darkroom* is needed only to load the developing tank. **It must be totally dark.** A small, windowless room or closet usually will meet this requirement, especially at night. The remaining operations may be done in normal room light; at home, a kitchen sink or bathroom basin is convenient and adequate.

Once the process has begun it goes rather quickly, so it is important to get together everything you will need before you begin. That will include:

* Sodium thiosulfate was used to dissolve silver salts as early as 1819 by Sir John Herschel, who called it, inaccurately, "hyposulphite of soda" (see Chapter 2). Today photographers still refer to it as "hypo." Correctly speaking, "hypo" is sodium thiosulfate, but the term is loosely applied to any fixing solution.

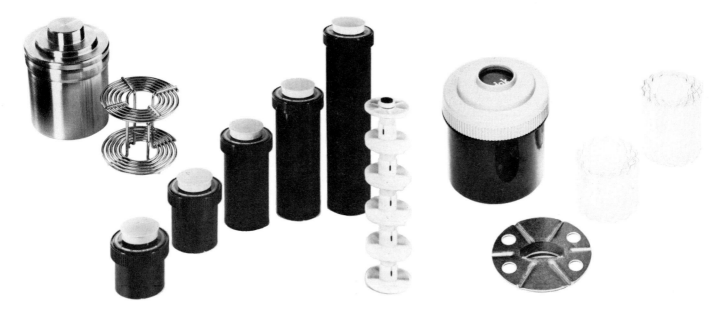

Stainless-steel developing tank and reel (left). Courtesy Honeywell Photographic Products. Paterson developing tanks and reels (center). Courtesy Braun North America Division, The Gilette Company. Kodacraft rollfilm developing tank, aprons, and weight (right). Courtesy Eastman Kodak Company.

1 Your exposed film.
2 A suitable developing tank. The ones pictured here are available from most photo dealers and are highly recommended.
3 A plastic funnel.
4 A graduated measuring cylinder or cup as large as the tank.
5 A thermometer made for photographic use.
6 A timer (your watch will do nicely).
7 Two wooden spring-type clothespins.
8 A bottle of developer solution.
9 A bottle of fixer solution.
10 Concentrated wetting agent.

If you are developing 35 mm film, you'll also need a pair of scissors and a cassette opener (a bottle opener will do). A plastic dishpan may also be helpful if the temperature in your work area is not about 70° F (21° C).

Loading the Tank

The developing tank must be loaded in total darkness. Once this is accomplished, the rest of the operation may be done in normal room light. Let's look at the tank.

Most serious photographers prefer a stainless-steel, spiral-reel tank like that illustrated here for developing roll and 35 mm film. This type fills, empties, and transfers heat quickly; it cleans easily, dries rapidly, and permits smooth, even development. The tank has only two shortcomings: its spiral reels are difficult for the uninitiated person to load, and it is moderately expensive, especially in larger sizes.

The Paterson plastic tank has most of the advantages of the steel type. It, too, may be inverted for smooth, even development, and its reel is not too difficult to load. Like the steel type,

the Paterson tank is designed as a modular system, making it possible to stack several rolls of the same type film in one large tank for simultaneous processing. In smaller sizes it costs about the same as similar steel tanks.

The Kodak plastic tank is the easiest for the beginner to load, and since proper loading is essential for good results, this is a real advantage. It has no reel but uses a crinkly-edged plastic apron or separator instead. *This tank cannot be inverted,* however, and smooth development requires very careful agitation. Only one roll of 120 film can be loaded in this tank, but it is popular and inexpensive.*

* With an additional apron and weight, two rolls of 35 mm film can be loaded, one on top of the other, in the Kodak plastic tank.

Opening a 35 mm casette in the darkroom. Courtesy Eastman Kodak Company.

Loading a steel spiral reel.

Follow the loading instructions included with each tank. Rollfilm, of course, must be separated *in the dark* from its backing paper. Ordinary 35 mm cassettes should be opened *in darkness* at their female end, as illustrated, and the film trimmed squarely with scissors to remove its narrow tongue and the first inch or two before loading the reel. Instamatic cartridges (110 and 126) can be opened *in the dark* by holding their two chambers, one in each hand, with your thumbs on the cartridge label. Then *bend* the cartridge *back* over your thumbs until it breaks, remove the roll of film from one end, and separate it from its paper backing.

A few tips for loading steel spiral reels: be careful to start the film straight in the core of the reel, engaging the clip or opening to loosely anchor the film end. Then turn the reel on edge against a table, as shown here, and let the reel load itself; don't try to push the film into the reel. Be sure you're going *with* the spiral, not against it.

With the Kodak plastic tank, be certain the plastic separator is clean and *exactly the same width as your film*. A 127 size separator is supplied with some of these tanks; it is too wide for 35 mm film and will ruin that size.

When you have everything in your work area organized, turn out all lights and load the tank. After the film is completely in the tank and the lid secured on it, the light may be turned on again.

Processing the Film

For any particular film and developer combination, consistently good results

depend on control of three factors: *time, temperature,* and *agitation.* Careful attention to these three points will insure predictable results. Don't be casual about them. Start timing, for example, as you fill the tank. When time is up, empty the tank as quickly as possible. Be consistent about this from roll to roll.

The temperature of the developer and all other solutions, including the running water wash, should be as close to 68° F (20° C) as possible, preferably ±2° *F (±1° C).* Use a good thermometer, and check it periodically against a more accurate one if possible. If you accidentally drop yours, check it before you use it again. Most developers may be used at temperatures other than 68° F (20° C), but those above 78° F (25.5° C) should be avoided since they might cause reticulation, which is a rippled, uneven, permanent swelling of the gelatin emulsion. At temperatures below 65° F (18° C), some developing chemicals become inactive and cannot give proper results. Avoid this situation, too.

From here on, specific instructions will vary somewhat according to the kind of film, tank, developer, and fixer you use. Development times and similar instructions should be obtained locally for your particular situation. Most of this information is supplied with the products you will use; follow it with care. A general working sequence is outlined here.

1 Developing. Prepare your developer, check its temperature, and determine the proper developing time. Now start the timer and *pour the premeasured quantity of developer into the tank with one, smooth, continuous pour.* Do not pause, and try not to spill any of the solution. As soon as the tank is filled, tap it gently against the sink to dislodge air bubbles that may stick to the film and prevent even development.

Thereafter, at regular intervals, agitate the developing tank. Capped steel tanks with spiral reels should be slowly inverted, as shown in the diagram, then returned to their former position. Uncapped tanks like the Kodak one must be handled differently: a slow, lazy, figure-eight movement has been found to provide good agitation. Points to watch: avoid vigorous agitation that might knock the film out of its position in the tank. Whatever agitation pattern you use, *it is important to be as consistent as possible from one roll to the next.* Many photographers prefer a specific pattern such as 5 seconds every half minute, or 10 seconds each minute. Neither is better than the other; *consistency* is what matters.

2 Rinsing. When the developing time is up, pour the developer quickly out of the tank without removing the lid. The used developer should be discarded unless you have been specifically instructed otherwise. *The tank must remain closed,* of course, since the film is still light-sensitive. Rinse the film by immediately filling the tank with water, gently agitating for about a minute, and then discarding the rinse water. Again, *keep the tank closed.*

3 Fixing. Next pour a measured amount of fixer into the tank, and treat the film for about 5 minutes with the same agitation as before. This step is not as sensitive to temperature as development is, but the precautions outlined earlier should be observed. Film should be fixed for *twice* the time

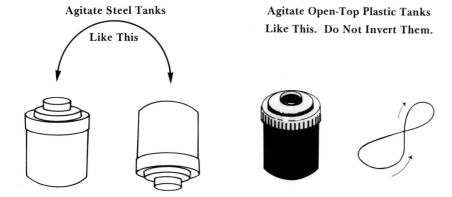

Agitate Steel Tanks

Like This

Agitate Open-Top Plastic Tanks Like This. Do Not Invert Them.

How to agitate steel developing tanks (left). How to agitate the Kodak plastic developing tank (right).

required to clear the milky appearance (undissolved silver bromide) from its emulsion. This also will insure adequate hardening. Any trace of milkiness remaining indicates inadequate fixing.

Most fixers are recyclable; usually they may be reused for many rolls of film (as many as 100 rolls per gallon over a two-month period) and so should not be discarded after each use. Furthermore, fixer is ecologically harmful, in large quantities, to disposal systems, but it can be processed to remove its toxic ingredients and recover valuable silver before its release. In any case, don't discard used fixer down the drain if a recycling system is in use; it is wasteful and ecologically unwise.

4 Washing. After fixing is completed, the film must be washed. Now remove the tank cover, since the film is no longer light-sensitive. Leave the film in the tank, on the reel or apron, to wash it, and adjust the stream of water so that it flows completely through the tank. With most tanks, the flow should be directed straight down the center of the reel (remove the weight from the Kodak plastic tank). At recommended temperatures, 10 minutes will provide adequate washing for most purposes, but 20 minutes will assure greater permanence.

5 Wetting Agent. Washed film must be dried, but at this point it can easily be damaged and must be handled with great care. A *wetting agent* used between washing and drying will minimize waterspotting on the film and hasten the drying process. It is particularly useful in areas where the water is "hard," that is, where it normally has a high content of dissolved minerals. The Kodak brand, Photo-Flo 200 Solution, is convenient and

inexpensive. Directions for preparation are on the bottle.

Flush the washed film for a moment with a direct, gentle stream of water to remove any scum or dirt, and then treat the washed film for about half a minute in the dilute Photo-Flo Solution. This breaks the surface tension of the water remaining on the film, permitting it to run off evenly with little or no spotting. Now put a clothespin on each end of the film and hang it up dripping wet—the wetter, the better.

6 Drying. Dry your film in a clean, dust-free place. *Be sure nothing touches it while it is drying,* for the gelatin is now hardening and any contact with another substance will mark it permanently. While the film is drying it might curl, but when it has dried completely it will flatten out again.

When the film is flat and the bottom feels dry to the touch, take it down and cut it into convenient strips to fit *negative protectors.* These inexpensive glassine wrappers, available from photo dealers, are a convenient way to protect negatives from finger marks and scratches.

7 Cleanup. Finally, rinse all parts of your tank carefully and completely. Traces of fixer often remain on the lid, and traces of wetting agent on the reel and tank. All of these must be *completely* removed. Also rinse the measuring cylinder, thermometer, funnel, and anything else you used for processing. Keep your equipment clean and ready to use again.

How do your negatives look? Film processing is a sequence of events rather than a single step, so each visible effect can have several causes, including those related to exposure in the camera. Most can be easily identified, but only by checking several aspects of the processed film and by going back over your procedures. In a school situation, your instructor or lab assistant can point out what to look for and how to interpret it.

For easy reference, the main steps of film processing are summarized in the following table.

Summary of Black-and-White Film Processing

The temperature of all solutions should be about 68° F (20° C).

Step	Solution	Time
1	Developer *	Time—temp
2	Water rinse	1 minute
3	Fixer *	5 minutes
4	Running water wash	10 to 20 minutes
5	Wetting agent	30 seconds
6	Drying	Until flat

* Agitation at regular intervals.

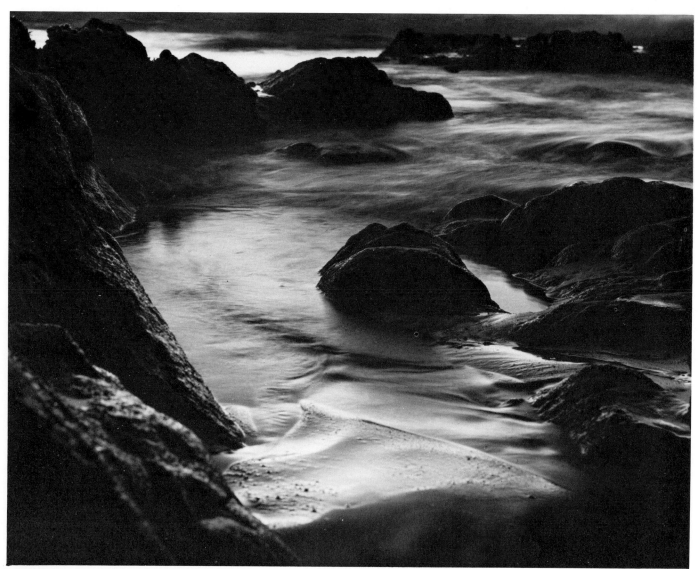

George M. Craven: Asilomar Beach, California, 1965.

Printing and enlarging 6

If photographic visualization seems to be an art, and the exposure and development of film a science, nowhere in photography do these disciplines come together more directly than in making the print. The experience of making a fine photographic print is both a sensitive visual exploration and a highly disciplined scientific process. In the former sense, it involves some of the same creative questions posed to the photographer by camerawork. And in the latter respect, printing is much like processing film; similar steps have similar reasons.

Most important, perhaps, photographic printing has all the attraction of traditional print making by other means, such as silk-screening, lithography, and engraving. All of our creative effort can be applied to make an individual statement, yet once arrived at, that statement can easily be duplicated. This principle has been fundamental to photography since Talbot produced the first negative; even if only one print is intended, the capacity for duplicates is there.

Furthermore, the rich variety of contemporary work has served to blur boundaries between traditional print-making processes. In particular, the silk-screen process and lithography are freely combined with the photographic process. This chapter, however, concerns itself with a contemporary approach to traditional silver print making. Other processes of current interest that are not too complex are discussed in Chapter 10.

In photographic printing we customarily take a *negative*, whose light and dark values are reversed from their original order, and make *another negative* image by passing light through the first. A negative of a negative, of course, is a *positive*; both terms, in fact, were given us by Sir John Herschel in 1840 and we still use them today.

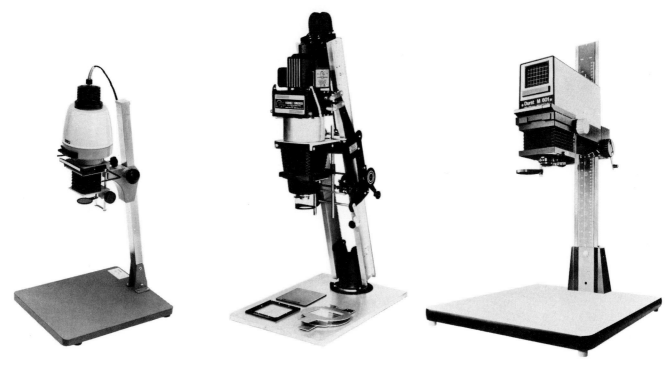

Vivitar E 34, Omega D2V, and Durst M 601 Enlargers. Courtesy Ponder & Best, Inc., Simmon Omega, Inc., and Durst USA.

The Enlarger

The cornerstone of virtually all contemporary photographic printing processes is the enlarger. A good one can be a remarkably versatile tool, serving numerous functions in addition to its more obvious ones. A poor enlarger, on the other hand, will only serve to limit the photographer's vision in the same way that any shoddy tool affects the work done with it. Equally important, a poor enlarger can negate all the effort and fine craftsmanship expended earlier to visualize the picture and obtain a good negative.

The enlarger works like a camera in reverse. Instead of reducing the larger dimensions of the real world to a few square inches of film as the camera does, the enlarger expands the image produced by the camera so the resulting picture can be more easily seen, physically and psychologically.

Because modern cameras increasingly rely on small formats (16 mm cartridge cameras are a good example), the enlarger has become an important link in the sequence of tools we use to move from our original impression of the object to the final expression of its image.

The enlarger, then, is a vertically oriented projector, with the same essential parts that a camera or any other projector has: a lens to form and project the image, a frame to hold the negative in the correct position, and a bellows or cone to connect them. In addition, it has another key part not found in cameras: a source of light.

Any good enlarger has three essential characteristics:

1 It must project a clear, sharp image of all parts of the frame.
2 It must distribute light evenly over the entire projected area.

3 It must be sturdy, and free from vibration or slippage of its adjustable parts.

The types illustrated here are a few of several excellent ones available at reasonable prices. Some come apart for compact storage and travel, and many have features to make routine work efficient. The enlarger lens has an adjustable aperture with f/ stops just like those on the camera. Its quality is very important; an excellent enlarging lens can cost as much as the enlarger itself, but such a lens is necessary to complement similarly high-quality optics on a camera. As with cameras, used enlargers are available from many photographic dealers, and a simple test can be devised to check for the three characteristics listed above.

Most enlargers contain a milky-white light bulb as the illumination source. This scatters and softens the

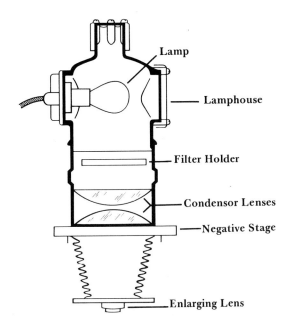

Optical system of a typical condensor enlarger.

light before it is directed through a set of condensor lenses to be spread evenly over the negative frame below. Add a good enlarging lens under the negative holder, and you have an optical system that can project an image of excellent contrast and definition.

Most modern enlargers have a filter drawer somewhere in the housing containing the lamp and condensor lenses. This drawer is used to hold colored filters needed to work with variable-contrast papers or different filters required if the enlarger is also used for making color prints. Variable-contrast printing filters are supplied in two forms: as thin, dyed, acetate squares which must be cut to fit the enlarger's filter drawer, or as flat, plastic frames which usually fasten under the lens instead. Acetate filters are inexpensive but easily soiled; the other form is more durable but more costly. Either kind is satisfactory for general work, but the acetate form colors the raw *light* before it reaches the negative; it does not interrupt the *projected image* and thus cannot soften or distort the latter. Either type, of course, must be kept clean.

In addition to the enlarger, a few accessories are needed to make a workable system. Most important are these:

1 A sable brush to remove dust from the negative.
2 A set of variable-contrast printing filters.
3 A timer. One that switches the enlarger on and off is most efficient, but any clock with a second hand that can be read in very dim light will do.
4 A proofing frame for making contact sheets.
5 An easel to hold the photographic paper flat while enlargements are exposed.

Photographic Paper

Let's consider the paper a moment. As we might expect, photographic paper is a layered product similar in many ways to film. The most prominent layer is the paper base. Made from wood pulp that has been manufactured to high standards of purity and quality, paper for photographic purposes can withstand long immersion in chemicals and water without disintegrating as ordinary paper would. It generally has a coating of barium sulfate (baryta) to improve its smoothness and provide a whiter reflective surface for the emulsion that is coated on it.

Paper emulsions contain crystals of silver bromide and silver chloride, or chloride crystals alone. Silver chloride emulsions are very slow and produce a neutral black tone; they are used almost entirely for contact printing, where the print and negative are the same size and are exposed together to a bright, direct light source without an enlarger. Enlarging papers contain both silver chloride and silver bromide. If chloride crystals dominate the mixture, the paper is moderately slow and produces a brownish tone, but with bromide dominant the paper is cold-toned and fast. Photographic papers are manufactured in great variety, so actual samples are the best guide to how an image on a particular kind of paper will look.

Photographic paper has eight identifying characteristics. Because there are so many kinds, these features are listed here as a guide to understanding labels and selecting products. The first three features relate to the paper base, the remainder to the emulsion coated on it.

1 **Weight,** the thickness of the paper base. *Single weight* is commonly used for black-and-white snapshots and general work. *Medium weight* and *double weight* are heavier and more durable, but more costly. A few other weights are available for special purposes.

2 **Tint,** the color of the paper base. White is standard, but a few papers are made in others such as cream, ivory, and buff.

3 **Water resistance.** Most paper base absorbs water and chemical solutions readily, requiring considerable washing to remove the latter. Recently, however, resin-coated paper has been introduced for general use. This new type is highly resistant to saturation and therefore washes very quickly, but this "RC" paper, as it is designated, must be air-dried. It cannot be handled on conventional drying equipment.

4 **Processing mode.** Most photographic papers are intended for wet processing by conventional developing and fixing methods. A few types, however, are designed for stabilization processing, which produces a damp-dry print in 10 to 15 seconds. The image is *stabilized* rather than fixed; it will last long enough for many uses, but is not permanent. Stabilization papers and processing are discussed in Appendix C.

5 **Speed.** Just like films, some papers are more sensitive to light than others. ASA numbers used for films are not applied to papers, but manufacturers usually supply comparable data with their products. As we noted earlier, the speed of a paper depends largely on whether silver chloride or bromide crystals dominate the emulsion mixture, and this also affects the next characteristic, tone.

6 Tone, the color of the developed image. This varies from a warm brown-black through neutral to cold blue-black. Slightly warm-to-neutral blacks are typical.

7 Surface texture. This affects reflective characteristics of the paper and therefore its depth of tone and image contrast. Glossy finish is the most common and versatile. It can be dried to a high gloss or a lustrous, brilliant finish, and for that reason is the first choice of many workers. Other surfaces such as mat and luster are widely used, and special textures (silk, tweed, canvas) are available on a few papers used mainly in the portrait trade.

8 Contrast, or exposure scale. This is one of the most important characteristics of photographic paper, and the most difficult to understand. We have listed it last in order to give it a closer look.

Paper Contrast

In the preceding chapter we discussed how to process film to a strip of negatives. If your negatives are typical, some will appear generally darker than others, and within each negative some areas will look thin or transparent, while others appear dark or opaque. *The range, or difference between these lightest and darkest areas within each negative is what we call contrast.*

All negatives, then, do not have the same tonal range, so we need a method to adapt their different ranges to the exposure scale of photographic paper. There are two ways to do this: by using different grades of paper, each with its own exposure scale, or by using variable contrast paper. Both methods are widely employed, but the latter is advantageous to the beginner as well as the skilled photographer, and its use is strongly recommended.

Graded Paper

Graded paper is made in several contrasts numbered from 1 through 6, or very soft through extremely hard, respectively. Lower-numbered grades have *long* exposure scales; this means that they require much longer exposures to produce a black tone than to yield a very light gray, and are best suited to negatives with a great range of gray tones in them. Higher-numbered grades, on the other hand, have *shorter* exposure scales; they produce their black tones with relatively smaller increases in exposure than the other types do from a normal negative, and are therefore suited to negatives whose tones are likewise closer to one another in value. Stated another way, low-number grades are for high-contrast negatives (those with clear shadows *and* dense highlights); high-number grades are for low-contrast negatives (which appear rather uniformly gray). Intermediate grades, of course, are for negatives of average contrast, and these usually contain a few weak shadows, a few dense highlights, and many shades of gray in between. Graded paper, then, solves the problem of contrast, but requires the user to keep several grades (therefore several packages) on hand.

Variable-Contrast Paper

A more convenient way to deal with negatives of varying contrast is to print them on variable-contrast paper. This remarkable material combines the ex-

posure scales of many grades into a single paper. It differs significantly from other papers in several respects, so let's examine it more closely.

Variable-contrast papers are supplied by several manufacturers under the following labels: DuPont Varigam and Varilour; GAF VeeCee Rapid; Kodak Polycontrast, Polycontrast Rapid, and Portralure.

These papers are made with *two emulsions* combined on a single base. One of them is sensitive to *green light* and has a long exposure scale: it produces *low-contrast images* with many shades of gray. The other emulsion is sensitive only to *blue-violet light* and has a short exposure scale: it produces *high-contrast images* with fewer gray tones but more intense blacks. Because the two emulsions are combined, they look and process like a single coating.

Exposure of these two emulsions is controlled by changing the color of the enlarger light with a filter placed in the lamphouse or under the lens. Contrast can be varied over a range roughly equivalent to four full grades of regular paper. Two systems of these filters are in general use. The Kodak Polycontrast set consists of seven filters ranging from 1 through 4 with intermediate half steps; a similar set made by DuPont contains five numbered filters (0 through 4). The two sets are *not* identical and should *not* be intermixed. Either set will work with any variable-contrast paper, but will not give identical results with every type.

Because one kind of paper can thus be adapted to widely differing negatives, variable-contrast materials are suited to both single-sheet and continuous-roll processing. In the latter system, individual prints are made in rapid succession on a continuous roll of paper, and processed in special equipment as a continuous strip to be cut apart automatically when dry. In this way large quantities of prints can be made quickly and economically. Complete instructions for varying contrast with this type of paper are given later in this chapter after a basic procedure for making contact sheets and enlargements is discussed.

Safelights

Graded papers are sensitive primarily to blue light. Variable-contrast types, as just noted, are an exception, and a few kinds specifically intended for making black-and-white prints from color negatives are panchromatic and must be handled in total darkness.

Most photographic papers may therefore be handled with reasonable safety in yellow or orange illumination provided by safelight lamps made just for this purpose. There are two types in general use. One consists of a filter or colored glass in a lamphouse containing an ordinary incandescent light bulb of low wattage; the second type uses the intense but pure yellow light of a sodium-vapor lamp, and is more suitable for large darkrooms. Some fluorescent light fixtures also can be filtered with special materials so that they emit only light of the proper wavelengths.

It is important to note that *safelights, as a rule, are not absolutely safe;* most will expose enlarging paper left under them too long or placed too close to the lamp. Those in general use are safe for about 5 minutes if the paper is no closer than four feet. *Paper not being used should be*

kept in lightproof containers at all times.

Setting Up Chemicals

Exposed prints are processed through much the same sequence as film is handled, and four trays will be needed for the darkroom. First comes development, to render the latent image visible. Paper developers, as a rule, are stronger and faster-working than their film counterparts. Two of them have become standard in America and many other countries. Kodak *Dektol Developer* (similar to published formula D-72) is mixed from powder to make a *stock solution*. This term, incidentally, may appear frequently on photographic chemical labels and jugs; it means that the solution is *moderately concentrated* to minimize deterioration, and must be further diluted for general use. For *Dektol*, a ratio of one part stock solution to two parts water (1:2) is standard. *Ektaflo Type 1* is a similar developer in highly concentrated liquid form. One part of the concentrate is diluted with nine parts of water (1:9) to make a working solution.

Once diluted, either developer should be discarded after a day's use, or sooner if it appears turgid or cloudy in the tray. Paper development is not quite as sensitive to temperature as film development is, and because of its greater contact with air while in a tray, paper developer will quickly stabilize at the temperature of the room. As with film, about 68° F (20°C) is best for all solutions.

Powerful developers such as these require an efficient means to stop development when it has fully revealed the image. Because most developers are alkaline, a mild acid is used as a *stop bath* in place of water that we used with film. The stop bath is usually prepared from a 28% solution of *acetic acid,* which is safe and inexpensive.* Dilute 1½ oz of 28% acid with 32 oz of water (47 ml of 28% acid with 1 liter of water) and pour this solution into the second tray. It, too, can be discarded after use.

Next, the stopped prints must be fixed. Any hardening fixer will work well, but if a universal or film-type fixer is used for paper, the dilution ratio will usually be different. Be sure to follow specific instructions for *print use.* Rapid fixers prepared for film are too strong for safe use with paper; overfixation and fading of print images can result. Follow mixing or dilution instructions carefully as you prepare the third tray.

The fourth tray should be filled with water. It will serve to collect fixed prints into batches for further handling. All remaining processing steps may be done in white light, and since two of them (washing and drying) can generate a good deal of heat and humidity with certain types of equipment, they are best removed from the confines of the darkroom. If you are working in a large class or group situation, specific instructions may vary somewhat from those given here, but the sequence will be similar.

* 28% acetic acid is first prepared from glacial (99.5%) acetic acid. Dilute 3 parts of glacial acid with 8 parts of water to make a 28% solution. *Glacial acetic acid is poisonous and highly irritating;* observe all precautions on the label and *always pour the acid into the water,* never the opposite.

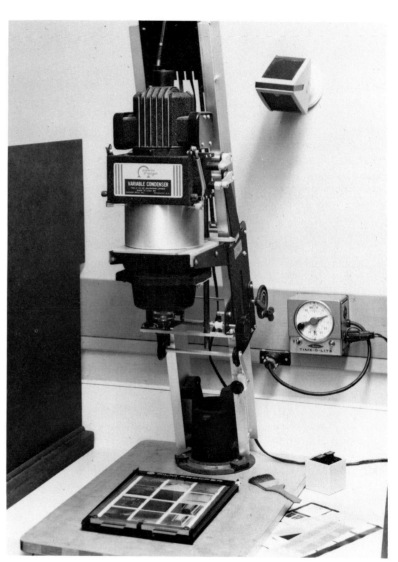

Contact printing setup.

Making a Contact Sheet

A *contact sheet* is a print made by placing the negatives so that their emulsions and the paper emulsion are in firm *contact* with each other, and then exposing the paper through these negatives. An entire roll of 120 or 35 mm film can thus be printed at the same time on a single 8 by 10 in. sheet of enlarging paper. Contact sheets are useful to the photographer as a convenient record of his work and as a means for selecting those negatives that will make the best enlargements. You can save much time and material in later steps by first making and studying contact sheets of all your work.

You'll need a *contact frame* to work efficiently, but if one is not available you can easily improvise it with 8 by 10 in. sheets of polyurethane foam and plate glass, both ¼ in. thick. *Remember: all operations must be done under a proper safelight. Use enlarging paper, not contact paper.* Let's take things step by step.

1 Place the empty negative carrier in the enlarger and focus a rectangle of white light about 10 by 12 in. on the baseboard. Center the contact proofing frame or foam pad in this lighted area. Stop the enlarger lens down about halfway and insert a No. 2 or 2½ filter in its holder. A typical setup is shown in the photograph here. Turn off the enlarger light.

2 Now remove a sheet of photographic paper from its package. Note that one side is shiny and usually curls inward; this is the *sensitive side,* and it *must always face toward the enlarger light.* Place it *face up* in the proofing frame (or on the foam pad). Next, carefully lay your negative strips *face down* on the enlarging paper. The face, or emulsion side of the negative also curls slightly inward as a rule, and it is always the *duller* of the two sides. Let the safelight reflect off each side for a moment, and you'll be able to identify them. Then with all negatives in place on the paper, lower the plate glass over them, and give a trial exposure by switching on the enlarger light for *exactly 10 seconds.* Finally, remove the exposed paper from the proofing frame; it is now ready for processing.

3 Slide the exposed print *face up* into the developer tray, and use care to make sure it is evenly wet. Rubber-tipped print tongs are convenient for this purpose; handle the print gently with them, since it is fragile and easily damaged. *Rock the tray slowly and continuously* during development by repeatedly lifting one corner of the tray an inch or so to keep the developer in continuous motion. You'll notice that as development progresses, shadow areas appear first, then middle tones, and finally highlight details can be seen. *Develop with continuous agitation for 3 full minutes, or for the maximum time recommended by the paper manufacturer.**

4 Stop development by transferring your print to the stop bath tray, and agitate it there for *15 seconds.* If the print is too dark, expose a new sheet of paper under the enlarger as before, using a smaller f/ stop or less time. If your first print is too light, repeat the procedure using a larger f/ stop or more time. Another way to do this is to cut several trial strips about 2½ in. wide from a sheet of photographic paper, and expose them one at a time under a single strip of negatives. Expose the strips for 5, 10, and 20 sec-

* Subsequent references to print developing time will be stated as 3 minutes, and this alternative should be understood.

onds, and develop as before. Try to find the f/ stop and exposure time that will give you a good contact sheet (showing both highlight and shadow detail) with 3 minutes development. *Make a note of those settings for future reference.*

5 Now transfer the print to the fixing bath. Agitate it for about a minute, and occasionally thereafter, by gently rocking the tray. Fix the print for the *minimum* time recommended for the type of fixer used; usually this will be about 10 minutes. Be sure to agitate the print occasionally with tongs while it is in the fixing bath. Normally we fix many prints simultaneously in the same tray; if you work this way, be sure they do not stick together, or incomplete and uneven fixing will result. After each print has fixed for the required time, transfer it to the tray of water.

6 You may now remove the print from the darkroom and inspect it in white light. This can actually be done after just a few minutes' immersion in the fixer, but in that case the print must be returned to the fixing bath after inspection for the full 10 minute cycle. *Whenever you remove a print from the sink for inspection elsewhere, always carry it in a tray;* avoid dripping chemicals on floors.

Examine the wet contact sheet for those frames most likely to produce good enlargements. Look for the frames that convey the strongest impression you have about the subject of your picture. An image with these visual qualities will usually be evident even in its small form on a contact sheet, although you may have to examine the sheet in white light to see all details. Additionally, look for a sharply focused frame with a good balance between highlight and shadow tones; at first, these will be the easiest to print successfully, and the fun and confidence you'll get from making a good enlargement are rewarding indeed. When you have made your choice, the contact sheet may be left in the water tray for continued processing with the enlargements later on.

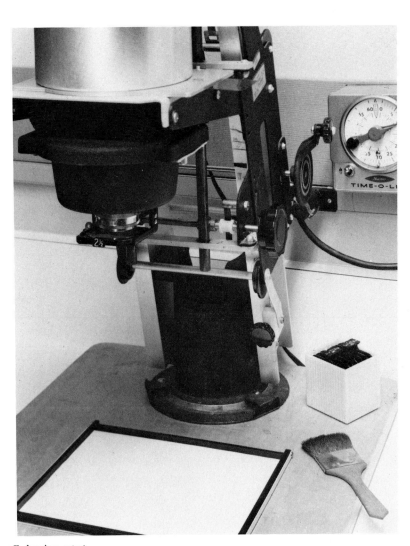

Enlarging setup.

Making the Enlargement

Place the selected negative in the negative holder *face down,* slowly dust both sides with the sable brush, and insert the frame in the enlarger. Open the lens to its largest aperture, and replace the contact frame below with the *enlarging easel* as shown in the photograph here. Take a few minutes to get a feeling for how the enlarger works mechanically. Raise or lower the enlarger head to make the projected image larger or smaller; focus the lens and note how the enlarged image quickly becomes sharp, then unsharp again. Shift the easel around on the baseboard to frame the best part of your image rather than the whole picture area. Just as you did with the camera, *frame to fill the picture area with important elements and eliminate non-essentials.*

Test Strips

When you've decided on the size and shape of your picture, focus the enlarger lens with great care to give the sharpest possible image. *Always focus with the lens aperture wide open;* then stop down the lens about halfway as before, or to the f/ stop you noted from making the contact sheet. Again, the idea is to find the exposure time that will produce a good print with 3 minutes development, and one of the simplest ways to do this is by making *test strips*. Here's how.

1 Turn *off* the enlarger light and cut a sheet of enlarging paper into strips about 2 in. wide, returning all strips but one to the paper package. Place that strip on the easel so that it will lie through middle-toned and lighter-toned areas of the image when the enlarger light is turned on again later. Avoid clear negative areas that will print as dark values (and won't be affected much by small exposure changes). Set the timer for about 12 or 14 seconds, and be sure the No. 2½ filter used earlier for contact printing is still in position. Now cover most of the strip with a piece of cardboard (anything opaque will do) so that only one end of it is exposed. Hold the cardboard slightly above the test strip.

2 Start the timer, expose the paper, and every 2 seconds quickly shift the cardboard to uncover about another inch of the paper strip. The idea is to make a strip that will contain a progression of exposure times in 2-second increments. Be careful not to move the test strip during exposure.

3 Develop the strip just as you did the contact sheet earlier, *for 3 minutes with continuous agitation.* Don't be casual about developing time! You are seeking accurate information now, and sloppy procedures will give you unrepeatable results. Maximum depth of tone in your prints *requires* full development.

4 When time is up, transfer the strip to the stop bath and examine it carefully under the safelight. Choose the time indicated by the segment that looks just *slightly darker* than you feel the print should be. This is to allow for the difference between the colored safelight and white light; experience will tell you how the print should appear in your darkroom, but you may want to make your *critical judgment in white light.* (If so, *fix* the strip for a minute first.) If the entire strip is too light, make another with a larger f/ stop or longer times; if it's all too dark, of course, repeat with a smaller aperture. Determine the time your chosen segment received by *counting down from the darker end of the strip.* Reset the timer for that interval and you're ready to enlarge.

5 Place a full-sized piece of enlarging paper carefully in the easel and expose it for the time determined from your test strip. Remove it from the easel and *process the sheet of paper exactly as you did the contact print earlier.* Again, slide the print into the developer face up and be sure it is completely immersed. *Agitate the tray continuously for 3 minutes as the print develops.* If it darkens too quickly in the developer, reduce the exposure in the enlarger; don't pull the print out of the developer early. When the full developing time has elapsed, drain the print for a few seconds over the tray and transfer it to the stop bath.

The Stop Bath

The *stop bath,* a very weak acid, neutralizes the chemically opposite alkaline developer, and stops the developing action. About 15 seconds is sufficient time. This bath also prevents carry-over of alkaline developer into the acid fixing bath; to permit that would weaken the fixer by reducing its acidity, and increase the risk of causing stains on prints. An acid stop bath thus helps prolong the useful life of the fixer, and should always be used when processing prints. Some prepared brands of stop bath contain a chemical indicator that changes color when the bath is exhausted.

Two-Bath Fixation

Print fixer, like film fixer, removes the unused light-sensitivity throughout the emulsion and hardens the gelatin. Thorough fixing is necessary for permanence, and if space in the darkroom sink permits, *two fixing baths used in succession are better than one* for processing photographic paper. In a two-bath process, most fixing occurs in the first bath while the second acts as insurance to fully dissolve undeveloped silver halides and properly harden the gelatin. The first bath thus does the "heavy" work, and exhausts more rapidly. When its capacity has been reached,* it is replaced by the fresher second bath, and a new second bath (with full capacity) is prepared. With this arrangement, the total fixing time is divided between the two baths, and about twice the usual number of

* A simple chemical test for fixing bath exhaustion is available from several manufacturers.

prints can be treated. For large volumes of work, then, the two-bath fixing method is both more efficient and less expensive, but even if you make only a few prints it helps to produce a more permanent image.

Clearing and Washing

After fixing, prints should be rinsed briefly in water to flush any residual fixer from the paper surfaces. The water "holding" tray following the fixer takes care of this nicely. Regular photographic paper, being made from wood pulp, absorbs large quantities of fixer. In addition, the baryta coating that most papers contain tends to retain thiosulfate ions, further complicating their removal. Washing photographic paper, then, is a more difficult job than washing film, and so a step not needed for film is often added to the process. This is known as *hypo clearing.*

After the rinse, fixed prints should be immersed for about 3 minutes in a solution of clearing agent prepared from any of several suitable products. Variously sold as hypo clearing agent, Perma Wash, or hypo eliminator (although none of them actually eliminates hypo), these products contain a mixture of salts which converts the thiosulfate remaining in the paper to a more soluble form without removing it. *It is important to note that these so-called eliminators and clearing agents actually remove nothing.* They simply make the remaining hypo or fixer more soluble, thereby permitting it to be washed out more easily in the *next* step. In practice, a 3-minute immersion in clearing bath can reduce print washing time by 60 to 80 percent while producing a chemically cleaner

Tray siphon in use. Courtesy Eastman Kodak Company.

result. Both time and water are thereby saved.

The next step, of course, is to wash out all remaining salts from the emulsion and paper base. Converted by the clearing agent, these salts now dissolve out readily, as does the clearing agent itself. *A continuous change of water in the washing tray is important.* This can be achieved by a simple device like the tray siphon pictured here, or by more efficient means for larger quantities of pictures. Whatever the setup, it is desirable to remove some of the contaminated water from the bottom of the vessel, as hypo released from the paper tends to sink if the flow of water through the container is not sufficient to remove it. The tray siphon, which attaches to any print tray and faucet, does an excellent job and is inexpensive.

The kind of paper being processed determines the washing time. If clearing bath has been used, single weight paper should be washed about 15 min-utes, *double weight about 30.* If single and double weight papers are washed *together,* the entire batch must be washed *30 minutes,* as if it were all double weight. *If a clearing bath is not used prior to washing, the above times should be **doubled.***

Once a batch of prints has begun to wash, no unwashed prints may be added to it without recycling the entire batch for the full washing time. Temperature is important, too. Release of fixer is impeded by temperatures much below 65° F (18° C) and additional washing time should be allowed; temperatures above 80° F (27° C), on the other hand, permit efficient washing of paper but risk damaging the gelatin emulsion. The 65° F to 75° F (18° C to 24° C) temperature range is best.

* Resin-coated "RC" papers should be fixed *only* 2 minutes, then quickly rinsed and washed 4 minutes. No clearing bath is needed for them.

Drying Conventional Photographic Paper

All photographic papers except resin-coated types may be dried by first removing the surface moisture from both sides of the print and then placing it face down between clean, lint-free photographic blotting paper. A blotter roll, available from photo dealers, is a convenient form. Alternatively, the damp-dried prints may be placed face down on clean cheesecloth or nylon screen stretched over a wooden frame.

Glossy paper may also be dried in this manner to produce a smooth, lustrous surface, but if a high gloss is desired, conventional glossy paper must be ferrotyped.

Ferrotyping

Ferrotype plates are sheets of thin, highly polished chrome-steel or stainless steel. The emulsion side of regular glossy photographic paper may be rolled or squeezed against this smooth, polished surface while the print is dripping wet. The idea is to insure perfect contact between the gelatin emulsion and the mirror-like plate surface, and rolling a thin film of water out from between the two surfaces seems to work. When the print has dried, the polished surface is imparted to it, thus giving it a high gloss.

Good, spot-free glossing depends on a number of factors, but clean plates and good contact are most important. Treating the prints for a few minutes in a glycerin-like conditioning solution usually helps. *Pakosol* is a concentrated liquid that dilutes economically for use. Several other manufacturers have similar products.

Pako model 26 continuous print dryer. Courtesy Pako Corporation.

All of the above methods require several hours for the prints to dry. When large quantities of prints are processed regularly, as in commercial labs and many school and college situations, heated rotary dryers are often used to ferrotype prints continuously. Large machines like the Pako model pictured can dry 8 by 10 in. (20.3 by 25.4 cm) prints in about 5 minutes. *Special precautions apply to any of these costly machines,* and they should be carefully observed. Pre-treatment of prints in a conditioning solution is usually necessary. Such a solution may be reused for many prints, but if it becomes dirty or contaminated by unwashed prints, *replace it at once.*

Drying Resin-Coated (RC) Paper

Resin-coated (RC) papers *should not be dried on blotters, ferrotype tins, or conventional dryers.* Instead they should be air-dried; the print surface will dry best if it does not come in contact with anything. Special air-impingement drying machines may be used with these papers, or the sheets may simply be wiped on both sides with a soft sponge to remove surface water and hung with spring-type clothespins, like film, to dry in the air.

For convenient reference, the main steps of processing conventional and resin-coated paper prints are summarized in the tables that follow.

Summary of Black-and-White Print Processing with Conventional Paper

The temperature of all solutions should be about 68° F (20° C)

Step	Solution	How Prepared	Time
1	Developer	Dektol 1:2; or Ektaflo Type 1, 1:9	3 min *
2	Stop bath	1½ oz 28% acetic acid in 32 oz water (47 ml/liter)	15 sec *
3	Fixer	As instructed on label for prints	minimum recommended †
4	Rinse	Still or slowly running water	as needed
5	‡ Hypo clearing bath	As directed on label for prints	3 min †
6	Wash	Running water (double time if step 5 is omitted)	15 to 30 min
7	‡ Print conditioner	Pakosol prepared as directed on label	3 min †
8	Drying	See text	

* With constant agitation.
† With occasional agitation.
‡ Optional but highly recommended.

Summary of Black-and-White Print Processing with Resin-Coated (RC) Paper

The temperature of all solutions should be about 68° F (20° C)

Step	Solution	How Prepared	Time
1	Developer	Dektol 1:2; or Ektaflo Type 1, 1:9	3 min *
2	Stop bath	1½ oz 28% acetic acid in 32 oz water (47 ml/liter)	15 sec *
3	Fixer	As instructed on label for prints	2 min †
4	Rinse	Still or running water	15 to 30 sec *
5	Wash	Separate running water container from above step	4 min *
6	Dry	Sponge surface moisture from both sides of paper and air-dry; do not ferrotype	

* With constant agitation.
† With occasional agitation.

George M. Craven: Ley Green, Devon, 1969.

Controlling Print Contrast

Now that we have considered a general procedure for printing and enlarging, it is time to make a few refinements in our basic technique. These, of course, should result in prints that more closely convey our visual ideas to our viewers. Like other aspects of technique, they are additional means to a visual end, and not exercises in themselves.

To review a moment, we know from making a test strip and an enlargement that giving a print more exposure in the enlarger makes it darker. Shadows appear to darken first, and as more exposure is given, even the brightest highlights will become gray until eventually the entire print will develop black. In printing, then, *increasing exposure makes the image darker.*

In the prints we have made so far, some parts of the image are dark while other parts of the same image are light, that is, nearly white. We may also see blank white areas without any image and deep shadows that appear absolutely black, as in the photograph of Ley Green reproduced above. Between these extremes in typical prints are many, many shades of gray, each representing a different exposure caused by different image tones in the negative from which the print was made. The *range* of these exposures actually given the print, from the darkest area to the lightest area within it, is its *exposure scale,* a physical concept. Ask any photographer what this is, however, and he'll say *contrast,* its visual equivalent.

All of us are familiar with the contrast of a black-and-white television picture, and we use the term the same

way in photography. Take any photographic print at hand and look for two things in it. First, find the *lightest area* in the picture that is *important* with respect to the subject and its meaning. This may be a large or small area, it may be white or very light gray, but it must be important to the picture, not some insignificant background detail or patch of sky. Next locate the *darkest area* in the print that is *similarly important*. Again, ignore tiny dark shadows unless they are subjectively important. *The difference between these lightest and darkest important areas is the contrast of that print.*

Now, if this difference is great, that is, if it ranges from pure white to jet black, we call the contrast *high* or *hard*. High-contrast prints seem to be dominated by black and white tones. If this same tonal difference, however, includes only a few shades of gray, we say the contrast of that print is *low* or *soft*. Low-contrast prints appear to have an overall gray cast. They may be generally light or generally dark, but in either case you will notice an absence of white and black together in the same print. The print we usually try to make lies at neither of these extremes but is somewhere between them. All three tones, blacks, whites, and grays, are present in and usually important to a *medium* or *normal-contrast* print.

Once we have determined the proper exposure for our print (by making a test strip), we can still adjust the contrast to produce a more expressive result. You'll recall that earlier we recommended the No. 2 or 2½ filter for the contact sheet and our initial enlargement. Those filters are

in the center of each set's range and reproduce the exposure scale of a negative generally as it is, without increasing or decreasing the contrast. *Lower number filters always produce less contrast in the print than there is in its negative; higher number filters produce more.*

A simple demonstration will show us what this looks like. Select an average negative (one that is neither too transparent nor too opaque), and using the method previously outlined, make a satisfactory enlargement from it using a No. 2½ filter. Then make an identical print (same exposure and enlarger setup) but with a No. 1 filter instead of the No. 2½. Also make a third print, but this time use the No. 4 filter and *triple* the former exposure time (the No. 4 filter absorbs much light and requires more exposure time to compensate for this loss). *After* each exposure, mark the filter number on the back of the print with a *soft pencil* (never use a ball-point pen because this may transfer to dryer belts and other prints).

Process the three prints together so that they develop for identical times, and after they have fixed, examine them in white light. If your negative has average contrast, the No. 1 print will appear too gray, the No. 4 print too contrasty, and the No. 2½ print about right, as described above. Since all three prints were made from the same negative, the difference you see represents the range of expressive variation available to you solely by controlling print contrast.

As you make the first print or enlargement from each new negative, then, look for these differences in tonal range. Make your first print with the

No. 2½ filter (from which you can move up or down as indicated) unless you feel sure from viewing the negative that a different filter is needed. With a little practice you will be able to see these tonal differences in the negative before you enlarge it, or on the enlarger easel, and make your initial exposure test strip with the appropriate filter.

Here's a tip: time your exposure of the paper to produce a faintly detailed white in the highlights of the picture with full development. Having done that, if the shadows are too gray, reprint with a *higher number* filter; if the shadows are too black and too many details seem to be lost in them, reprint with a *lower number* filter. Exposure times with different filters are approximately equal, except when the higher number ones are used. These require longer times; the Kodak filter set contains a simple calculator for this purpose.

Graded Paper

Graded paper is printed *without filters* in the enlarger, that is, with white light. Again, different brands are not identical, so it is best to stick with one type. The grades of Kodabromide and Medalist paper, two popular types, closely match Polycontrast printed with the filter of the same number. Grade 1 paper is always low in contrast: it has a long exposure scale and produces many shades of gray. Grade 2 is considered normal, grade 3 hard or higher in contrast, while grade 4 is very high in contrast and produces fewer gray tones between white and black from an average negative. A few papers are also made in grades 5 and 6.

Local Image Control

Once you have obtained a generally satisfactory print by using the proper exposure and contrast filter (or paper grade), take a closer look at local areas within the picture. If the overall exposure and contrast seem about right but some small areas are too dark or too light, the exposure will have to be manipulated a bit. It is not uncommon to find that when the print is generally good, a strong highlight such as a sky area or a reflection in water may be too light, or an important shadow or distant face, perhaps, too dark. If the problem seems to be local, its correction is local, too.

Small areas that are too dark in the first print may be lightened by a technique called *dodging*. You can do this most easily by placing your hand in the light beam of the enlarger just above the paper during its exposure, and moving your hand so that its shadow masks the selected area for *part* of the exposure. If the area needing correction is very small, a piece of opaque paper taped to the end of a thin stiff wire might be easier to use.

If your first print contains areas that are too light, however, these must be locally darkened by additional exposure. After you make the overall exposure, hold a piece of cardboard with a small hole cut out of it over the area to be darkened, just above the easel, and give extra exposure time there. This technique is called *burning;* you can also do it with your hands by using them to shade all parts of the image you do *not* want to darken.

A few points about manipulations like these ought to be kept in mind. First, they are used *after* the basic exposure and contrast have been determined; second, the hands or cardboard dodging masks must be vibrated or otherwise kept in *constant motion* to prevent a shadow line from forming on the print; and third, whatever method or combination of methods you use, *keep the whole process simple.* Many experienced photographic printers literally do a dance with their hands over the easel during the print's exposure, although often the mask and wand are just as easy.

Here, too, lies another advantage of variable-contrast paper. You may change filters as you mask, printing most of your image, say, with the No. 2½ filter, then using a higher filter to add contrast to a small area as you mask out the rest of the picture. *Use the lower number filter first,* and be careful not to disturb any other part of the enlarger setup as you change filters. A rigid enlarger is required.

Don't be discouraged if your first results aren't exactly what you want; you'll need a little practice, of course, to use these techniques effectively. You may have to make several trial exposures, and burning times may even seem unreasonably long. This is not unusual, but if you need too much manipulation to get a desirable print, your negative is probably not as good as it ought to be. Techniques like these are not cure-alls. They can make a good print immeasurably better, but they cannot correct significant faults in a negative. Only a new negative can do that. Directions for other techniques such as local chemical reduction of the image, variable-contrast developers, and chemical toning (to change image color) can be found in additional references listed in the bibliography. All are intended to "fine tune" the tones of your print so it can convey your visual idea more precisely and effectively.

Angelo Rizzuto: Sidewalk Fishing, New York, 1959. Rizzuto Collection, The Library of Congress.

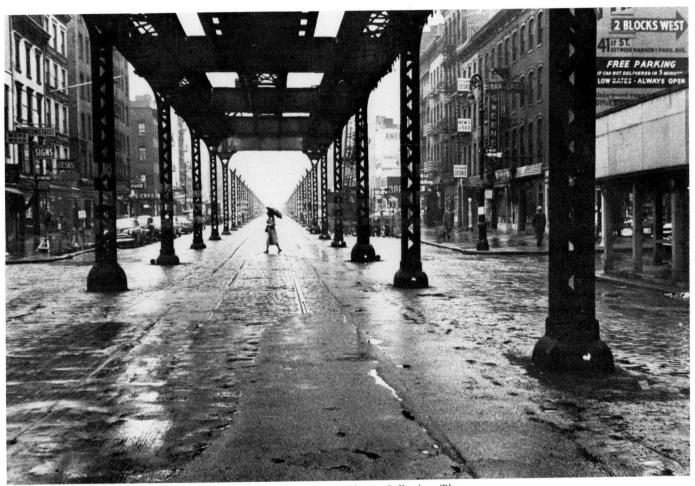

Angelo Rizzuto: Third Avenue and East 41st Street, New York, 1956. Rizzuto Collection, The Library of Congress.

Print Finishing

Once the prints are dry, a few additional steps remain to complete them. Prints intended for exhibition or serious study should be *mounted* on illustration board to isolate them from their surroundings and keep them flat. Exhibition prints and those intended for reproduction or publication must be *spotted* to remove dust and similar imperfections from their images. Finally, fragile surfaces of many photographic papers may require protection against abrasion if prints are stacked or frequently handled.

Dry Mounting

There are a number of ways to back prints with more substantial material, but the best method is one called *dry mounting*. Dry mounting binds together porous materials such as paper without moisture or solvent-type adhesives. It may be used with any such materials not damaged by moderate heat, and is particularly suitable for mounting black-and-white photographs. An absence of moisture helps prevent wrinkling; the lack of volatile solvents (such as those in rubber cement) avoids chemical reactions that could damage the photographic image.

Materials being dry mounted are sealed together by a sheet of thermoplastic material called *dry mounting tissue* placed between them. Heat is used to melt the sealing material so it can run into the pores of the photographic paper and the mount; moderate pressure applied with the heat keeps the materials flat. *The process is permanent;* once mounted, the materials cannot be separated without damaging them.

Products suggested for this work are Kodak Dry Mounting Tissue or Seal MT-5 Tissue. Both are available in standard sheet sizes and in continuous rolls, 30 and 40 in. (76 and 101 cm) wide.*

A dry mounting press and tacking iron, both thermostatically controlled, are convenient for the process. Allow them about 10 minutes to reach the proper temperature range of 225 to 270° F (107 to 132° C) for black-and-white photographs. You'll also need a paper trimmer and a sheet or two of clean, kraft (brown) wrapping paper as large as the press.

White cold-press illustration board of medium thickness is recommended for the mount, although any good quality board may be used. This is obtainable from art supply stores. The mount generally should be about 2 to 3 in. (5 to 8 cm) larger than the print in each direction. Here is a step-by-step procedure:

1 Begin by *preheating* everything *except* the mounting tissue: the photograph, illustration board, and wrapping paper should be gently warmed for about 20 seconds in the press (without pressure) to drive out moisture.
2 Prints to be mounted should be left untrimmed to start. Fasten the mounting tissue to the back of the photograph with the tacking iron in

* Kodak Dry Mounting Tissue is packed with pink paper interleaved; these pink sheets are not adhesive and must be separated from the mounting material. Other brands are not interleaved.

Dry mounting press and tacking iron. Courtesy Seal, Incorporated.

the *center only,* sticking a spot about the size of a half dollar.

3 Next, trim the photograph and tissue together, *face up,* taking care that the tissue does not overlap or extend beyond the edges of the print. A straightedge or ruler laid over the print close and parallel to the edge you are trimming will help hold the print flat for a true cut.

4 Now place the trimmed photograph and tissue face up on the mount, position it securely, and raise one corner in a *broad curl* (so you will not crack the emulsion). Fasten the tissue to the mount with the tacking iron, working from the center of the photograph *outward* toward a corner, with a single stroke. Take care to *leave the extreme corner* of the tissue *free,* that is, unstuck. Without shifting the position of the photograph, repeat the

above procedure for the other three corners.

5 Place the preheated cover sheet (kraft wrapping paper) over the photograph and mount, and insert the entire sandwich into the mounting press, *face up.* Close the press completely for about 30 seconds, then open it and remove your work. Flex the mount *gently* as it cools; this will help it remain flat and will also verify the seal. If your work comes unstuck, return it to the press for additional time. That will usually correct the trouble.

If a dry mounting press is not available, small prints up to about 8 by 10 in. (about 20 by 25 cm) usually can be successfully mounted with an electric household iron. Its tip may be used for tacking. Be certain that no steam can be produced, and set the

thermostat between "silk" and "wool." Prepare and tack in the usual manner, but make the final seal by starting the iron in the center of the print, moving slowly outward in a spiral pattern. Seal the corners last.

Remember these points: preheat everything (except the thermoplastic material) to drive out moisture. Heat, not pressure, makes the seal; a faulty bond is usually caused by too short a time or too low a temperature. Most importantly, *remember that the photograph and its mount together form a single statement.* A sloppy mounting job will weaken the strongest photographic image. Don't let all of your earlier effort be undermined in these final steps.

Spotting

No matter how careful we are in the darkroom, a little dust usually manages to stick to our negatives and this shows up as tiny white specks on our prints. These should be removed by *spotting.* The best way to do this is with Spotone retouching dyes, which come in a set of three colors; by mixing them, the tone of any photographic paper can be matched. You'll also need a fine, tapered tip, sable brush, size 00.

The easiest way to use these dyes is to shake the bottle and work with the residue left in the cap, but if colors must be blended to match the tone of your paper, this can be done in a saucer with a drop or two of water. Set the open bottle well aside so it won't spill on your print. Moisten the tip of your brush with saliva, pick up a bit of dye, and fill the white spot on the print with color. Use the dye very sparingly; build the color up slowly with repeated applications rather than applying it all at once. Even highly glossed prints may be spotted in this manner, because the dye goes *into* the emulsion rather than on it, and if the brush is only damp-dry, the gloss will not be affected. The dye itself, of course, should not be noticeable; most other spotting colors on the market are pigments that remain visible on the print surface. Like other manipulations, spotting takes practice, easily done on discarded prints. And spotting should always follow dry mounting; heat might change the color of the dye.

Protecting Finished Prints

Like most other forms of photographic images, prints are fragile; they must be adequately protected from anything that might damage their delicate surfaces. Never stack prints face to face without a separator between them. If mounted prints are stored together, it is best to place a cover sheet over the face of each photograph. Any clean, soft paper will do; newsprint (unprinted newspaper) is inexpensive and satisfactory for short-term storage. For long-term storage of fine work, however, pure white tissue will give better protection. If possible, store mounted prints vertically like phonograph records, and never allow them to slide against one another.

Unmounted prints may be stored conveniently in empty photographic paper packages. Don't mix sizes, for this permits small prints to slide against others when the box is placed on edge. And never fasten photographs to other things, such as letters, with paper clips—they leave their own impression in the picture.

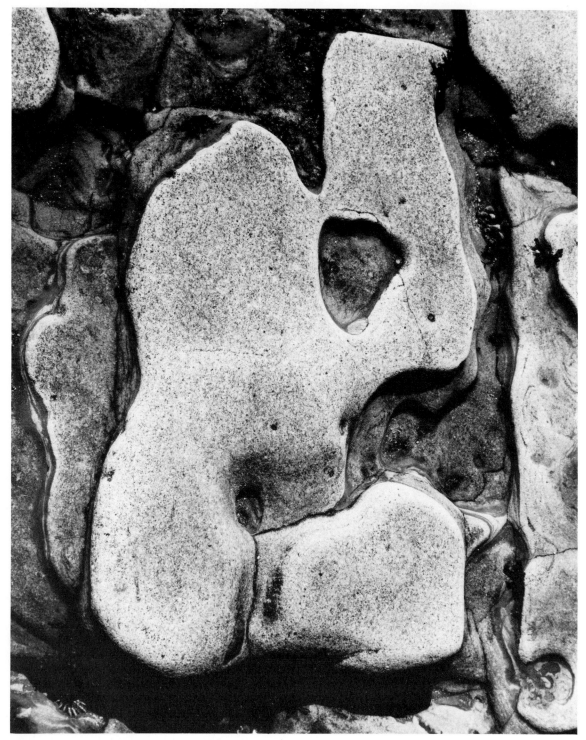

Edward Weston: Eroded Rock, Point Lobos, 1934. Collection: The International Museum of Photography.

The direct approach

The direct approach to making a photograph encourages us to discover the most important aspects of a subject, visualize them as simply and directly as possible, and present them in a photograph as forcefully as we can. This approach to the image employs methods that we identify more strongly with photography than with any other means of making pictures. These methods include forming a clear, incisive image with a lens, recording that image directly on film without manipulation, and printing the negative to produce the strongest visual impression possible.

Photographs made in this manner usually are rich in continuous tone and detail. They make the most of *light* as a designing element to reveal significant form and texture, to define space, and to unify the image as a picture. The work of Edward Weston and Ansel Adams contains many examples.

Using this direct approach, then, we can create an illusion of reality so strong that the presence of a camera, and sometimes even that of the photographer who directed it, can go unnoticed: we can bring to the viewer of our pictures an extraordinary sense of *being there.* In effect, our photograph says to its viewer, "You are here. You (rather than the photographer) are witness: you are seeing this object or event. And since seeing is believing, what you see must be true." Photographs made like this create a feeling of *presence;* our willingness to equate seeing with believing reinforces it.

We can observe this phenomenon in any popular magazine or TV commercial. Photographs document facts; they convince those who doubt. Photographs in advertising and package design persuade people to buy goods and services by vividly describing those commodities and by making them attractive and desirable. In other words, photographs help to create a want or need by stating facts and arguments more convincingly than mere words can do. Business and advertising

thus capitalize on such direct visualization and vivid expression. Furthermore, because it stresses those aspects so basic to the very nature of the medium, this direct approach underlies other styles and uses of photography today.

The approach is classic. Direct photographs seem to do what photographs can do best: communicate a wealth of visual information, and do it accurately. Moreover, they are least suggestive of pictures that could be made better by drawing or painting: direct photographic images have an unquestionable photographic appearance.

Photographic images visualized like this, of course, are not new. Daguerreotypes, conceived as unique pictures unlike any others, provided the first examples. Today snapshots, with all their charm, are the most common and innocent examples of this fundamental approach. Common, of course, because they are produced by the millions. And innocent because a person taking a snapshot typically is most conscious of what happens to be in front of his camera, and least aware, at that moment, of the photograph which will result. That photograph, and everything it contains and means, are discovered later when he sees the print. The approach is a direct one since nothing intrudes between the photographer and his photograph except his camera and film—both photographic devices—but the approach is dissipated short of its goal because of the photographer's preoccupation with picture taking. He doesn't *use* all the potential inherent in his medium for effective expression or communication.

Unlike a snapshooter, the creative photographer begins with the meaning of his picture. He perceives an idea within himself or his subject, and visualizes the final picture that he thinks will most effectively convey it to the viewer. Both approaches are direct, but the creative photographer follows through. For him, making a photograph is simply the most straightforward way to state his idea—to express himself.

A Single Idea

More often than not, the direct approach is most successful when it is used to visualize a single object or idea with the greatest possible strength. Edward Weston's *Artichoke Halved* is a beautiful example: here there is little doubt about what this photograph seems to be saying. On at least one level of communication, its message is clear. There may, of course, be other levels, and some of these may be obscure, but a primary meaning is evident. Therefore any guideline for working in the direct approach may usefully begin with a suggestion to *concentrate on visualizing a single idea* —on seeing one thing, clearly. Because the world as we find it usually is more chaotic than orderly, the photographer habitually begins by sorting out. He must cull and detach from his environment the raw material of his picture. This *act of selection* may be intuitive or carefully reasoned; it may be instantaneous or involve a succession of decisions. However it is done, it is fundamentally an individual and human decision, and therefore the most important one a photographer can make. *Selection,* then, is the primary step in all forms of photographic visualization.

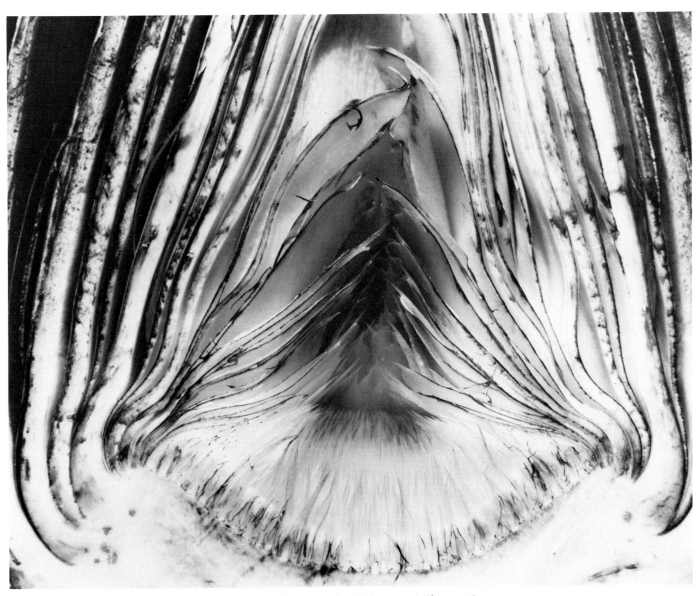

Edward Weston: Artichoke Halved, 1930. Collection: The International Museum of Photography.

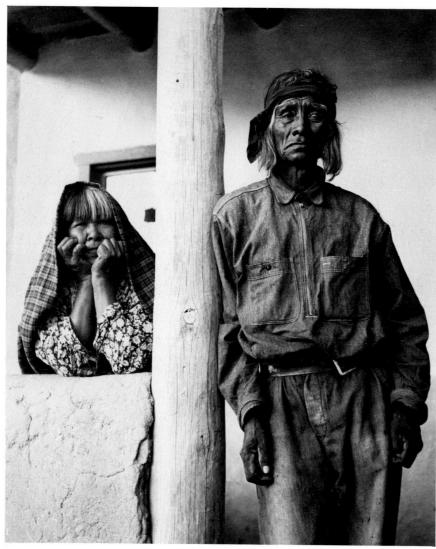

Alma Lavenson Wahrhaftig: San Ildefonso Indians, 1941.

Framing the Subject

Whenever we point a camera at something we hang a frame on the real world. We select what is significant within our field of view and locate it within the framework of the picture's edges. Thus we isolate the image from all that lies beyond that frame. Set apart in that manner, our image takes on a new significance. John Szarkowski, in *The Photographer's Eye,* points out how important this isolation is to the photographer:

To quote out of context is the essence of the photographer's craft. His central problem is a simple one: what shall he include, what shall he reject? The line of decision between in and out is the picture's edge. While the draughtsman starts

Aaron Siskind: Martha's Vineyard 108, 1954.

with the middle of the sheet, the photographer starts with the frame.*

We can demonstrate this by overlapping two L-shaped pieces of cardboard to form an adjustable frame. Move this cutout slowly around in front of one eye, and notice the effect. Things that become isolated together within this frame, like Alma Lavenson's Indians, take on a stronger relationship to each other. Holding the frame close to the eye will show the effect of a wide-angle lens. Objects close at hand occupy a large part of the space; larger in scale, they may

* From *The Photographer's Eye* by John Szarkowski. Copyright © 1966 The Museum of Modern Art, New York. Reprinted by permission of the publisher.

seem more important. Moving the frame to arm's length has the same effect as increasing the focal length of the lens or further enlarging the negative. Now fewer things, at a greater distance, compete for our attention.

Framing objects apart from their surroundings causes other things to happen. By surrounding two objects as we have noted, and eliminating everything else, the frame establishes a new relationship between them. It shapes the *space* around objects, too, as Aaron Siskind shows us in *Martha's Vineyard 108*. And then there is that "line of decision"—the picture's edge. The edge cuts objects in two and discards one segment; the part may be used to suggest the whole, or the picture may simply show an uncommon section of a common object. Paul

Paul Strand: The White Fence, 1916. Collection: The International Museum of Photography.

Strand's classic *White Fence* led the way here. Nothing is completely revealed in this picture; everything here is a fragment.

Fragments tend to extend a viewer's perception beyond the confines of the picture itself; things that are visible in the photographic image allude to others which are not. Because of their cut-off feature, then, the picture's edges become important elements in its structure and geometry. Ignoring these edges weakens snapshots, where the effort too often seems unconsciously directed to centering people or objects within the frame. We should take care, then, when composing a view with the camera, and again when cropping the negative in the enlarger for final printing, to use the framed space of the picture format fully.

Brett Weston: Aspen Tree, 1972.

Get Closer

Another way to fill the frame with our subject is to get closer to it. Our photographic process, as we know, can record an immense amount of detail. Closing in on our subject helps to reduce this abundance of detail without diminishing its clarity. The direct approach to making photographs, then, encourages us photographers to see things from a short range; we can get close enough to concentrate on how things really look, as Brett Weston has done, without irrelevant objects diluting the intensity of either our vision or our picture. Most cameras permit focusing directly as close as $3\frac{1}{2}$ ft (1.07 m) from the subject, and even closer if special lenses can be attached (see the section on closeup attachments in Chapter 11).

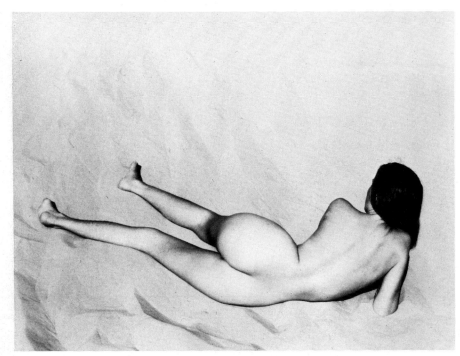

Edward Weston: Nude on Sand, 1936. Collection: The International Museum of Photography.

The Importance of Light

Form—the shape of objects within the frame—does not need to dominate a directly perceived photograph, but so often it is such an important part of the image with any way of working that it becomes a picture's major organizing element. Thus we can properly consider it here. Form in any picture is dependent on the artist's point of view, and, of course, on the nature of the objects themselves. But in photography, it also depends on *light*. In a two-dimensional photograph, depth and form can be visualized more forcefully by using light and its absence, shadow, to reveal the shape of objects within it.

Our ability to distinguish an object from its environment—what we sometimes refer to as a figure–ground relationship—can be strengthened in a photograph by careful arrangement of light and shadow. Imogen Cunningham's *Rubber Plant* gains much of its dramatic power from this simple yet incomparably photographic device. Light separates enough of the object's shape from surrounding shadows to reveal the essential statement. Notice, however, that only separation is required for clarity: Don Worth's dramatic landscape, made in the Owens Valley of California, separates dark objects from a lighter ground. Here the rocks appear to come forward; the rest of the picture tends to recede.

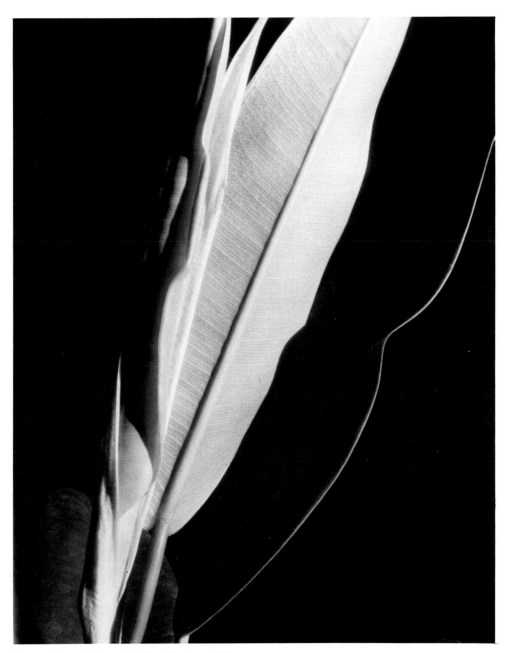

Imogen Cunningham: Rubber Plant, c. 1929.

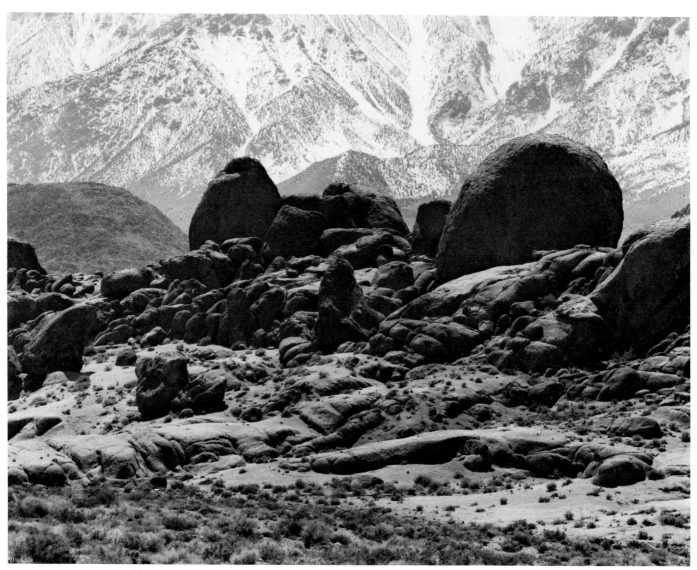

Don Worth: Rocks near Lone Pine, California, 1968.

Harry Callahan: Detroit, 1941. Courtesy Light Gallery, New York.

Light can contribute to a direct photograph in other ways. In Harry Callahan's image of grasses and water, reflections framed with the objects themselves reinforce and extend the vital rhythms of this scene. The *mood* of a photograph can be struck by yet another aspect of light. Harsh lighting can intensify differences between things that are held together by the frame. Ansel Adams's dramatic photograph of the Sierra Nevada from Lone Pine evokes the magic of a spectacular mountain landscape on a cold winter morning. Long a master of using natural light, Adams has often employed it to dramatize the more commonplace as well.

On the other hand, soft, diffuse light, typical of overcast or foggy days, usually has a flattening effect that minimizes other contrasts within a scene. Thus closely visualized portraits and objects such as Brett Weston's tree detail will take on a subtle but vital feeling more in tune, as a rule, with the photographer's actual impression of them. Landscapes made in such light, however, may look dull and dreary because without shadows to vary the brightness range and strengthen the impression of depth, only a formless, gray scene is recorded. This monotonous gray tone, though, can be relieved by other factors such as snow or water to reflect light within

Ansel Adams: Sierra Nevada from Lone Pine, California, 1944. Collection: The International Museum of Photography.

Wynn Bullock: The Stark Tree, 1956.

the scene and add life and tonal variety to the picture. Water, in fact, has always drawn photographers to it because it is a natural reflector of light and is symbolic of life itself. Fog, incidentally, imparts a sense of mystery to a photograph just as it does to nature. Including the light source itself in the picture, as Wynn Bullock has done, can have a similar effect; it also tends to unify the composition.

It appears, then, that there are numerous ways to use light in photography, quite apart from its physical role in the recording process. Whenever light will help reveal the essential qualities of a subject, or convey the significance of an event or idea, it should be used vigorously and imaginatively. Light, that infinitely variable element of photographic design, is basic to the direct approach.

Technique

So far our definition of this basic approach to photography has considered only the problem of visualizing an image in the camera. An unrecorded image, however, is not yet a photograph. We must employ suitable materials and methods—our technique—to complete the task.

Most serious photographers argue that questions of technique must remain subservient to expression at all times. They believe, quite simply, that the ends to which the photographic process is put should determine one's choice of tools and methods. In some of the variant and non-silver processes outlined later in this book, technique and statement are so directly interrelated that they cannot be considered separately. In the direct approach, however, this is not the case. Its classic simplicity makes it easier to consider ends apart from means; this, in turn, allows us to keep the emphasis where it belongs—on *what* we are saying, rather than how. *A flexible yet disciplined technique should provide the freedom for creative vision and expression along with the confidence necessary for consistently good results.*

Because technique obviously affects the final print, and thereby the intensity of our statement, certain aspects of it have seemed important to many photographers working in the direct manner. To be consistent with a straightforward approach, our technique should be as simple and as direct as possible. Fundamental here is the action of light on our sensitive film and paper: increasing exposure produces darker tone in the negative and print. By carefully controlling the exposure and development of these materials, we can produce a range of continuously changing tone from brilliant white to jet black. Long tonal scales are essential to brilliant prints, and a brilliant print evokes a sensation of intense presence more effectively, as a rule, than a softer one does. A brilliant print sings joyfully. Long scale prints, then, seem particularly well suited to working in a direct, forthright style.

What makes a print brilliant? Why do one photographer's prints seem vibrant and alive, while another's appear muted and lifeless? Choice of materials has some effect. Glossy papers can produce richer shadow tones and a longer tonal scale than mat papers can, but they don't guarantee these results; dead, gray prints can be made on glossy papers, too. Good craftsmanship in exposing and processing the negative is unquestionably desirable. But a vital requisite of a brilliant print, and one frequently overlooked, is the presence of clean white and maximum black areas in the picture. They need not be large in size, nor relatively important in subjective terms. The only essential requirement is that they be *there*, in the print, and noticed by the viewer's eye.

Black and white symbolize many opposites. It has often been said, for example, that they portray despair and hope. But in addition to this important symbolic role, black and white are the key tones or values of the traditional silver image. They are visual anchors. And they are tonal absolutes, the only ones in the photographic image; all other tones are relative to them. Each is readily defined in practical terms. *White* is the clean, pure

Ed Cismondi: Rawhide, Nevada, 1967.

reflection of the coated white paper base, undimmed by any visible deposit of silver in the emulsion after processing. Quite simply, *white* is the result of processing unexposed photographic paper. *Black* is the darkest and heaviest deposit of silver that an exposed and fully developed print will yield. Any other value, by definition, is *gray*.

Our impression of a print's tonal scale hinges on these two absolute values—white and black. If that scale stretches from one value to the other, an appearance of brilliance will be unmistakable.

George M. Craven: Jamestown Elevator, 1971.

Systematize Your Technique

Making a photograph with a long tonal scale, fortunately, is not difficult. But neither is it automatic. A workable technique that you can practice with sufficient discipline and rewarding confidence can be developed from the basis outlined in previous chapters. With experience, you can refine your procedures to make them more responsive to your ideas and more expressive of your skill. Many seasoned photographers systematize their working methods, and some of these systems include visualizing the image as well as executing the photograph. This combination has the incomparable advantage of tying *seeing* and *photographing* together, providing a rational means to progress from a visualized image to the finished picture.

One of the best and most famous systems of this kind is the *Zone System* of Ansel Adams. It provides a common language for relating the *subject*— what is in front of the camera—with the *negative* and the *print;* it is a major aid to *visualizing* the picture at *any* stage during its evolution. Unlike most other techniques which relate exposure and development to visible results in a negative, the Zone System permits us to visualize an expressive *print* as we consider various possible interpretations of a subject before our camera. The method is a systematic yet flexible tool. A thorough explanation of the Zone System is beyond the scope of this book, but excellent references to it will be found in the bibliography.

We've said it before, but it bears restating: any technique, whether a

Peter Henry Emerson: Gathering Water Lilies, 1886. Collection: The International Museum of Photography.

simple, empirical procedure or a methodical one like the Zone System, is only a means to an end. So, too, is the approach, the way we use photography. For when these procedures become ends in themselves, our work becomes sterile, impersonal, and ultimately of little meaning. Experimenting with many approaches, including a direct one, can help us define our personal objectives in using the photographic medium. This is the first step toward developing an individual style.

In Retrospect

Usually there are some familiar elements in everything new that we see and do. Ideas and their symbols in art and communication evolve. They develop by example, and by the interaction of people who test them. In the brief but lively history of photography we can find enough examples, and their challengers, to see how a pure, direct approach evolved.

As we have already noted, the concept of a direct approach is neither new nor revolutionary. The work of many early photographers appears to be consonant with this idea. Nevertheless, an English physician and amateur photographer, Peter Henry Emerson, seems to have been the first to submit that this direct way of seeing and working was especially suited to photography. His 1889 book, *Naturalistic Photography*, a broadly based, theoretical discourse, tried to present a reasoned approach to the camera that argued for clarity and directness rather than an imitation of prevailing,

Alfred Stieglitz: The Terminal, 1893. Collection: The International Museum of Photography.

pre-impressionistic painting. Emerson was not a persuasive critic, however, and soon abandoned the controversy to his opponents, although in the clearer hindsight of history his arguments seem more defensible than theirs were.

Since then, the idea behind direct photography periodically has been debated by others. The American photographer Alfred Stieglitz, and the Photo-Secession, a group of contemporaries whom he brought together in New York, reaffirmed the esthetic in 1902. Over the next eight years, Stieglitz was very influential in getting photography to be recognized as a fine art in its own right, and on its own terms. The Photo-Secession demonstrated the difference between the photographic record and the photographic expression; they showed that criteria appropriate to the former could not suffice for the latter. Although many Secession members turned thereafter to more impressionistic styles, Stieglitz himself continued to work along pure lines. He discovered others, such as Paul Strand, whose work was direct and intense.

Paul Strand: Blind Woman, 1916. Collection: The International Museum of Photography.

Thirty years later, in 1932, a similar informal association of fewer than ten people formed around Edward Weston in California. They called themselves Group f/64; they made and exhibited expressive photographs in the direct approach, while arguing their convictions in the press with other workers who favored impressionistic and manipulated pictorial styles. Through the work of photographers like Ansel Adams, Imogen Cunningham, and Weston himself, of course, the direct photographic style of Group f/64 was again shown to be vital and basic. Although practiced everywhere, it became strongly identified as a "West Coast School." More importantly, it provided the esthetic foundation for the best documentary and journalistic work of the next three decades. Today it remains a major expressive course. The directly visualized image produced by the interaction of light, lens, film, and paper continues to be vigorously practiced by artists, amateurs, and professional photographers alike. After more than a century of picture making by photography, it is still the classic method.

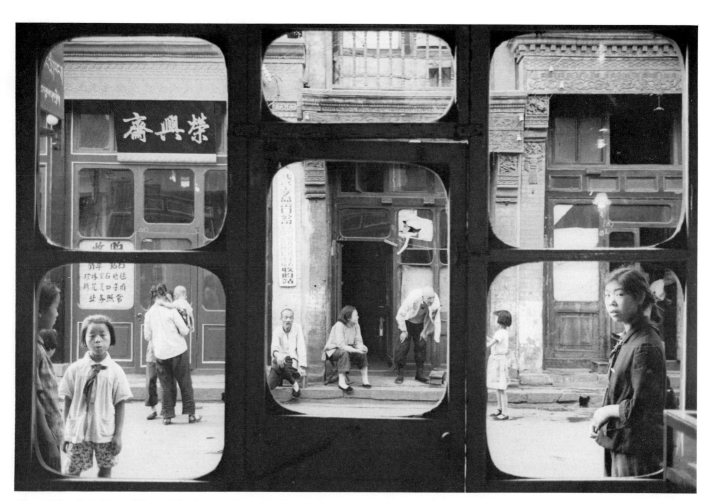

Marc Riboud: Peking, China, 1965. Courtesy Magnum.

If the direct approach is concerned with the essence of an object or idea, the reportorial approach is concerned with its *context* as well. Not only with the irreducible fact of the matter, but also where it occurred, and when. Reportorial photography considers how an object is related to others around it: it places an object in *space*. It also considers how an event is connected to what preceded the moment of exposure and what follows it: it acknowledges a continuum of *time*.

Space and Time

Photography does not transcribe space or time but alters them in subtle ways. A camera image has its own structure imparted to it by the lens, and a photographer approaching his subject must take this into account. He may think of *space* as the arrangement of everything (including the primary object) within his view, an area he will later reduce to concrete dimensions by his camera frame. Or he may be more selective and limit his perception to a single plane that his lens can isolate.

Similarly, he must understand what surrounds his subject in *time,* for every exposure, long or short, is only a moment plucked by his camera from an irreversible sequence of events. If this context of time is inevitable, the meaning it gives his picture, however, is not. A photograph may suggest that what is momentarily pictured actually has been that way for some time, or that the view may continue unchanged thereafter. Consider, for example, Walker Evans's photographs of the American South. Are they documents of particular places at certain moments of time, or are they symbols of an era? Once it is removed by a camera, a moment becomes suspended in the present tense. If Lee Harvey Oswald's final minute (Chapter 1) is now only a memory, it is nonetheless fixed forever in its photograph.

A camera shutter, then, like its viewfinder frame, is a selector, to be used by the photographer with judgment based on his awareness and perception of space and time. Henri Cartier-Bresson has suggested that in the real world of objects and events there is rarely a second chance; we photographers deal in things that are continually vanishing.

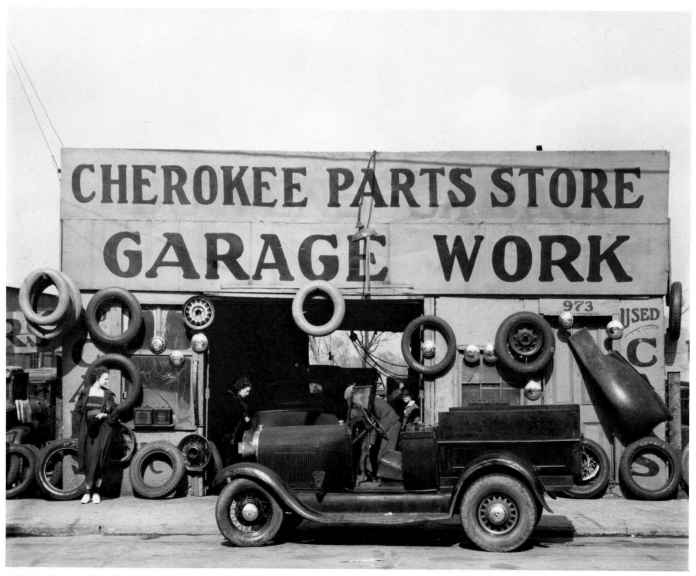

Walker Evans: Cherokee Parts Store, Atlanta, Georgia, 1936. The Library of Congress.

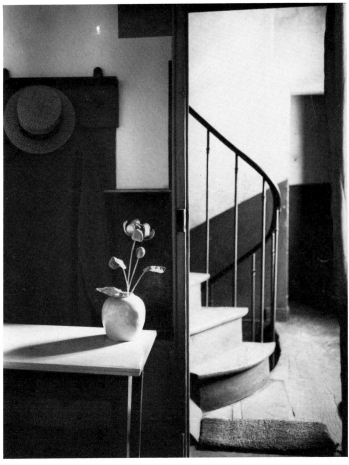

André Kertész: Chez Mondrian, Paris, 1926.

Depth of Field and
Selective Focus

How we can interpret space with a camera is related, of course, to how the lens forms an image. Whenever the camera frames objects at different distances from the lens, some of those objects will be rendered sharper than others in the picture. This area of greatest apparent sharpness is called the *depth of field,* and includes everything between two limits, near and far, of acceptable clarity in the image.

When André Kertész photographed Mondrian's doorway, he probably wanted to emphasize the vase and doorway over the stairwell and hallway beyond. By focusing on the door frame and using a moderately large aperture, Kertész limited his depth of field to the emphasized objects. He

could have focused everything sharply by using a smaller aperture, but that would have given the hallway equal prominence.

With all but the simplest lenses there is only one position of the focusing mechanism that will give the sharpest possible image of an object at a given distance from the camera. Objects at other distances will be less sharp. The change is gradual, and is most noticeable with large f/stops and when the objects focused on are close to the lens. Under these conditions the depth of field is shallow, focus is selective, and the plane of greatest sharpness in the image is readily apparent. Focusing selectively to emphasize an object, then, is easy since the effect is visible on the ground glass.

As the lens is stopped down to smaller apertures, or focused on objects at greater distances from the camera, the depth of field *increases.* The aperture of many SLR cameras can be momentarily stopped down to preview the depth of field at various settings. On TLR and rangefinder cameras, however, this cannot be done, but the actual depth of field at smaller apertures will be greater than that observed through the viewing lens at its largest setting. Such cameras usually contain a depth of field indicator on the focusing scale. In the example shown, if the lens is focused on 10 ft. (3 meters) and set at f/16, objects from about 8 ft. to 15 ft. (2.4 to 4.6 meters) will appear sharp. If you study the indicator carefully, you'll notice that depth of field rapidly decreases as you close in on a subject, but increases as you focus farther away. You can quickly confirm this on the ground glass.

Depth of field indicator on camera.

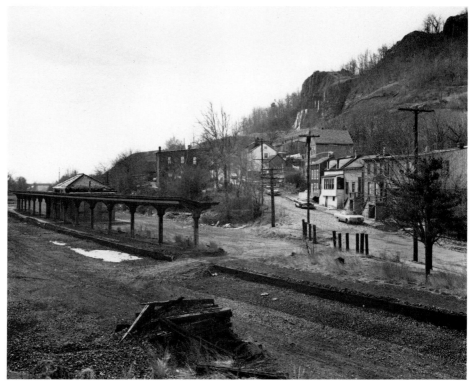

George A. Tice: Lackawana Station, Paterson, New Jersey, 1968. From Paterson, *Rutgers University Press.*

Photographers often face a different problem: how to get most or all of the image sharp. While documenting the city of Paterson, New Jersey for a book of that title, George Tice photographed an abandoned railway station. He took care to get everything from the nearest crosstie to the distant horizon sharp and clear. No single object here was more important than any other, so he unified the space by focusing it sharply throughout. The picture as a whole evokes a feeling of sadness and perhaps nostalgia. We can sense the weariness of a city that found its economy stagnating and its identity slipping away. Yet in those freshly painted houses beyond the street we can perhaps detect a few small voices of protest; not everyone has given up. If Tice had focused selectively on either the station or the houses, he would not have been able to communicate this delicate balance of frustration and hope. Tice, then, conveys meaning through the *context* of objects in his picture. The photograph speaks of a place and a time: it simultaneously echoes the past and alludes to the future.

Hyperfocal Focusing

Since he couldn't select a single important object to focus on, Tice chose a plane about one-third of the way into the frame of his picture. Why one-third? Focus your camera lens on any moderate distance and it will produce a depth of field in your image. This depth of field might be shallow and select, or extensive and obvious, but it will be there. However great it is, *one-third of this depth of field will always extend from the plane of focus toward the camera, and two-thirds of this depth will lie beyond that plane of focus in the subject.* The upper diagram illustrates this relationship.

The same conditions apply when the camera is focused on *infinity,* that is, on a very distant plane beyond which all objects appear sharp simultaneously. One-third of the depth of field again extends from infinity toward the camera, and the remaining two-thirds coincides with infinity focus itself. Thus a near limit of that depth of field can be visually established by focusing on infinity and selecting the nearest object whose image is acceptably sharp. *The distance from the lens to this nearest sharp object, when the lens is focused on infinity, is called the hyperfocal distance.*

But, as we have just noted, when a lens is focused at infinity only one-third of its depth of field is actually used, although the remaining two-thirds depth is sharp because of infinity focus. Now let's change the camera's focus to the newly found *hyperfocal distance* instead of infinity. Again we get a depth of field. One-third of it extends toward the camera, two-thirds of it toward infinity. This

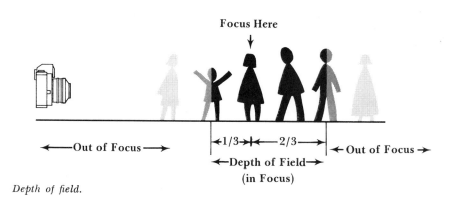

Depth of field.

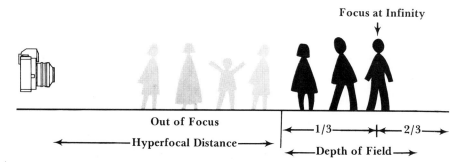

Depth of field at infinity focus.

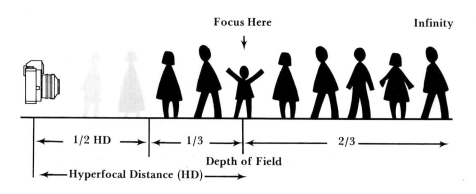

Depth of field at the hyperfocal distance.

time, however, the *far limit* of that depth of field *touches infinity* and thus extends its sharp focus instead of overlapping it. At the same time, the *near limit* of our depth of field has now reached a point halfway between the lens and its hyperfocal distance. *The total depth of field thus extends from half the hyperfocal distance all the way to infinity, and is the maximum depth of field that can be obtained for a given focal length and aperture setting.*

Hyperfocal focusing can be used with any adjustable camera, and is entirely a visual method; no charts or actual distance measurements are necessary. Let's review its main points again to see how easy it is to use. There are three steps, and their sequence is important.

Hyperfocal Focusing Summary

1 Focus on *infinity*, and look for the *nearest* object whose image is acceptably sharp. Consider how much enlargement and how sharp a result you'll probably need. If you can stop down the viewing lens on your camera, close it to the smallest aperture permitted by exposure conditions before you select your nearest sharp object.*
2 Next, *shift* the camera's focus to that nearest acceptably sharp object. This is the hyperfocal point.
3 Your depth of field *now* extends from half that distance to infinity, and is the *maximum depth of field*

* Remember that stopping down the lens reduces the amount of light for exposure and requires a longer shutter time to compensate this light loss. Review *Relating the Shutter and Aperture* in Chapter 3 if necessary.

obtainable at that aperture. At smaller apertures it will be even greater.

Hyperfocal focusing is not the only useful way to increase depth of field. In Bernard Freemesser's photograph of Telluride, Colorado, nearby buildings and distant mountain peaks appear with equal clarity because a very small aperture was used and because nothing in the view is very close to the camera. The resulting richness of detail provides a counterpoint to the strong pattern of light and shadow. A similar effect of depth can be produced by substituting a lens of *shorter focal length* if your equipment will permit this. The *smaller* image thus produced will appear to have *more* depth of field.

On the other hand, if a lens of *longer focal length* is used, the resulting image will be *larger* and will appear to have *less* sharpness from near to far planes within it. Working close to your subject and using a large aperture as Marion Patterson has done here will also produce a highly selective effect.

Another factor affecting depth of field is how critical we are of the image itself. Although important, this question has no simple answer. If the print must be greatly enlarged from its negative and still look sharp, focusing that image in the camera and getting sufficient depth of field should be very carefully done. The photograph by Brett Weston in the preceding chapter is a case in point; it is enlarged from a $2\frac{1}{4}$ in. square (6 by 6 cm) negative to an 11 by $12\frac{1}{2}$ in. (28 by 32 cm) print. On the other hand, the photographs by Freemesser and Tice were printed by contact from much larger negatives. When little or

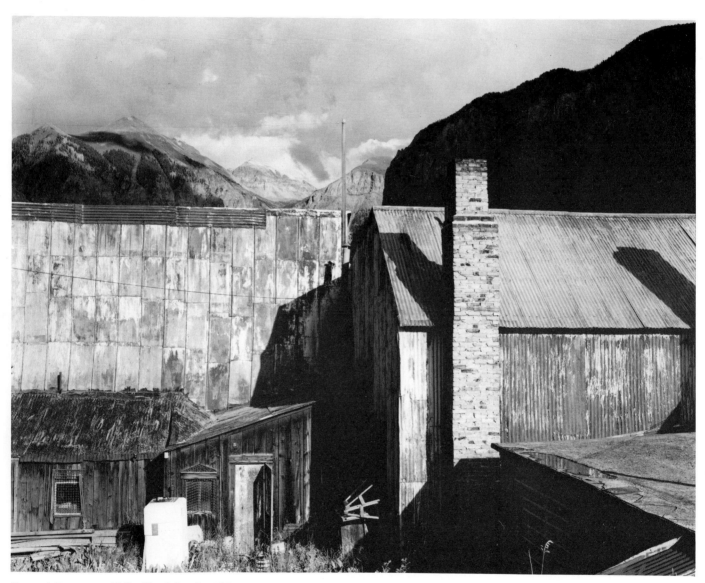

Bernard Freemesser: Telluride, Colorado, 1970.

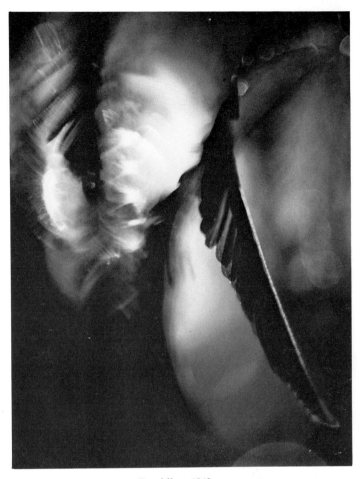

Marion Patterson: Leaves, Yaxchilan, 1965.

no enlargement is required, extreme sharpness might not always be necessary to preserve the visual impact of the picture.

Let's summarize, then, the factors that affect depth of field.

For *maximum* depth of field, we should:

1 Use the smallest practical aperture.
2 Focus on the hyperfocal distance.
3 Enlarge the negative as little as possible.

For *minimum* depth of field, we should:

1 Use the largest practical aperture.
2 Get as close as possible to our subject.
3 Enlarge the negative liberally.

In practice, not all of these factors can be optimized, and one may cancel others out. For instance, you may have to get close to your subject, use a small aperture because of bright light conditions, and moderately enlarge the negative. Moreover, although it directly affects depth of field, the focal length of your lens should be selected for other reasons such as image size and framing. *Adjusting the aperture* usually is the most convenient way to control the depth of field.

Anne Noggle: [untitled], 1969.

Perspective

It seems hardly necessary to mention perspective, that familiar pattern of projected outlines that helps us perceive three dimensions on a two-dimensional plane. In *central perspective* we represent what is infinitely large by a mark that is infinitely small. A vanishing point on the horizon line —a dot—signifies unlimited space. And because the camera lens focuses light to form projected outlines of objects, it produces its direct image the same way.

This, of course, isn't new to us. Ever since the Renaissance our way of seeing has been conditioned by the camera lens. For nearly a century now, photomechanical reproduction has made possible accurate and unlimited duplication of pictures, and more re-

cently the electronic media have conveyed them everywhere. Thus overwhelmed by this spatial concept in printed and televised images, we have to put forth some effort to see things any other way.

Other ways of representing space in pictures, though, are very much a part of our visual experience. The draftsman, for example, can present space as a thing itself by rendering an object in *isometric perspective,* which shows all three dimensions simultaneously to the same scale. Although a camera cannot produce this effect with a single exposure, separate images can be combined into a single statement. Such multiple images will be considered in Chapter 10.

Occasionally, however, a simple photographic image seems to contain more than one vanishing point. The effect is most apparent in photographs made with a very wide-angle lens, as Anne Noggle's image on a street corner suggests, but a closer examination of this picture will reveal a single and central organization of its image structure.

We see a scene in perspective, or perceive depth in a picture, then, because we readily notice *change.* If we can sense a gradual change in space or in the relative size of similar objects, we know immediately that we are not looking at a flat, perpendicular plane. For example, the crossties, rails, and poles along a straight railroad track appear smaller and closer together as they get farther away from us—they converge. Actually, we know that things are not as we see them, but this apparent distortion doesn't bother us. On the contrary, if it weren't apparent, we would find the view quite disturbing.

Time and Motion

Nothing attracts our attention to change more strongly than *motion* does. We sense an object to be in motion when it changes its relation to other objects that are stationary, or that do not change in space relative to one another. As an object moves, it changes the space around it. It also changes in *time* as well as space, and thereby creates a happening or event. *Time,* then, is the interval between events and, as such, the dimension on which we measure all change.

Time and motion, as Einstein reminded us, are relative concepts. We can show them graphically in various ways. A blurred image seen against a sharp, clear background, for example, will strongly suggest movement. This can be created by leaving the shutter open longer than usually would be done. Since the exposure time must be related to the object's relative motion, no simple rules apply. Times of 1/15 second to several seconds provide a useful range for experimenting, and they often will reveal visual images that cannot be seen with the eye alone. Ernst Haas has used this technique to stretch the moment into a new visual dimension. His celebrated essay on bullfighting is a classic example.*

When we experiment with shutter times for this purpose, we must remember that *longer exposures require smaller apertures:* more time must be balanced by less light to avoid overexposing the film. Slow films (ASA 16 to 50) may be helpful for such work, especially in bright sunlight.

* Ernst Haas, "Beauty in a Brutal Art," *Life,* July 29, 1957, pp. 56–65.

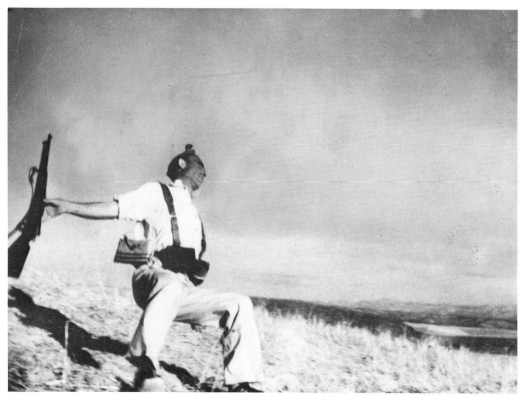

Robert Capa: Death of a Loyalist Soldier, Spain, 1936. Courtesy Magnum.

Panning

Although *motion* is clearly suggested by the preceding technique, the moving object itself may be difficult to identify. Reversing the relationship between still and moving elements, however, usually clarifies the situation. For example, *panning* the camera (tracking a moving object so that its image is held still in the viewfinder) renders the *object* more clearly than the background, which blurs. Panned pictures contain an unmistakable feeling of movement, yet the object usually remains identifiable. The technique is often used in sports photog-raphy, and can capture both the fact and feeling of a rapidly moving event. *Sports Illustrated* and similar magazines provide many examples of this device.

If the moving object and the space around it are both important to the picture idea, it may be necessary to "freeze" the action by using a very short exposure, perhaps the shortest time that shutter settings will permit. A great deal of action can be stopped momentarily at $\frac{1}{500}$ or $\frac{1}{1000}$ second. But *shorter exposures require larger aperture settings;* less time must be balanced by more light for proper exposure of the film. A high-speed film (ASA 400 or above) may be useful, especially if the light is not ideal for brief exposures.

All this concern for time and movement does not mean that space can be neglected, for it is inseparable from time. A running figure, for instance, needs space to move in. Simple enough, it seems. But framing that space *ahead* of the figure leads him onward—it gives him someplace to go; framing it *behind* the figure, as Cartier-Bresson did at Hyers, suggests that the figure is running away from something. Thus the way we include space around a moving figure can affect the meaning of our picture.

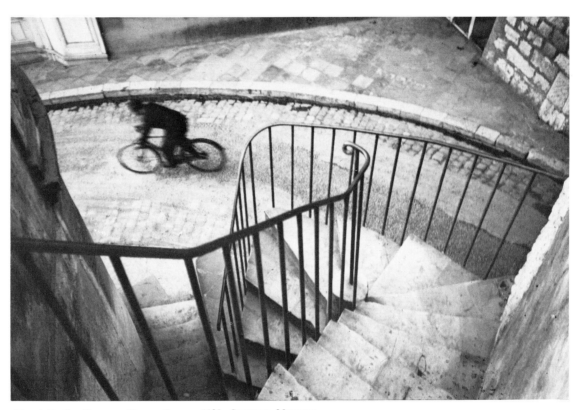

Henri Cartier-Bresson: Hyers, France, 1932. Courtesy Magnum.

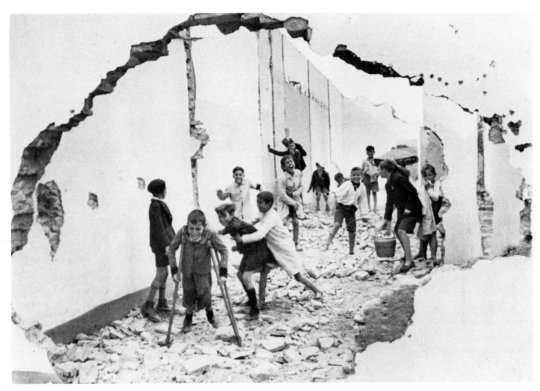

Henri Cartier-Bresson: Children Playing in the Ruins, Spain, 1933. Courtesy Magnum.

The Decisive Moment

Because time and space are insepar-able, the *moment of exposure* will affect our final pictorial statement as much as any other factor. Selecting that moment, then, means that we must anticipate when the image in our viewfinder will convey *the most intense moment of an event through the most dynamic arrangement of its elements in space.* That is what Henri Cartier-Bresson, the legendary photo-journalist, has called the *decisive mo-ment.* Timing is extremely important; a second early or late and the oppor-tunity may be missed. We must in-stantly recognize it and swiftly react.

The 35 mm camera, used as an exten-sion of our eye, makes such photog-raphy feasible.

No other photographer has more consistently demonstrated the visual impact of a decisive moment than has Cartier-Bresson. His photograph of Abruzzi shows only a few figures walk-ing; all others are still. No rapid move-ment is suggested, but the balance of elements in the picture creates a deli-cate rhythm of lines and spaces, much like the visual impression of notes on a music staff. It gives the picture an arresting and unifying quality. An-other moment of time, or another point of view, and this feeling would be gone.

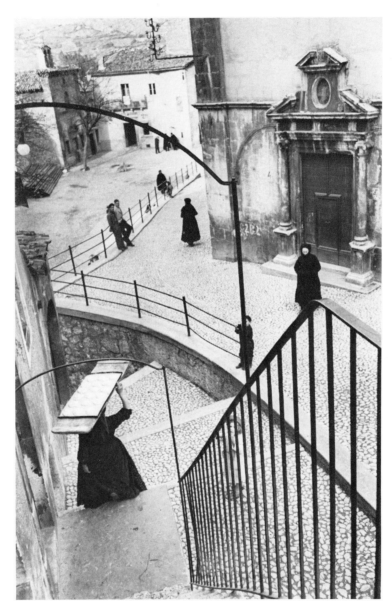

Henri Cartier-Bresson: Abruzzi, Italy, 1953. Courtesy Magnum.

Wynn Bullock: Rock, Sea, Time, 1966.

Not every moment, of course, is decisive, but the connection between space and time is always present. In recent years other photographers have consistently expressed this relationship in their work. Wynn Bullock's approach, for instance, has been fundamentally classic: he seeks the underlying structure of an event and reveals it directly. Space is carefully perceived as a positive volume rather than emptiness, and his exposures may be many seconds long. Never mere records, his work evokes a feeling of space and time that often suggests the basic structure of the universe.

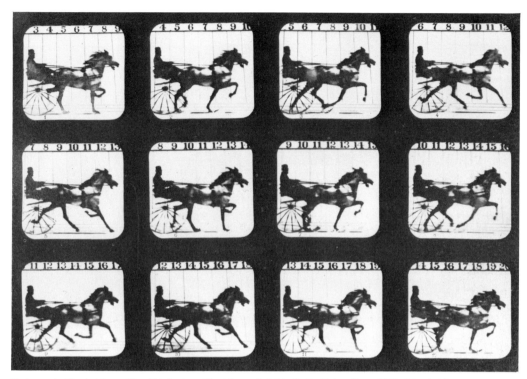

Eadweard Muybridge: Abe Edgington Trotting at 2:24 Gait, Palo Alto, 1878. Muybridge Collection, Stanford University Museum of Art.

Early Experiments

Photographers have been aware of the space–time dimension in their images ever since the long exposures of early daguerreotypes failed to record moving objects, but for the most part they were content to photograph what could be held immobile. Collodion, and later gelatin, with their higher sensitivities that permitted shorter exposures, changed all that, and the pursuit of action began.

Today we recognize Eadweard Muybridge's famous and ingenious photographs of Leland Stanford's trotting horses in 1878 as one of the first deliberate attempts to analyze movement with the camera. He was not the first, however, to have the idea: for five years previous, a French physiologist, Etienne Jules Marey, had conducted similar experiments, but without the aid of photography. Marey immediately recognized the value of Muybridge's work. So did the noted painter, Thomas Eakins, of Philadelphia. Eakins's photographs, made with a device of Marey's design, show his figures outdoors, in sunlight, against a plain, dark background. Successive exposures on the same film did not

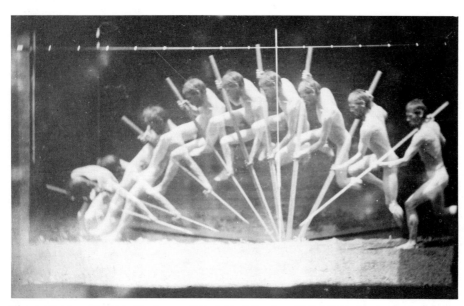

Thomas Eakins: The Pole Vaulter, c. 1884–1885. Collection: Philadelphia Museum of Art.

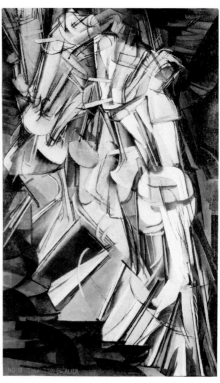

Marcel Duchamp: Nude Descending a Staircase, No. 2, 1912. Oil on Canvas. Philadelphia Museum of Art: The Louise and Walter Arensberg Collection.

fully expose the background, and thereby permitted each momentary position of the subject to be adequately recorded. Other painters used the technique to define their images; Marcel Duchamp painted his famous *Nude Descending a Staircase* from such a photographic study. This same method today lets us reveal a choreography of movement with the simplest camera; a shutter that can be repeatedly cocked and released without advancing the film is necessary, and the camera should be on a steady tripod, but no more complicated equipment is needed.

Many of Muybridge's images, on the other hand, were possible only with equipment of his own design. Early cameras rarely had shutters. Exposures were made by uncapping and recapping the lens, a simple method that was satisfactory until small cameras using fast collodion plates required shorter exposure times. In 1869 Muybridge invented one of the first camera shutters, and by 1878 he had devised a means to make exposures as brief as 1/1000 second. His zoopraxiscope, a projection machine that resynthesized motion from still photographs, led directly to development of the cinema, and he is therefore regarded by many as the father of motion pictures.

Additional significant experiments with time and motion occurred after 1931, when the invention of the repeating stroboscopic lamp made exposures of extremely short duration possible. Examples will be discussed in Chapter 12.

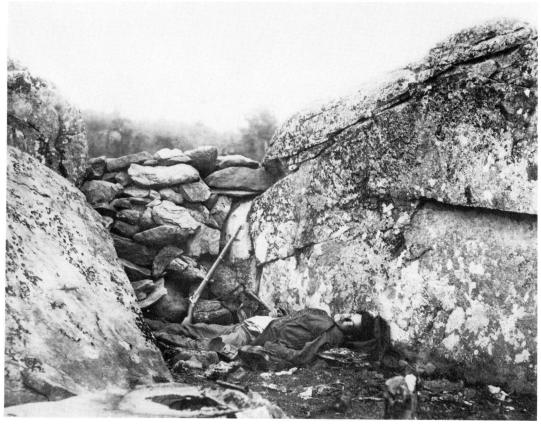

Alexander Gardner: Home of a Rebel Sharpshooter, 1863. The Library of Congress.

The Historic Record

Ever since the first exposure was made, photography has been recording its own progress with a degree of accuracy that historians of other matters have long wished for but rarely obtained. By its own nature, photography can reveal the nature of other things in an exact and convincing way, and its special capability where words seem inadequate is widely acknowledged.

Mathew Brady, as we noted in an earlier chapter, was perhaps the first to realize the importance of the photographic record. He and his operators recorded situations as they saw them, and occasionally, as at Richmond in 1865, their statements became potent revelations of universal truths. We can also sense this quality in Alexander Gardner's record of a dead sniper at Gettysburg. Brutally direct in its cold realism, this is no stereotype of contemporary warfare, as field reports by draftsmen and painters often were. Historian Beaumont Newhall has observed that

This man lived; this is the spot where he fell; this is how he looked in death. There lies the great psychological difference between photography and the other graphic arts; this is the quality which photography can impart more strongly than any other picture making.*

* From *The History of Photography from 1839 to the present day* by Beaumont Newhall. Fourth edition 1964, second printing 1971. All rights reserved by The Museum of Modern Art, New York. Reprinted by permission of the publisher.

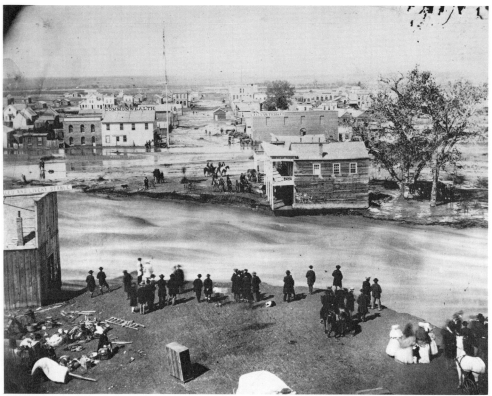

George D. Wakely: Cherry Creek Flood, Denver, Colorado, 1864. The Library of Congress.

After the war, photographers continued to exploit this dramatic recording power of the camera. Gardner, like his associate T. H. O'Sullivan, accompanied railroad survey parties through Kansas and the New Mexico Territory. Other frontier photographers such as L. A. Huffman in the Montana Territory and George D. Wakely in Denver were among the early settlers in their regions. They missed little that was significant in an expanding and rapidly developing area, and were important members of their pioneer communities. For while the camera occasionally was blessed with a perceptive eye under the darkcloth, it was still a tool for the hands of a skilled specialist. The territorial photographer was a special breed.

While these cameramen were recording frontier life in the American West, others were examining the human condition in our urban East. Failure of the Irish potato crop in the 1840s and European revolutions had given impetus to a rising wave of immigration to America in the decades that followed. Photographs sent to the old country by newly settled Amer-

Alexander Gardner: Crossing of the Line at Tecolote Creek, New Mexico Territory, 1867. Collection: The International Museum of Photography.

Jacob A. Riis: Bandit's Roost, 39½ Mulberry Street, New York, 1888. Collection: Museum of the City of New York.

icans showed them to be well fed and relatively prosperous, and so the immigrants came. Many of them settled in New York City, their port of entry, jobless, often destitute, forced to live like animals in unbelievably squalid housing where crime was rampant.

All this seemed unnecessary and intolerable to Jacob Riis, a police reporter for the New York evening *Sun,* who covered the tenements and their misery. Riis knew these ghettoes well since he had come as an immigrant himself in 1870. In a now classic illustrated book, *How the Other Half*

Lives, published in 1890, he campaigned effectively for housing reform. His photographs, crudely reproduced by an early photomechanical process, were revealing and compassionate.

Lewis W. Hine, a photographer who was also trained as a sociologist, had a similar concern for human welfare. In 1908 he undertook a crusade with his camera to expose the exploitation of children by American industry. Hine's determined effort aided the passage of child labor legislation. Later he photographed extensively for the American National Red Cross.

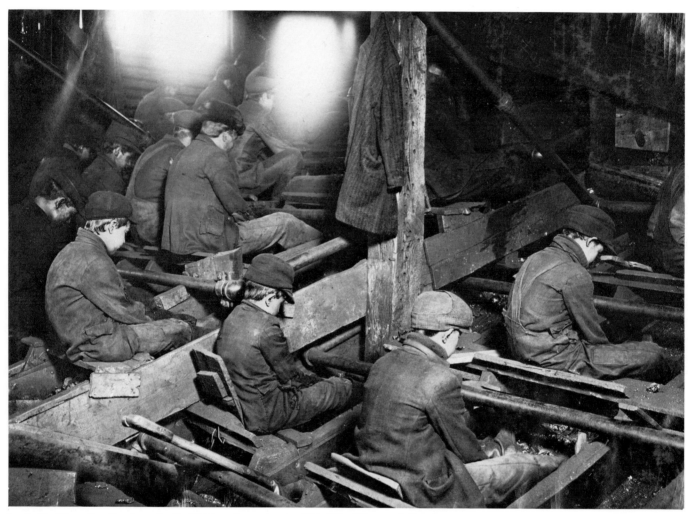

Lewis W. Hine: Boy Breakers, South Pittston, Pennsylvania, 1911. The Library of Congress.

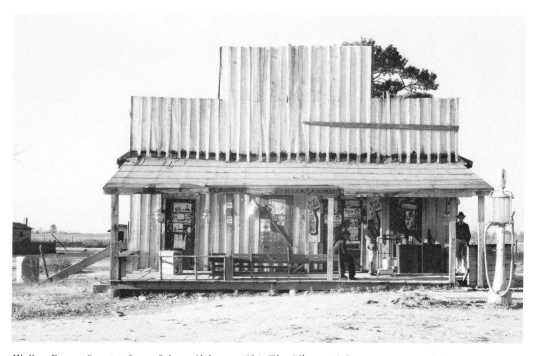

Walker Evans: Country Store, Selma, Alabama, 1936. The Library of Congress.

Documentary Photography

No one called these pioneers of the reportorial approach *documentary* photographers, but the idea was well-established by the early thirties when America's great depression was being felt across the country. Thousands of small farmers were forced from their land by falling prices, growing mechanization, and record drought. As dust storms swept the plains, the Department of Agriculture in Washington began a controversial program to relocate these dispossessed people. In those days federal aid was not looked upon as a cure-all for society's problems; urban people, particularly, had to be convinced that a massive effort was needed.

To do this persuading, the Farm Security Administration formed a team of 13 top-flight photographers under the direction of Roy Stryker, then a Columbia University economist. For seven years these men and women assembled one of the most remarkable documents of the human condition that has ever been produced by any government. That collection, now in the Library of Congress, is a classic example of how photographs can convince.

Many of the photographers on the FSA team have since become legendary. There was Walker Evans, whose sensitive portrayal of both the rural South and the urban Northeast revealed the dimensions of the problem. Arthur Rothstein, who showed the

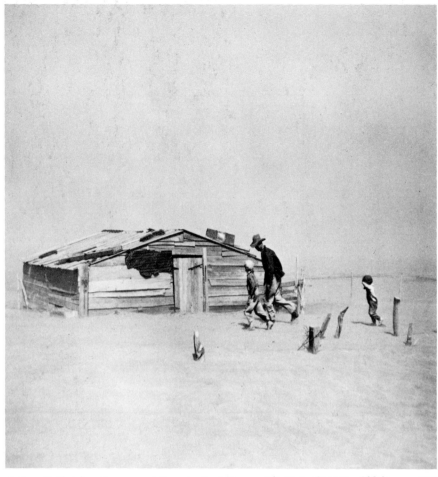

Arthur Rothstein: *Farmer and Sons in Dust Storm, Cimarron County, Oklahoma, 1936.*
The Library of Congress.

need for soil conservation, later became director of photography for *Look* magazine. The nomadic people that Dorothea Lange so compassionately photographed in California were the source of John Steinbeck's great novel, *The Grapes of Wrath.* But for all the power and conviction of their images, Steinbeck and Lange only defined the problem and pointed the way. Mechanically, great strides have been made, but the farm boycotts and strikes of the sixties and early seventies attest that in human terms the solution has been slow to mature.

Today we see these documentary photographs in a different light. They cannot withstand the pervasive im-

mediacy of the constantly talking and moving television image. And today, of course, we're more mobile: we've seen more of our world and understand it much better. Riis photographed a community of squalor just a few miles across town and it was a revelation. The plight of Walker Evans's southern sharecroppers and Dorothea Lange's migrant farm laborers in California and the West must have seemed equally unreal to eastern city dwellers. In our modern world of instant communication, we've become inured to "eyewitness" accounts, but this does not diminish the value of these pictures in their own time. They were forceful then, and are exemplary

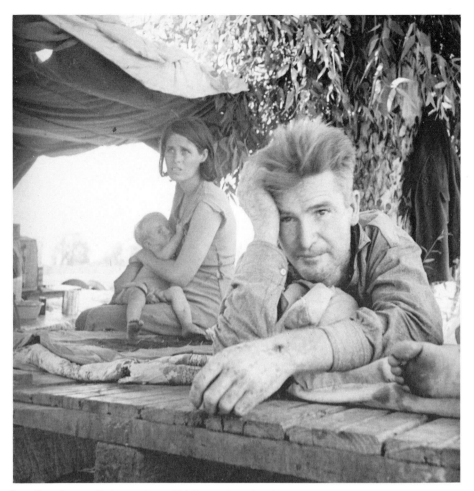

Dorothea Lange: Refugees from Oklahoma Camping by the Road, Blythe, California, 1936. The Library of Congress.

now, because they represent a compassionate and dignified point of view. These same qualities again guided Stryker when he recently selected nearly 200 of these pictures for a remarkable book, *In This Proud Land.*

The idea behind such pictures has again been revived by the United States government, this time to document the environment that we are rapidly polluting. More than 40,000 color photographs have been collected by the Environmental Protection Agency and assembled into a computerized picture library for public use.

The documentary photographer, then, is first of all a realist with a point of view. Whether that perspective is sympathetic or antagonistic has nothing to do with photography. That outlook depends, rather, on what the photographer himself brings to his subject, on his basic intelligence, his education, and on his ability to perceive and interpret the situation before him. A documentary photographer seeks understanding, not art; honesty, not objectivity. Photographs have always *looked* believable, but an honest photographer can try to enhance them with the dignity of truth, and a dedicated one can imbue them with a sense of purpose. This is a challenge and a responsibility of the highest order.

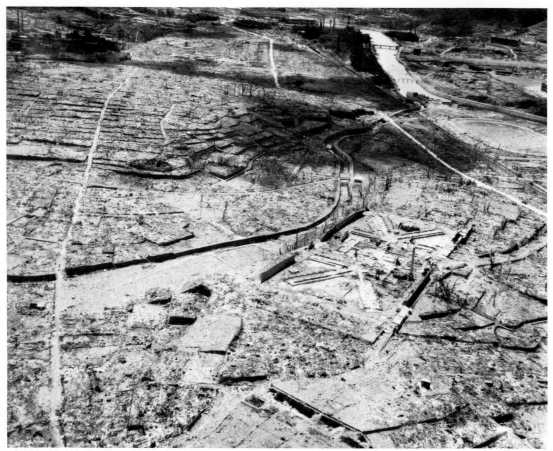

George Silk: Nagasaki, 1945. *LIFE Magazine* © *Time Inc.*

Photojournalism:
The Picture Story

Each photographer on the FSA project responded to a particular situation in his own way. He tried to interpret what he found, knowing that the story was far greater than he alone could tell. It remained for others, then, to relate the pictures and assemble a narrative from them.

Essentially, the *picture story* is **a** sequence of images produced and selected according to a predetermined plan. Although it evolved from the documentary work of the thirties, the picture story was brought to a focus by the editorial direction of two great magazines, *Life* and *Look,* which ap-

peared in the middle of that decade. As the concept matured, it was given a name: *photojournalism.*

To Wilson Hicks, executive editor of *Life* during its formative years, photojournalism was "good headlines plus good photographs plus good captions," and the crux of the matter was how they all were put together. The key to successful picture stories, as *Life* was to demonstrate again and again, was *planning the essay in advance.*

The photographer's outline for a picture story is known as a *shooting script,* usually researched and prepared by the editors before assignment of the story. It keeps the photographer close to the story line and

thus helps establish a series of *related images*. It also helps insure adequate material for a cohesive unit with a beginning, a middle, and an end.

Actual shooting may involve dozens or even hundreds of exposures as the photographer interprets the story line and searches for those elusive moments that lay it out yet bring the story together. After processing to contact sheets, the pictures are *edited* to select the most important images from the lot, and to sequence them for effective presentation. The result is a photographic essay, or picture story.

Perhaps there are no innately finer examples of the photographic essay than the three classic stories for which W. Eugene Smith has become justly famed. First of these to appear in *Life* was "Country Doctor," published on September 20, 1948. The photographer depicted a typical day for Dr. Ernest Ceriani, a general practitioner in a small Colorado mountain village.

On April 9, 1951 came "Spanish Village," one of Smith's finest achievements. After long preparation and study, he traveled dusty Spanish roads for a month and a half in search of a balance between the medieval and the modern, individual aspirations and political realities, and the riches of a simple people in the midst of poverty.

Smith's own favorite essay was his sensitive and moving portrayal of Maude Callen, a black midwife in the backwoods of North Carolina. "Nurse Midwife" was published on December 3, 1951. This essay, says Smith, "was the most rewarding experience photography has allowed me." Like "Country Doctor," "Nurse Midwife" is a warm, intensely human statement.

Other Printed Media

Consumer magazines such as *Life* and *Look* are gone, victims of a fundamental change that television and shorter working hours have produced in our buying and reading habits. The photographic essay, however, is still very much alive. Today it appears in hundreds of special-interest and limited-circulation publications, each tailored to a more select and responsive audience. Each of us is familiar with some of these: *Playboy, National Geographic Magazine, Sunset, Yachting, Woman's Day,* to name just a few of the more successful ones devoted to leisure time, regional, and special interests. The list also includes hundreds of corporate news publications (house organs, annual reports, and customer relations pieces) such as *TWA Ambassador, Small World* (Volkswagen), and *We* (Western Electric Co.).

Reportorial photography is much in demand by other printed media too. Greeting cards, posters, and record jackets represent a market that is accessible to the beginning photographer as well as the established professional.

The basic believability of direct and reportorial photography has accounted for an increasing use of these approaches in advertising illustration. In the studio, of course, the photographer still can arrange all the elements of his picture, but once outside that studio he is generally inclined to work with the world as he finds it. Thus the difference between editorial and advertising photography, once readily apparent in the pictures themselves, today can best be discerned from how those images are used.

Electronic Media

In recent years the printed picture has been seriously challenged by the electronic one. Television, for example, has shown itself to be the ideal visual medium for quickly responding to news events: it can be immediately transmitted to its audience. And the TV image is a moving image; it is super-realism, conveniently packaged and delivered to the home. When competently presented it *compels* attention.

TV is a superb delivery system, and its ability to market goods and to entertain has been amply demonstrated. But the TV image, as customarily broadcast, is fleeting; it must be grasped in an instant, and except for commercials which are deliberately repeated, cannot as a rule be restudied until its meaning becomes clear. There simply isn't time.

Television's ability to quickly respond, however, does not have to be its Achilles' heel. Electronic media can not only keep their images moving but can also store and recall them on demand. Such flexibility has tremendous implications for the educational process, and television journalism frequently uses this feature to explain complex or rapidly breaking news events. The *instant replay* has become a part of our language.

Television is rediscovering the still photograph, too. TV's technology usually makes its presence obvious, and thereby exerts an influence on the event it reports merely by being there. Still photography is less intrusive; its technology often allows the photographer to blend into the scene, or to

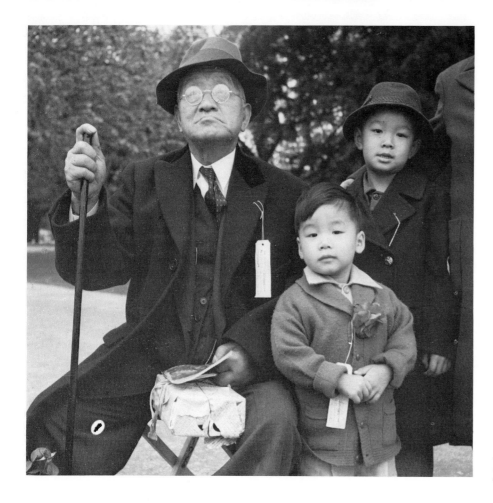

Dorothea Lange: Japanese Americans Awaiting Relocation, Hayward, California, 1942. War Relocation Authority Records in the National Archives.

observe it while remaining unobserved himself. Remember the 1968 presidential election? Television reported both conventions and their related events in its characteristic manner. It caught balloons and ballyhoo, riots and speeches, delegates and candidates—even the voting—with the quick glimpse, the long shot, and the brief interview. Yet one of the most penetrating coverages on television was a program assembled entirely from a series of stills by veteran combat photographer David Douglas Duncan, who was able to catch significant human aspects of the whole process that live TV could not reveal. The picture magazine format also has been borrowed by television: programs such as "Sixty Minutes" and "First Tuesday" group several short but substantive

visual stories together in a manner familiar to magazine readers.

The enormous complexity and expense of the mass media, both printed and electronic, impose certain restrictions on anyone using them. The photographer and filmmaker must contend with government regulation of the public airwaves presently required by television broadcasting; they may sometimes be required to chart a course between their own honest response to a controversial situation and what the regulated media will permit them to show. Magazine photographers, too, have long complained about editors who butcher their stories to fit space that is controlled by advertising budgets. But advertising sales reflect readership, and readers choose a magazine for its editorial content,

not its ads. All who work with the printed media must understand this important relationship.

Exhibitions and Books

Faced with these restricting aspects of the mass media, photographers are predictably turning more and more to exhibitions and books to convey their personal views to the public. David Douglas Duncan, for instance, photographed *I Protest!*, his moving and impassioned dissent from American involvement in the Vietnam war, during eight days of the siege at Khe Sanh in February, 1968.

Equally compelling is the photographic essay recently assembled by

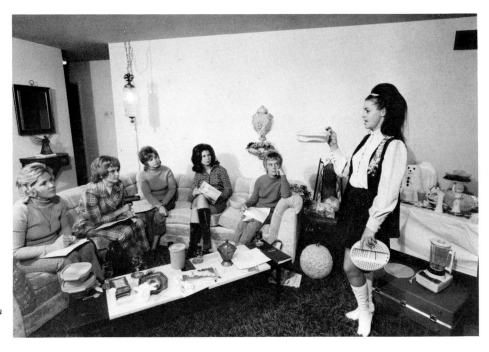

Bill Owens: Tupperware Party, 1972. From Suburbia.

Maisie and Richard Conrat from the records of an earlier war to retell a long-hushed story of injustice and fear. Executive Order 9066, which resulted in the internment of 110,000 Japanese-Americans in 1942, was an affront to the Constitution and an outrage to the people it victimized. It will forever be a blemish on the conscience of this country. Two exhibitions made from the photographs in the book brought the guilt-ridden message to an even wider audience.

On the other hand, Bill Owens's book, *Suburbia,* gives us a penetrating look at ourselves. It's so direct and uncompromising that viewing its pictures at times is a painful experience. But the book is impeccably honest: Owens let the people in it speak for themselves.

There seems to be little doubt that future dissemination of printed media will increasingly be by electronic means, but that does not mean that paper is obsolete. Is there any form of printed communication more convenient than a book or magazine? It gives us a permanent rather than a transitory impression, and we don't need electricity or a machine to look at it: books and magazines go anywhere. Furthermore, we can read faster than we can speak or listen to the spoken word, and a good photograph can be "read" in a fraction of the time that an equivalent verbal description would take. Ink-on-paper communication, then, will continue as an indispensable cultural force, and reportorial photography in its various forms will remain a vital part of it.

Minor White: Peeled Paint, 1959.

Photographs have long been used in place of the real objects they represent, and whenever we substitute them for actual things in this way, those images function as convenient windows to the external world of objects, events, and experiences. But while a photograph portrays the real, the physical, it can simultaneously stand for something else, such as an emotion or idea. While showing us an impression of one object or event, it can represent a feeling about an altogether different experience. In other words, while it *signifies* one thing, it can *symbolize* another.

In the *symbolistic approach* we give the photograph this dual role. This approach communicates a visual impression of the real world as other approaches do, but more significantly, it *also transforms* that impression to convey another, quite different meaning. In this latter regard the photograph functions as a catalyst: it makes possible a change through it without becoming altered itself in the process.

The Photographic Metaphor

Most of us are familiar with a device in literature called the *metaphor*. We use it there to speak of one thing as if it were another, unrelated thing: "Beauty is a witch," wrote Shakespeare, "against whose charms faith melteth into blood." Or "all the world's a stage." Words, of course, are one kind of symbol, and if they can be used in this manner, photographs—another kind of symbol—can too. The photographic metaphor may be less familiar to us, but it functions the same way as the literary one does. It operates as if it were something else: the picture becomes a *symbol* of something unrelated to it.

Minor White's photograph of peeled paint is direct and arresting, but it probably holds little interest for us as a factual record. Instead we are more likely attracted to it by the tensions that it so strongly portrays, and by the conflict represented through light and dark elements brought so carefully

into balance by the photographer's perceptive eye. The photograph speaks of things that are durable yet perishable; it symbolizes intensely human qualities while showing us a bit of insignificant reality. Although it seems to be saying several things at the same time, its emotional message—what it says about feelings—is more engaging for many viewers than its record— what it conveys about facts.

For all its symbolism, however, this photograph is still an image of peeling paint, devoid of color. Whatever *else* it conveys to us must depend, in large measure, on what each one of us who looks at it brings to that encounter. Perhaps the image will remind us of certain experiences in our own past. What we find in the picture, of course, will condition our response to it: just as different people do not see the same things in an inkblot, each of us reacts to the experience of this photograph in our own way because we don't get an identical message from it. *The transforming role,* then, *occurs not in the photograph but in the mind of the viewer,* who thereby becomes an essential element in equating the image with its symbolic message.

Perhaps we're more accustomed to looking for such symbolism elsewhere. Painters and sculptors, of course, have employed it since ancient times, and from the early twentieth century on they have been submerging detail and identity to reveal underlying truths. But photographers slowly realized that they, too, could see beneath the surface. In nineteenth-century camera work, symbolic vision was extremely rare: a few of Brady's images, such as the *Gallego Mill Ruins at Richmond* (Chapter 2), seem to possess this attribute. In the early twentieth century, however, it gradually emerged.

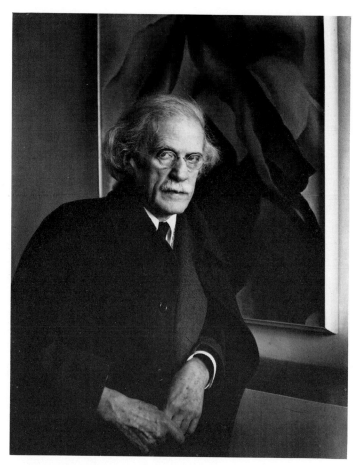

Imogen Cunningham: Alfred Stieglitz, 1934.

Alfred Stieglitz: The Equivalent

The first to champion such an approach, almost single-handedly, was Alfred Stieglitz. On a voyage to Europe in 1907, he tired of the steamship's first class company and one day chanced upon the forward end of the upper deck. There he looked down upon the steerage, where passengers paying the lowest fare were herded together like cattle. In the interplay of shapes between the funnel and stairway, straw hat and winch, mast and suspenders, Stieglitz sensed a *picture* charged with emotion. Rushing back to his stateroom for his camera, he returned to find all as he had left it, and exposed his plate. His resulting picture, *The Steerage,* is one of the great humanistic statements in photography, but it is a much different image than Lewis Hine (Chapter 8) might have made. Hine *documented* human values; Stieglitz's photograph *symbolizes* them.

In subsequent years, Stieglitz's portraits attracted much attention because they were direct and unaffected, simple and honest. Some critics who knew him accused Stieglitz of hypnotizing his sitters; in response he photographed clouds to see if he could express his feelings through them. Stieglitz called these cloud photographs *equivalents.* Through their shapes and tones he tried to reveal some of his innermost feelings about life, and when others who had not shared his original experiences were able to get a similar feeling from those photographs, Stieglitz knew he had succeeded.

With his photographs of clouds, then, Stieglitz demonstrated what many others have subsequently rediscovered: that if we can respond as

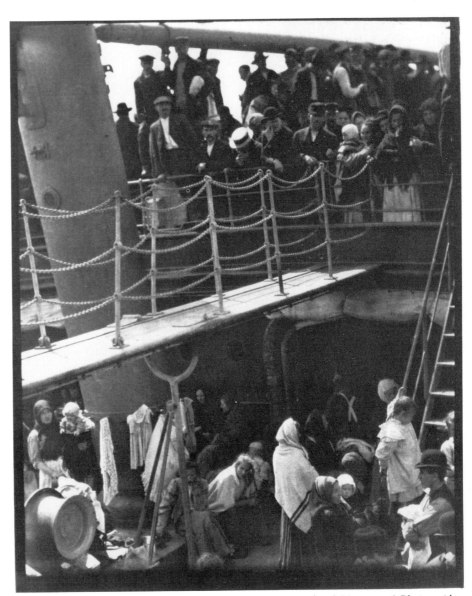

Alfred Stieglitz: The Steerage, 1907. Collection: The International Museum of Photography.

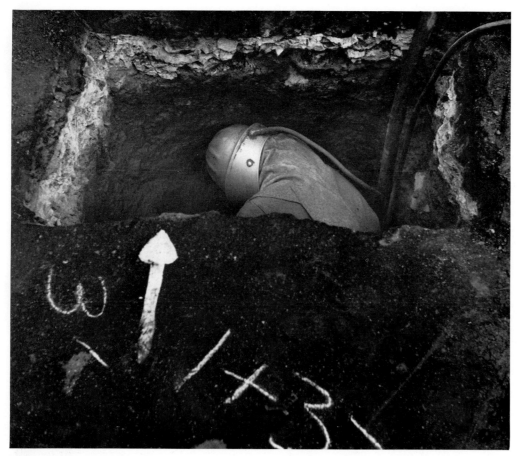

Minor White: Sandblaster, 1949.

photographers to the objects and experiences we bring before our camera, and transform what they mean to us through equivalency, then we can also respond as *viewers* to a photograph and transform its meaning in the same way. Moreover, almost anything we find can be used to make a photographic metaphor. If the object or its image seem to suggest an idea otherwise unrelated to the actual object, then the transformation is possible.

Minor White, in his writing and teaching, has suggested that there are various *levels* or degrees of equivalence at which photographic images can function. His photograph of a sandblaster at work in a street excavation is not only a factual statement—a record—but simultaneously and spontaneously is an arrangement of visual symbols full of unanswered questions. What manner of man, for example, hides within the mask? Is he rising from the matrix of the earth, or descending into a bottomless pit? What

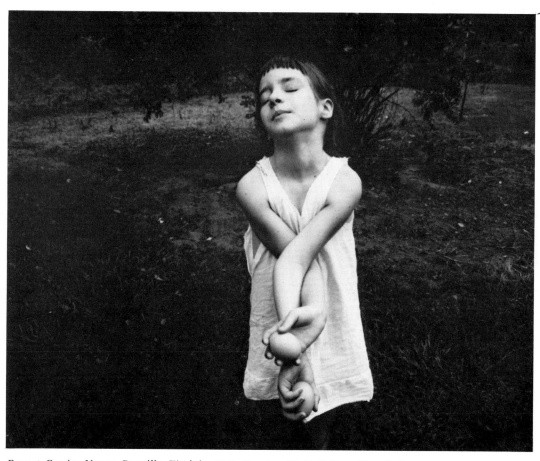

Emmet Gowin: Nancy, Danville, Virginia, 1969. Courtesy Light Gallery, New York.

does the arrow point to? All these elements and others—the dark pavement, our focus on the helmet, the camera's tight framing that only intensifies our enigmatic response—contribute to the unquestioned ability of this image to function as an *equivalent*. Here is a photograph made of a moment, perhaps to fill an emotional need arising from the chance encounter of an object and an image in the mind of a photographer.

Emmet Gowin is another photographer whose images often function on several levels. His photograph here, for example, evokes not only a child's playful innocence but also a deep reverence for life. Gowin is able to combine the spontaneity of a snapshot with an intensity of feeling that can only come from a deep and honest involvement with the people in his pictures. If we can recognize a parallel experience in our own life, then we can easily get emotionally involved with his images.

Carl Chiarenza: [untitled], c. 1959.

The Photograph as a Mirror

Whenever we identify with a picture and feel our way into it like this, we transfer a bit of our own personality to it. So it isn't surprising that *a photograph functioning as an equivalent acts to some degree as a mirror in which we see ourselves.* We're likely to sense this in any picture with which we can easily get involved, and realism generally helps. Test this idea with photographs in the previous chapter, especially those by Dorothea Lange and Bill Owens. See if you can empathize with them and briefly become one with their subjects.

Such emotional involvement also can occur with pictures whose arrange-ment or design dominates their subject matter. Carl Chiarenza, for example, has utilized evaporated chemical crystals to produce a graphically powerful image that transcends its source to suggest other associations. Minor White's photograph of a snow-bound garage in Chapter 14 exhibits a multiplicity of tensions and symbolistic meanings that have nothing to do with either snow or garages. Many people respond to Aaron Siskind's recent photographs (here and in Chapter 14) as they would to similar forms in paintings. This does not deny the subject matter of these photographs, but it indicates that the suggestive power of their forms is equally as strong as their visible facts.

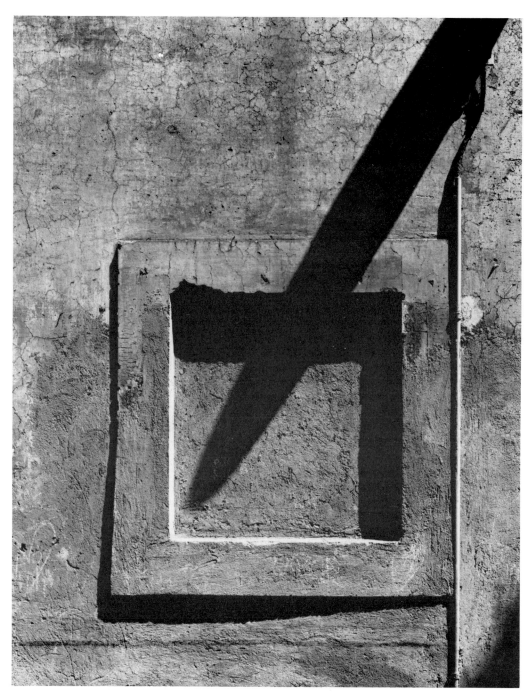

Aaron Siskind: Rome 30, 1967.

Michael Bishop: [untitled], 1971.

This points up another value of the *equivalent* to the expressive photographer: its power to evoke a response about something that *cannot* be photographed through another thing that *can*. Many contemporary photographers whose work appears in these pages have demonstrated this capacity of the photographic image. Michael Bishop, for instance, brings together unrelated *objects* with different visual characteristics and functions. His photographs give us a fresh viewpoint on the human dimension of man's increasing dependence on a complex technological world.

Jerry Uelsmann, on the other hand, combines symbolic *images* to construct a world of fantasy all his own. Uelsmann is no apologist for photography's insistence on a foundation of realism. Instead he not only acknowledges this base but also employs its suggestion of authenticity to intensify our involvement with his fantastic world. Even if we feel like strangers in his world, we cannot ignore it. Uelsmann's way of working is briefly outlined in Chapter 10.

Sometimes a photographic image is unrecognizable, perhaps presenting us with something that we have not experienced in our own life. It may seem a bit adventurous, but can we not find it possible to get involved with such a picture by inventing a "subject" for it? Perhaps we can do this with Oliver Gagliani's image from Crockett, California (Chapter 14), and call it "mysterious figure," even though its actual subject matter is something entirely different. Or we may try this procedure on other photographs in the book, such as those by Henry Holmes Smith, to see if they increase our awareness of ourselves. Whenever we

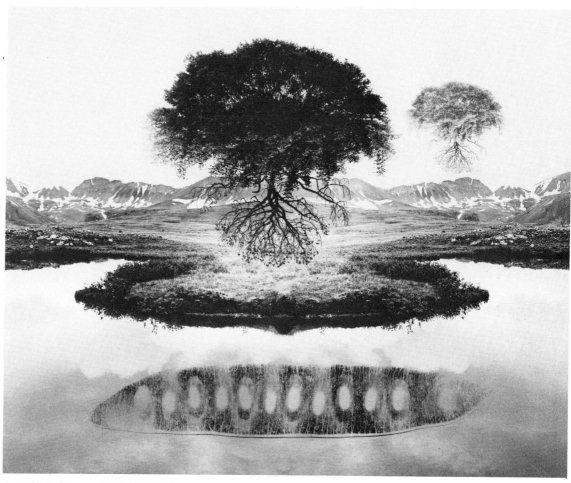

Jerry N. Uelsmann: [untitled], 1969.

assign a subject identification to an image that does not suggest its own to us, we're bringing *what we want to see* to the picture, and are using it to mirror ourselves.

As an additional experiment, look intensely at any of the photographs in this chapter, or at any other image in the book that seems to "turn you on." As you live with it for a few minutes, make a list of whatever that image suggests to you, and describe in a few words, if you can, how it makes you feel. Then show the list to a friend who knows you well, but who has not seen the photograph. Ask him to evaluate how closely your list seems to sketch your own personality as he perceives it to be. The correlation may be surprising.

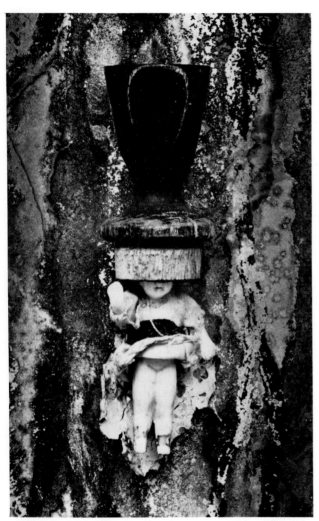

Frederick Sommer: All Children Are Ambassadors, 1950. Courtesy Light Gallery, New York.

Contemplating Our Work

If a photograph can mirror its viewer, it can also reflect the feelings of the photographer who made it. Photographers, after all, usually view their own pictures before other people get to see them, and for many contemporary photographers, repeated contemplation of their own work is a vital part of the discovery process inherent in it. Only through such study of the evolving image, they believe, can deeper meanings be perceived and communicated. Such a process helps to break down the mental and emotional separation between us and the photographs we make; it may help us gain maximum involvement with an image, but without losing ourselves in it altogether. This sole reservation is an important one, for part of our pleasure from any photograph comes from knowing that in reality, it *is* a photograph, not only *before* it is *anything else,* but also *after* it has become *everything else.*

What ultimately separates the expressive photograph from the mere record, then, is what also makes a sensitive musical performance different from a mechanical reading of the score. It's the same thing that makes literature stand apart from mere writing, and poetry a special form of both. There may be no single word that adequately describes this essential difference, but one that Alfred Stieglitz used certainly comes close: *spirit.*

Whatever we choose to call it, *spirit* is the moving force behind the photographic experience that we call *equivalence,* and its evocation is therefore essential to the symbolistic approach.

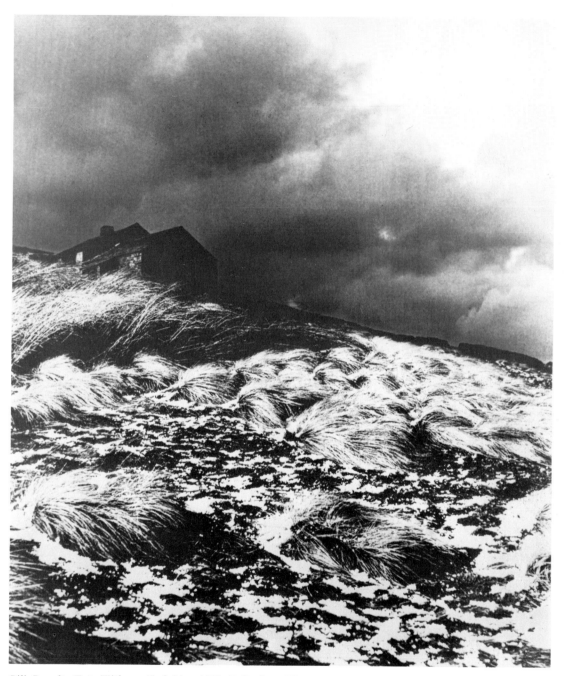

Bill Brandt: Top Withens, Yorkshire, 1945. Collection: The International Museum of Photography.

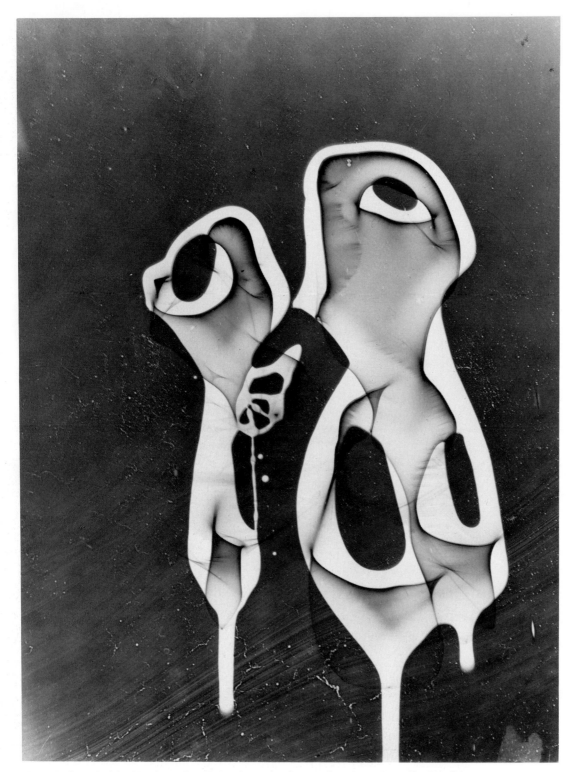

Henry Holmes Smith: Meeting, 1972. Refraction print in negative. From Portfolio II, 1973,
Center for Photographic Studies, Louisville, Kentucky.

184

In the preceding chapters we discussed several attitudes about making photographs that have become fundamental to contemporary work. All involve visualizing subject matter that is broadly based on a personal yet realistic view of the world, and all make general use of the conventional silver bromide print. The direct approach, for example, is concerned with interpreting the *essence* of subjects, the heart of the matter, as intensely as visualization, tools, and materials will permit. Reportorial photography extends our interpretive effort to include the *context* of subjects in space and time. It includes a frame of reference and a point of view, and it concerns how our photographs and their factual content consequently affect those who see them. And then there are symbolistic photographs, which have a dual role: they usually represent their subject matter, but more importantly they also stand for *other* subject matter or ideas at the same time. And they may require a viewer to study them

with care (some call this "reading" a photograph) before the photographer's idea comes across. Nonetheless, such a photograph remains a factual statement, in other words, a *picture of* something, whatever its more compelling message may be. And even that most common photographic image, the snapshot, essentially is a momentary record of a relentlessly factual world.

Increasingly in recent years, photographers have refused to be bound to what some have called this "tyranny of visual facts." They have recognized that although the camera is a superb device for recording visual information, it can be employed for other kinds of imagery as well. A photograph typically resembles a bit of reality, but that resemblance may be quite obscure and unimportant. Indeed, photographers have convincingly argued that whatever resemblance to reality we see occurs, at most, only to a degree, and that in any case, a photograph does not recreate the real world at all.

Away from Realism

Given this reasoning, then, it is not surprising that photographers have sought opportunities to move away from this grip of realism and find other modes of expression that are less stringent yet still photographic. The images created are less representational but are still made by the action of light on a surface that is sensitive to it.

The methods most frequently used seem to radiate in three general directions from the conventional image. One inclines toward *combining images* to produce new visual statements. This group of variations includes such well-known methods as multiple exposures and the combination of separate images, both negative and positive, into a silver bromide print that ultimately is a visualization of the photographer's imagination.

Another general trend leans toward *eliminating* the *detail* and familiar *tonal scale* that are the conventional

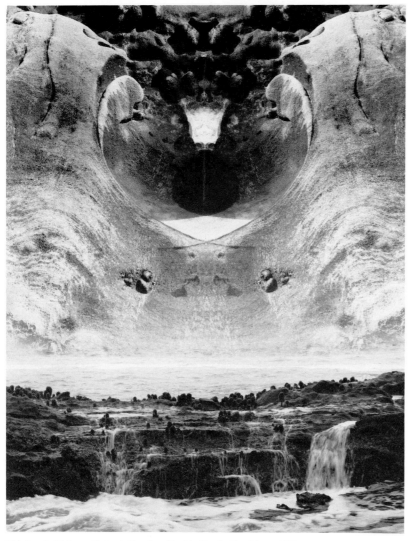

Shirley I. Fisher: Out of the Cradle, Endlessly Rocking, 1970.

photograph's stock in trade. This is done by reducing the gray scale to a few arbitrary steps, by eliminating all tones except black and white, by producing a negative image where we would ordinarily expect a positive one, or by greatly exaggerating the grain structure of the film, thereby reducing the amount of detail it can record.

A third direction includes numerous other methods that *do not yield a conventional silver image* as a final product. Among these processes are the cyanotype (or blueprint), gum bichromate, photographic screen print-

ing, and xerography. In addition there are many others.

Each of these methods retains some characteristically photographic advantages. For example, the basic image can be formed quickly and accurately by a camera, and the final print can easily be duplicated. All are at least as permanent as the silver image, and most produce some elimination of detail. But each of these methods offers other advantages too. Cyanotype, gum bichromate, and photo screen printing allow the introduction of *color* to the photographic picture while retaining

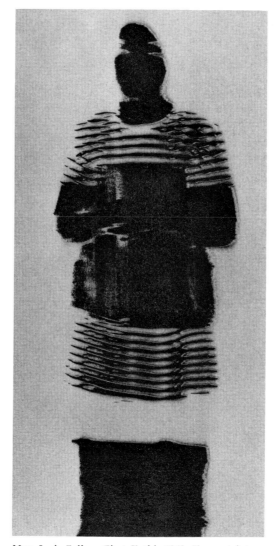

Max J. A. Fallon: First Kathi, 1968. Xerox print.

the simplicity of black-and-white processes. Screen printing lends itself to bold colors, while gum printing permits a softer, more pastel palette encompassing an entire spectrum. And whereas conventional photography is pretty much restricted to paper and film-base materials, the non-silver processes mentioned here can be used on other material such as fabrics, wood, and metal. This opens the way to combine the photographic image directly with other art forms such as painting and sculpture.

Many of these techniques and processes are freely combined with each other. This makes possible a bewildering variety of contemporary methods, and from this mixture of photographic media anyone can select a means of image making that appeals to his own subjective and technical interests. In this chapter, then, we'll discuss those various diversions from realism that are simple enough for anyone to attempt with a foundation of the work discussed in previous chapters of this book. Few of the methods outlined here are new, but all of them are enjoying renewed popularity.

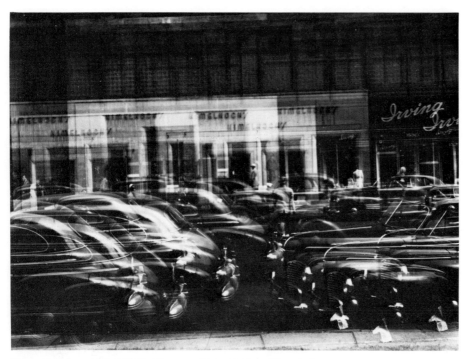

Harry Callahan: ME 4, 1943. Courtesy Light Gallery, New York.

Multiple Images

Multiple images, like other types, have been made for almost a century. The photograph by Thomas Eakins in Chapter 8 pointed the way. Several successive exposures of objects against a dark background can be planned and made on the same frame of film. If the images overlap each other very little, a full, normal exposure can be given each one. If much overlapping is intended, however, try giving each image half or a third of its normal exposure, and if the resulting negative is too low in contrast, repeat the process but develop the film 50 percent longer than before. A little experimenting will acquaint you with the variables involved.

Multiple exposures lead to images that are uniquely and unquestionably photographic. Imogen Cunningham's photograph in Chapter 1 of the poet and filmmaker, James Broughton, demonstrates this potential. Harry Callahan, who has explored multiple exposures perhaps as much as any other photographer, retains in them the classic simplicity and elegance that characterize so much of his photographic work.

Multiple images can also be produced by combining several images to form a single print. The most celebrated contemporary photographer who works in this manner is Jerry N. Uelsmann. While acknowledging our predisposition to directly made photographs that are visualized before ex-

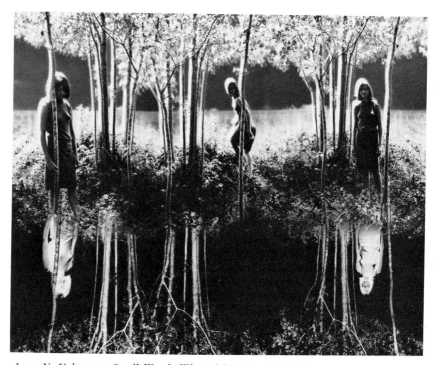

Jerry N. Uelsmann: Small Woods Where I Met Myself, 1967.

posure and produced by a standard technique, Uelsmann views the darkroom as a "visual research lab, a place for discovery, observation, and meditation." He terms his method *postvisualization,* insisting that the photographer remain free to revisualize his image at any point along the way to its completion. This way of making photographs combines the analytic methods of conventional photography with the synthetic ones of painting and drawing: images made initially by selective elimination through the camera are then revisualized and combined through an elaborate printing exercise. Several enlargers may be used, with each negative set up separately and masked or shaded so that only desired areas print.

In *Small Woods Where I Met Myself* we can see how Uelsmann works. The initial images portray a woman. She was photographed three times, each time in a different position, in the shade of a small clump of trees. These three images were then combined side by side into a single picture. A dense, negative (tonally reversed) image of this combined state was then made and flipped top to bottom. On this image, the central figure was blacked out (by a local exposure to light); with only two figures and some trees remaining, it was added to the print below the three-figure positive exposed earlier. Finally, a less dense, tonally reversed image of that same earlier state, somewhat out of focus and carefully offset with regard to the

three-figure image, was printed in the blank white spaces between the trees in the upper half of the combined picture.

Any such analysis of Uelsmann's complex method risks overlooking the more personal and vital component of his photographs, and that, of course, is his superb imagination. For his is the vision of a fantast, admirably served by his skillful use of the photographic process. Few photographers have so thoroughly experimented with as many aspects of the medium as he has, while developing from that total experience a personal, dynamic style.

While Uelsmann's vision is unmistakably his own, his basic technique was demonstrated by Oscar Rejlander and H. P. Robinson in England more than a century ago. Rejlander's famous Victorian tour de force, *The Two Ways of Life,* was printed from more than 30 separate negatives. That allegorical scene contrasted sensual delight on the left with industry and charity on the right, and appears to have taken its graphic inspiration from Raphael's sixteenth-century *School of Athens* in the Vatican. Robinson's later pastoral scene is less ambitious—only three negatives were combined—but equally a tableaux. Such artifice was painterly but popular in its own time, and it stirred P. H. Emerson to argue for a more direct and natural approach to photographic work (Chapter 7).

The freedom to construct non-representational images that is inherent in *combination printing* and *photomontage* work has appealed to numerous contemporary photographers. Shirley Fisher, for example, combines differences in scale and perspective with a homogenous tone. Allen Dutton's pho-

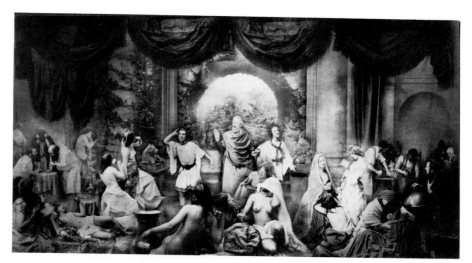

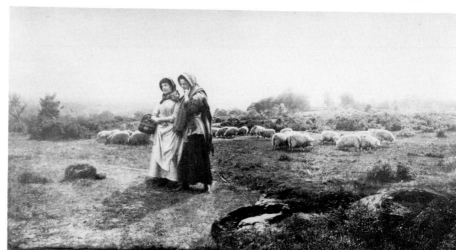

Oscar Rejlander: The Two Ways of Life, 1857. Royal Photographic Society Collection, London (top).

Henry Peach Robinson: Caroling, 1887. Lent to the Science Museum, London, by the Royal Photographic Society (bottom).

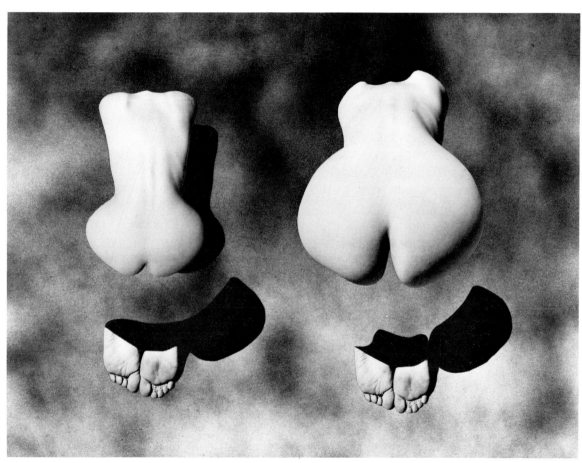

Allen A. Dutton: Photomontage, 1970.

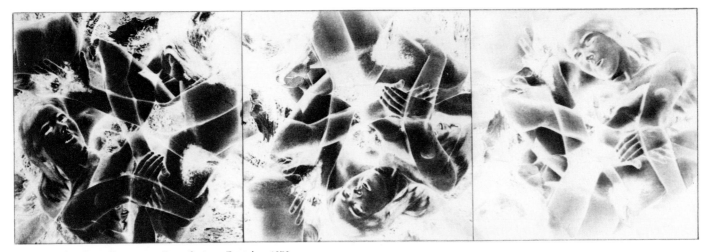

Robert Heinecken: Erogenous Zone System Exercise, 1972.

tomontage functions on a less complex graphic level, but it is equally a bit of fantasy. The worldly, yet other-worldly appearance of images like these demonstrates that photography can, indeed, move beyond the confines of realism to include the surrealistic as well.

Robert Heinecken, whose work and teaching have influenced a great number of younger photographers, has demonstrated the visual possibilities of *found objects* used as "negatives" to expose the final image. For example, he has discovered a new order in superimposed, unrelated images that occur back to back on magazine pages. Their positive-to-negative tone reversal removes them farther from their sources and gives them stronger identities. Heinecken refuses to take seriously any definition of photography that erects limitations on the medium, preferring instead an open-ended rationale and the wider area for continuous exploration and discovery that it gives him.

Ray K. Metzker uses yet another combining method to assemble his large images from carefully related smaller ones. His composite photograph of a nude, measuring 75 by 38 in. (190 by 96.5 cm), creates a dynamic design by bringing together numerous high-contrast images. The resulting photograph contains only three tones: black, white, and a single shade of gray where the others overlap.

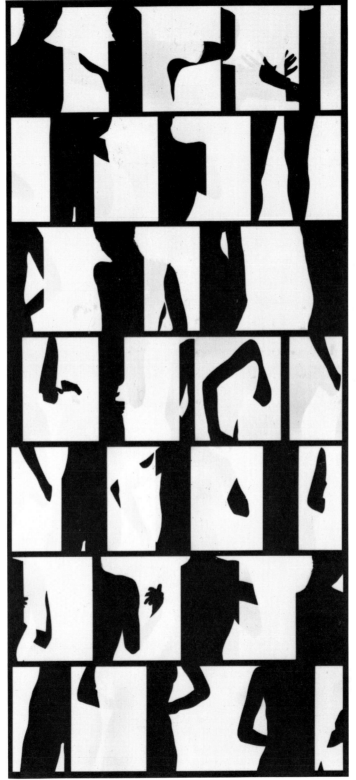

Ray K. Metzker: Nude, 1966. Collection: Dr. and Mrs. Harold Schwartz.

High Contrast

Not all diversions from conventional photography need to be complex. One of the simplest of all is the high-contrast image or *dropout,* so called because gray tones are dropped out or eliminated, leaving only black and white. The photograph here by Barbara Crane, and Harry Callahan's *Eleanor* in Chapter 5 are examples.

Special films, obtainable from most photographic dealers, can be used to obtain this effect. For 35 mm cameras, Kodak High Contrast Copy Film is available in familiar 36-exposure cartridges and also in long, bulk rolls (the latter must be cut and loaded into reusable cartridges in a darkroom). This film is panchromatic—sensitive to all colors of light—and must be loaded into its developing tank like other pan films, in total darkness. Its ASA rating is 64. It should be processed according to the instructions supplied with it; Kodak D-19 developer is recommended.

With other types of rollfilm cameras, the photograph should be taken on any ordinary panchromatic film and developed in the usual manner. It can then be transferred to a high-contrast sheet film known as *Kodalith.* The trademark *Kodalith* designates a special family of films that yield images of extremely high contrast. Although intended primarily for the printing trade and similar photomechanical work,* several of these lithographic films are

* View cameras and others accepting sheet film can use these films directly. Try an ASA rating of 5 or 6 in daylight. Kodalith is also available from some dealers in 35 mm bulk rolls, 100 ft. (30.5 m) long.

useful in general photography when images of extreme contrast are desired. Kodalith Ortho Film 2556, Type 3, is the one for general use; a similar product is made by GAF, DuPont, and other film manufacturers.

Using Lithographic Films in the Darkroom

Generally these films are *orthochromatic* and can be handled under a *red* photographic safelight such as the Kodak Wratten 1A. In such illumination *the emulsion side appears lighter than the base.*

Rollfilm can be printed on Kodalith Ortho and similar films using a contact proofing frame and the enlarger as a light source. Set up the enlarger exactly as you would for making contact sheets (review Chapter 6 if necessary) but use no printing filter, only white light. With the lens stopped down about halfway, make a series of test exposures of 1, 2, 4, and 8 seconds by the familiar test-strip method.

Kodalith and similar films may be processed in a tray like photographic paper. Any of several Kodalith developers will produce excellent results when mixed and used as directed on their packages. Note that these developers are prepared as two separate solutions; parts A and B must be stored separately because they deteriorate in a few hours when combined. Mix together enough of each part to fill the developing tray about ½ in. deep. Like other film developers, it should be about 68° F (20° C).

A second tray should contain a stop bath like you make for print processing, while a third tray is needed for a similar quantity of any standard film fixer.

Barbara Crane: Figure No. 1, 1965.

Slide the exposed film into the developer *face up,* then lift it and tap its edge sharply against the tray to dislodge any bubbles of air that may be clinging to it. From this point on, *agitate* the film *constantly* by rocking the tray. Handle it as little as possible until development is completed. The exact developing time depends on the type of developer used, but will usually be about 3 minutes. Stop development and fix as you would a paper print (lithographic films fix quickly; twice the time required to clear the unexposed emulsion is sufficient). Then wash the film for about 5 minutes in running water (a tray siphon works well), bathe it in Photo-Flo, and hang it up to dry.

A correctly exposed Kodalith or High Contrast Copy Film image—negative or positive—will look different from an ordinary negative or print. Hold your litho film image up to the light and look for these points:

1 Black areas should be even-toned and so dense that virtually no light gets through them. Weak, gray tones here indicate too little exposure; streaks signal uneven development.
2 Blacks should be free from pinholes. These are caused by dust particles and are most numerous in underexposed images.
3 Clear areas should be clean-edged; any veiling indicates too much exposure.
4 Examine the width of any lines in the image. If black lines are too thick and clear lines are broken or poorly defined, the image is overexposed. If thin, clear lines appear too wide, and thin, black lines are broken, the image is underexposed.
5 The shape of small image areas should look correct. Clear areas that are too large indicate underexposure; black areas that seem "puffy" indicate overexposure.

This visual checklist may be helpful because exposure of lithographic film is rather critical: as its threshold point is approached, small increases in exposure rapidly make the image darker. Make a note of the enlarger setting, f/ stop, and time that give best results.

Small negatives (such as 35 mm) may be enlarged onto litho film instead of being printed by contact. Either way, of course, litho-film images printed from ordinary camera negatives will be high-contrast *positives.* If a high-contrast *negative* is needed, simply transfer the image again by the same process, exposing a new piece of lithographic film through the positive you just made. Wait until the first litho film has dried (don't try to print from it wet), and keep the two emulsions face to face for sharp results. The final negative can always be placed in the enlarger upside down to give a correctly reading image.

On any litho film image, pinholes in solid black areas may be removed by painting them with photographic *opaque.* This is a thick watercolor paint, available in red or black, that is applied with a sable brush to the emulsion. The red is easier to see when you apply it. When touched up, the negative may be printed like any other.

Polaroid Type 51 material can also be used for high-contrast images (see Appendix B). Weston Andrews produced his picture here by rephotographing two high-contrast images that were made earlier from a regular photograph.

Weston M. Andrews: Portrait, 1972.

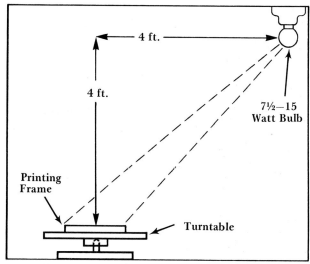

Tone-line or spin-out setup.

Tone-Line or Spin-Out Images

An extension of the high-contrast treatment just described is the *tone-line* or *spin-out process,* which converts any major *difference* in image tone, such as a line in the picture where dark and light areas meet, to a thin black line on a white ground. Any sharp negative can be used, but one with a strong graphic arrangement of light and dark areas will usually yield a more successful result.

Two litho film images, one positive, one negative, must be made from the original photograph. Use the method described in the preceding section. If the original negative is smaller than 4 by 5 in. (10.2 by 12.7 cm), the first litho image (a positive) should be enlarged to at least that size since it is very difficult to control the line formation with smaller ones. Best results are obtained if the lithographic image

is made as large as the final print, but any size from 4 by 5 in. up is usable. The second lithographic image (a negative) can then be contact printed from the first.

It is essential that both litho images be *exactly the same size.* They must next be *registered* on the underside of the contact proofing frame glass so that the two images are *back to back.* Tape either image to the underside of the glass so that its emulsion is *against the glass.* Thin transparent tape (the so-called "magic" variety) works best. Next, tape the other litho image over the first so that the two are *exactly aligned* in register. Use care to get *all* parts of the image perfectly aligned, or very uneven line formation will result. The emulsion of this second lithographic image must *face away from* the first one. Properly assembled, the sandwich will look uniformly dark when viewed by transmitted light,

George M. Craven: High contrast image and tone-line variation.

since each lithographic image masks out the clear areas of the other.

This sandwich will permit a thin band of light to pass through it along the tone edges of the two images, but only if that light strikes it at an oblique angle. Perpendicular rays, as you can easily see, are virtually blocked. Since the tone edges in the image lie in all directions on the picture plane, the exposing light must strike the sandwich from all sides but always at an oblique angle to the film itself.

The easiest way to do this is to place the printing frame on a turntable in the darkroom. A phonograph set for 33⅓ rpm works well, or a kitchen turntable or "lazy susan" may be used. The exposing light can be a bare bulb in the ceiling. It *must* be situated at about a 45° angle from the turntable (see diagram).

With only a red safelight on, place a sheet of unexposed litho film in the contact frame so that its emulsion *faces* the sandwich taped there. Close the frame, start it spinning, and expose the film for several seconds. A few trials may be necessary to establish the correct time, but it must *never* be less than one complete revolution of the frame.

Process the exposed film by the usual Kodalith method. Thin, weak lines mean a longer exposure is needed, but if thick, bleeding lines result, shorten the exposure time or use a weaker light bulb. The resulting image, of course, can be tonally reversed by contacting again on litho film. This will yield a negative that will produce dark lines on a white ground in the print. The final image may resemble a detailed ink drawing, but it is thoroughly photographic and can be directly combined with other photographic images.

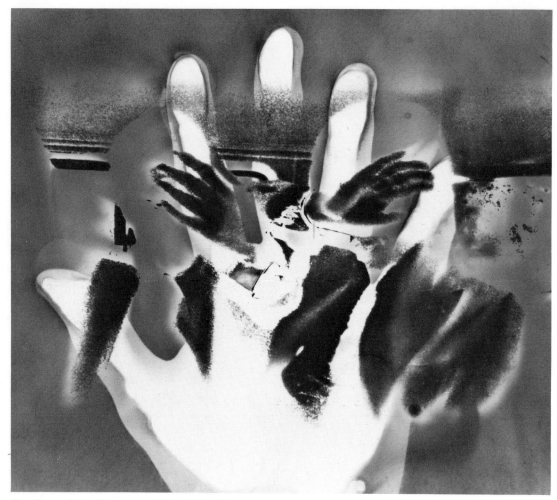

Van Deren Coke: Homage to Richard Hamilton, 1970. Collection: The International Museum of Photography.

Negative Images

The most fundamental of all photographic effects is that *light makes dark.* Virtually all photographic processes since 1835 have depended on this reversal of values. Yet our all too persistent belief that the lifeblood of photography flows through an umbilical cord of realism leads us to regard the negative image as a step to the positive one. We insist on reverting values to their original relationship.

While this return from negative to positive obviously is useful in representational work, it is not always essential in recording and is even less necessary in art. When we store verbal

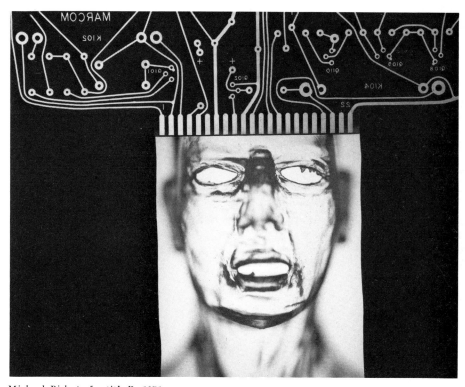

Michael Bishop: [untitled], *1971.*

information on microfilm, for example, a negative image contains just as much useful and retrievable data as its positive counterpart. Other first-state images such as those on X-ray films are used commercially in their negative aspect. And today any visual image produced or transmitted electronically can be flipped between negative and positive states at will. We prefer the positive, it would seem, as much by custom as by necessity.

By leaving the image in its negative state, then, we create another visual dialect in the language of photography. As noted earlier in Chapter 4, we often do this with the photogram. Van Deren Coke's *Homage to Richard*

Hamilton provides another example of this; Henry Holmes Smith's *Meeting* utilizes more fluid material to modulate the exposure of light. But we can use camera images this way, too. Michael Bishop, for example, has combined dissimilar images to create his photograph here. Its negative state helps keep the visual emphasis on his theme rather than on its construction. We have also seen how Robert Heinecken portrays a human element rather than a specific individual through negative images. Heinecken also employs them to deflate the factual authority of positive ones; he finds them a useful antidote to the gospel of realism.

Enlarged Negatives and Positives

Today we generally think of a negative as a small image from which we enlarge a positive, since the prevailing trend in camera design is toward smaller rather than larger formats. But many of the photographic images being made today are possible only with larger negatives. There are three reasons for this. First, the manual alteration, masking, and retouching that some photographs require are virtually impossible on small negatives; there simply isn't space to work cleanly and accurately. Second, large negatives are used as intermediate, step-up images to produce extremely large prints such as photomurals. Third, some of the photographic processes that are being re-explored today do not rely on silver bromide chemistry but instead use other salts that are less sensitive to light. These emulsions require intense light sources for exposure and must be printed *by contact;* this, in turn, requires film negatives or positives as large as the final print.

There are several practical ways to make enlarged negatives and positives, and the simpler ones are briefly outlined in the following list for those readers who wish to work processes requiring them.

1 Direct Duplicating Film. This method employs a special film to produce an enlarged negative directly from a smaller one. Kodak Professional Direct Duplicating Film SO-015, available in standard sheet film sizes up to 8 by 10 in. (20.3 by 25.4 cm), is used. This film differs from most others in that it does *not* reverse image tones; exposing an original negative onto this material will therefore produce another negative rather than a positive.

The film should be handled under a red safelight similar to that used with most lithographic materials. Complete instructions for exposure in an enlarger accompany the product. Times are similar to those for slower enlarging papers, but, with a direct film such as this, *increasing* the exposure produces a *lighter* duplicate image, while decreasing the exposure makes the duplicate darker. It's exactly the reverse of an ordinary film's response. Develop the exposed duplicating film in a tray of Dektol developer, diluted 1:1 (one part stock solution, one part water), for 2 minutes at 70° F (21° C). Rinse, fix, wash, and dry the film as you would any other. The development time may be adjusted a bit to get the best contrast in the enlarged negative.

2 Kodalith Diapositives. Kodalith Ortho film, described earlier in this chapter, can be used to get an enlarged *positive* image, from which a negative can then be made by contact printing. Litho film diapositives and the negatives made from them will have more contrast than will similar images made on the direct duplicating film just described. The diapositive method, with films like Kodalith, is therefore useful to enlarge small, original negatives of very low contrast. Refer to the section, *Using Lithographic Films in the Darkroom,* page 194, for working procedures. In this application, however, try developing both the enlarged positive and its contact-printed negative in Dektol diluted 1:8 (one part stock solution to eight parts water) for about 60 to 90 seconds. The dilution ratio can be varied somewhat; more dilution will produce lower image contrast.

3 Paper Negatives and Diapositives. Regular, single weight paper prints can be used to make intermediate negatives by contact on a sheet of Kodalith or similar film. Some brands of paper have the manufacturer's name lightly printed on the back, and these should be avoided, but other brands of smooth, glossy paper are useful. This procedure offers a somewhat less expensive route to larger size Kodalith negatives, since size for size, paper is cheaper than film.

Paper prints (positives) may also be used to make *paper negatives* by contact. To insure good image definition, uniform contact is important, and this is easily obtained if both sheets of paper are wet.

In the darkroom, under a safelight, soak the positive print and a sheet of *unexposed* enlarging paper in water until they are limp. Drain them and press them together with a roller in a clean, flat-bottomed tray so that they are emulsion to emulsion with the positive print on top. Next expose this wet sandwich under the enlarger to white light as you would a contact print (a larger aperture might be necessary). Then separate the two prints and process the undeveloped one. If your enlarger has a wooden baseboard, be sure to protect it from getting wet. It can easily be covered with a plastic dropcloth, saran wrap, or butcher paper, and this will prevent the baseboard from warping.

Non-Silver Processes

Most non-silver printing processes we use today have been inherited from photographers of the late nineteenth century, when a flurry of experimenting resulted in numerous alternatives to albumen and silver chloride paper. Very few of these methods have remained commercially viable, but some have recently become popular again, while newer processes based on long-established principles have been introduced.

Non-silver processes offer several advantages to the contemporary photographer. For example, color may be freely introduced without getting involved in the complex chemistry and materials of modern color photography. Photographic images may be transferred to and duplicated on surfaces that are not sensitive to light, and prints carefully made on good materials by non-silver processes usually are more permanent and less fragile than conventional photographs.

In recent years another situation has also spurred development of non-silver systems, and that is the rapidly diminishing supply of silver itself. The United States Bureau of Mines has estimated that America has reserves of something over a billion ounces, enough to last about ten years at current rates of consumption. Photography accounts for about a third of this use; hence the search for processes and systems less dependent on this valuable metal. For two decades, much of the silver used in photography has been recycled from processing systems whose volume permits practical treatment, and more recently it has been found desirable to remove silver from processing effluents for ecological as well as economic reasons: silver is harmful to biological treatment systems and marine life.

It is not our intent here to provide step-by-step guidance for making prints by these processes. Sources for such information are listed in the bibliography. Our purpose instead is to point out that the familiar silver bromide print is not only a final state of the contemporary photographic image, but also a bridge to others. Let's look at some of them.

Iron Processes

In 1842 Sir John Herschel discovered that certain organic iron salts are reduced when exposed to light, and from his investigations came the *cyanotype,* the familiar blueprint known to engineers and construction tradesmen everywhere. Blueprint paper contains a coating of ferric ammonium citrate and potassium ferricyanide; exposing it to ultraviolet light forms a weak, green image that turns bright blue when rinsed with water. The water washes unexposed iron salts away, so no fixing is required.

Other iron-based processes are less familiar. *Platinum printing,* which binds a platinum salt to an iron one, gives rich, long-scale prints that have an uncanny sensation of depth. They are expensive to make, but unassailably permanent. It is impossible to *reproduce* a platinum print in ink: you have to see the original to appreciate it. *Palladium prints* are chemically similar, and almost as costly.

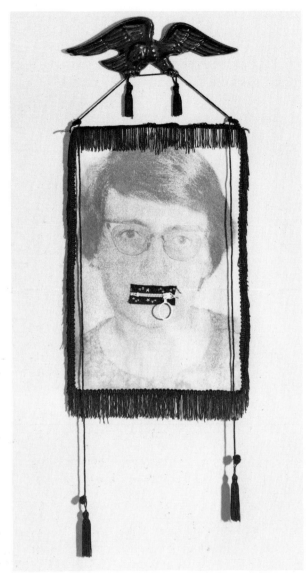

Gayle Smalley: Photograph for a Passport, 1973. Photographic object (gumprint, notions, and zipper).

Gum Bichromate

Here is a non-silver process that has had a remarkable revival by contemporary artists. Gum bichromate uses a colloid, *gum arabic,* which is made light-sensitive by potassium bichromate. The gum carries a pigment—watercolor or poster paint; it can be manipulated to produce varied color combinations. Although using black pigment can yield a print similar to a conventional photograph, the attraction of gum printing to contemporary photographers lies in its capacity to blend textures and colors with a monochromatic photographic image.

Light hardens the sensitized gum arabic, making it less soluble; unexposed areas are then carefully removed with water, leaving the harder image on the support. A print may be recoated and locally reprinted in a different color several times, adding to the creative opportunity of the process.

Both the gum emulsion and the paper or cloth on which it is coated must be prepared by the photographer. It is a slow process, not well suited to making multiple editions, but ideal for combining multiple exposures of different colors in a single image. The process was patented in 1858 and it first became popular around the turn of the century. Like the iron processes, gum printing requires a negative large enough to make a contact print.

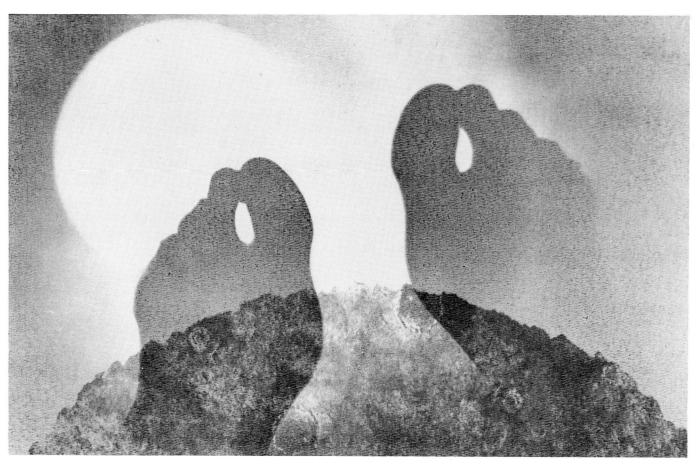

Gayle Smalley: Starset over Bodyscape (with dead planet), 1971. Gumprint.

Photo Screen Printing

This process is well suited to making large prints with bold colors. The final image is in ink and can be printed on almost any kind of surface to which it will adhere: T-shirts, glass bottles, wood, metal, and plastic objects have been used. No light-sensitive materials are used in the final stage.

Photographic screen prints require a *positive* image as a starting point; as with other methods described here, it must be as large as the desired final print. Any photograph that can be reduced to a black-and-white, high-contrast image by the previously described litho film method may be printed by the screen process. However, if the photograph contains gray tones that are important to its image, these tones must first be changed to black through a *halftone* process.

Halftone refers to a procedure by which gray tones are converted to a pattern of *tiny dots* that vary in size but are uniform in tone. In a halftone litho film, for example, all dots are solid black, but their varied size permits differing amounts of clear film between them, allowing the eye to blend the two values into shades of gray. Examine any reproduced photograph in this book through an 8X magnifier, and you'll see this halftone pattern. Halftone conversion is not difficult with modern materials. For screen printing, original photographs on sharp, small-camera negatives such as 35 mm can be directly used as source material because they can be enlarged in this preliminary operation.

Here is how photo screen printing works. A film positive is used to expose a negative gelatin image on a temporary plastic support called *screen process film*. This material is available either unsensitized or pre-sensitized and ready to use, but the two types must be exposed and developed in different ways. With either type, the negative image on screen process film is then imbedded in a fine, screen-like material (traditionally silk but now more commonly nylon, polyester, or other material) that has been stretched over a wood frame. Then the temporary support is stripped away, leaving a negative image in gelatin on the screen.

Ink made specially for this process is placed above the screen within the frame. Finally, the paper or other material on which the image is to be printed is placed under the screen and the ink forced through its mesh. The open areas, of course, are situated wherever there is no gelatin, and thus a positive final image is obtained.

Screen inks come in brilliant, even fluorescent colors, and since no special preparation of the paper (or other final material) is necessary, a large edition of identical prints can be produced. Illustrated, step-by-step directions for photo screen printing are in the Time-Life book, *Frontiers of Photography;* additional instructions are included in the Gassan *Handbook* (see bibliography).

Photolithography

This is another ink-on-paper process, and an important one: in its offset form it accounts for most of the printed material we use today, including this book. Direct photolithography, although not so widely used commercially, is more feasible for the artist-printmaker since it does not require elaborate printing equipment.

In photolithography a flat plate of zinc, aluminum, or other suitable material is sensitized, usually with a commercially available *resist*. The photographic image is contact printed onto the plate from a litho-type (high-contrast) negative, and the plate prepared for printing by various means according to its type. A litho plate is essentially a flat surface composed of printing areas that accept ink but repel water, and nonprinting areas that retain water but repel ink.

The prepared plate is positioned on a press, wet, and then inked. Paper is then placed in contact with the inked plate, and both are drawn under a pressure roller that helps insure an even contact between them. In this manner the ink impression is transferred directly to the paper.

Charles Swedlund's photolithograph was made from two such impressions. Most of the image was printed from a single plate using gray ink, but a second Kodalith negative containing only the deepest shadow areas was made from the original photograph, and a plate made from this negative was printed in black. Both images were carefully *registered,* that is, positioned with respect to each other; the paper, of course, was run through the press a second time to receive the black image. Other colors of ink and paper may be used, and the process is well suited to editions of moderate quantity.

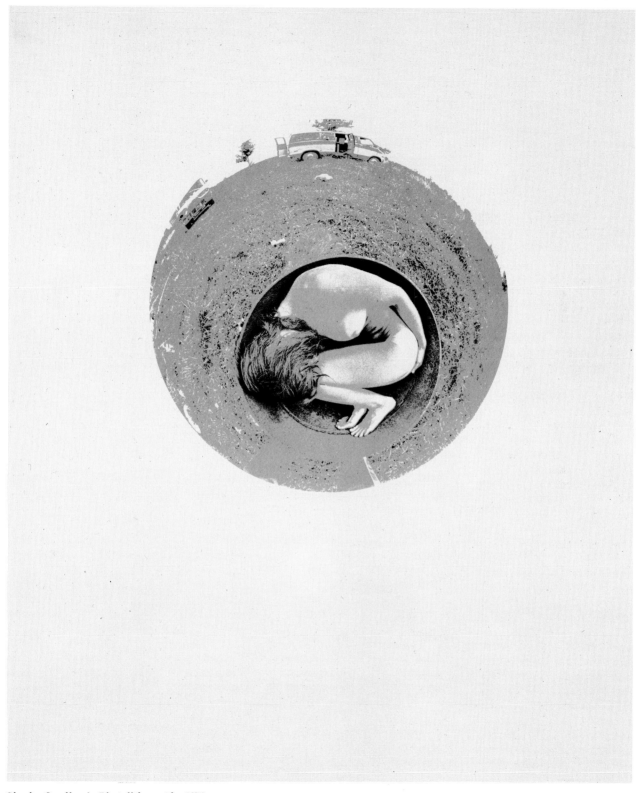

Charles Swedlund: Photolithograph, 1972.

Diazo Materials

Diazo materials have been commercially available for about 40 years. They have the advantage of producing a positive directly from a positive; no intermediate negative is needed. Diazonium salts are decomposed by ultraviolet light, and in such a state these salts are colorless. But when they are not exposed, as under the black lines of a positive drawing, these salts can produce an azo dye when brought in contact with a strong alkali. The usual practice is to include the dye-forming chemical in the diazonium coating of the paper; after exposure, the paper is fumed with ammonia and this produces a visible image.

The diazo process is a relatively dry substitute for the traditional blueprint (in this application it is known as the whiteprint process). Diazonium compounds are now combined with numerous other materials. Many produce no dye at all but alter the hardness of a resist, change the wetting properties of a lithographic surface, or form a latent image for some other subsequent purpose.

Electrostatic Systems

These systems depend on the fact that light will increase the electrical conductivity of amorphous (non-crystalline) selenium or zinc oxide. Such materials, when properly charged electrically and exposed to light through an image, can retain an electrical charge pattern corresponding to the image that was printed on them.

The best known of these processes is *Xerography*. For this process, an electrically conductive metal plate or cylinder is permanently coated with a very thin layer of amorphous selenium. This coating is electrically resistant in the dark but conductive when exposed to light.

Most of us have experienced the sensation of walking across a nylon carpet in a dry room and getting a shock when we touched a metal object like a door knob. A similar electrostatic charge is first uniformly applied to the Xerographic plate or drum. Exposure to light then permits this charge to leak from the coated surface to its underlying base metal, where the charge is grounded. This step leaves on the drum surface an electrostatic charge directly corresponding to the original image.

Next, the plate or drum surface is covered with finely ground resin particles that can carry charges electrically opposite to the drum surface itself. These particles stick only to the charged image areas on the drum. At a later point in the operating sequence, a piece of paper or other material is given an electrical charge opposite that of the particles on the drum, and when this paper is brought into contact with that surface it picks up the resin image from it. The paper is then briefly heated and pressed to fuse the resin and bond it to the sheet. A positive copy of the original results.

Since its public announcement in 1948, the Xerox process has been developed into a widely used, high-quality document reproduction system. Packaged into a variety of convenient, automatic machines, it has become a standard, dry, office-copy process capable of reproducing its image on almost any kind of surface. These

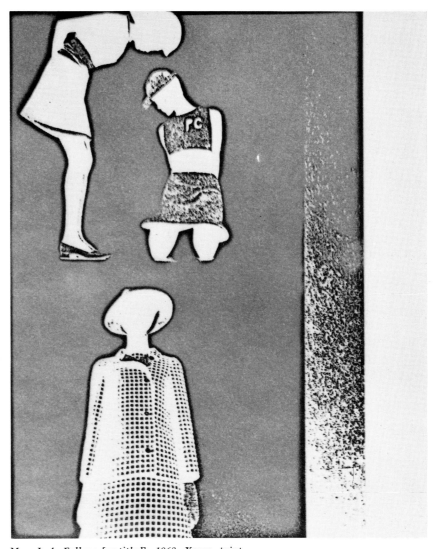

Max J. A. Fallon: [untitled], 1968. Xerox print.

unusual properties have led some photographers to explore its reproduction capabilities with material other than the printed matter for which it is ideally suited.

Max J. A. Fallon has demonstrated this capacity of the process to reproduce high-contrast photographic material. But some peculiar characteristics are quickly evident. The electrostatic charge does not seem to distribute itself evenly over large areas of uniform tone. Tone edges (between light and dark) become charged more strongly than the central areas; an un-

even tone in such areas seems to be typical of a Xerox image. Some machines that operate with cut sheets of paper (rather than a continuous roll) permit the operator to introduce colored paper and other materials in place of the typical white sheets. This is what Fallon has done to reproduce his images. Like other non-silver systems, Xerography represents a viable alternative to conventional photocopying methods, and improved rendering of intermediate tones on the black-to-white scale is one aim of continuing research.

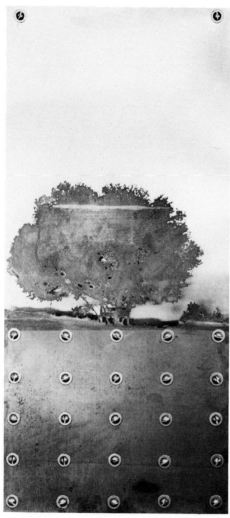

Jerry McMillan: [untitled], 1972. Brass and copper landscape (with bolts).

Photosculpture

Jerry McMillan is another artist who demonstrates that photography cannot be limited to its traditional image forms. A few years ago he astounded the photographic community by exhibiting photographs mounted on the inner walls of small paper bags. These photographs usually presented an outward expanse of space; they were made all the more enigmatic by their arrangement to form an inner space or environment.

More recently, McMillan has used the photographic image as a stencil to create natural forms in metal. By coating brass or copper sheets and coils with a photo-sensitive resist that hardens on exposure to ultraviolet light, he can transfer his image photographically to the metal surface. After the resist is printed, its unhardened (unprinted) areas are removed and the metal then etched through with an acid. An outline of the photographic image in the metal, from which the remaining resist is then dissolved, forms a sculptural relief.

Ever since the daguerreotype, improvements in technology have resulted in new kinds of photographic images. Commercially available light-sensitive materials are no longer limited to film and paper, although other forms are not usually obtainable in units convenient for the student or amateur experimenter. One solution to this problem lies with *liquid emulsions* that can be coated by the photographer himself on various materials, but these materials must then be able to withstand any required wet processing.

Another solution has been demonstrated by the painter, Chuck Close,

Richard Hamilton: Towards a Definitive Statement on the Coming Trends in Men's Wear and Accessories. (a): Together let us explore the stars, 1962. Oil and collage on panel. The Tate Gallery, London.

who uses precise photography as both source and process to prepare his over-size (84 by 108 in.) canvases. Using a grid pattern for accurate projection, Close typically translates a tightly framed, sharply focused photograph of a person's head to his large canvas. Then, with an airbrush and acrylic paint, he builds a continuous tonal scale that is virtually photographic. His careful rendering of detail completes the grand illusion. Close thereby produces a "photographic" image in a scale and on a material where we do not ordinarily look for one. His pictures are dramatically ambivalent—as real as a photograph and as unreal as a painting, and vice versa.

In this chapter, then, we have noted some of the more familiar photographic processes separately, but we have also pointed out that many of them, in their contemporary forms, may be combined with one another and with other media. Richard Hamilton in the United Kingdom, for ex-ample, consistently has utilized painting, photography, and sculpture to assess contemporary life. He often combines these media in unexpected ways to increase the intensity of his statements. The quantity of inventive work this artist has produced—170 items in a recent retrospective show—suggests that he will likely be a major influence on photographers everywhere as they continue to pursue their muse through endless variations on photographic themes.

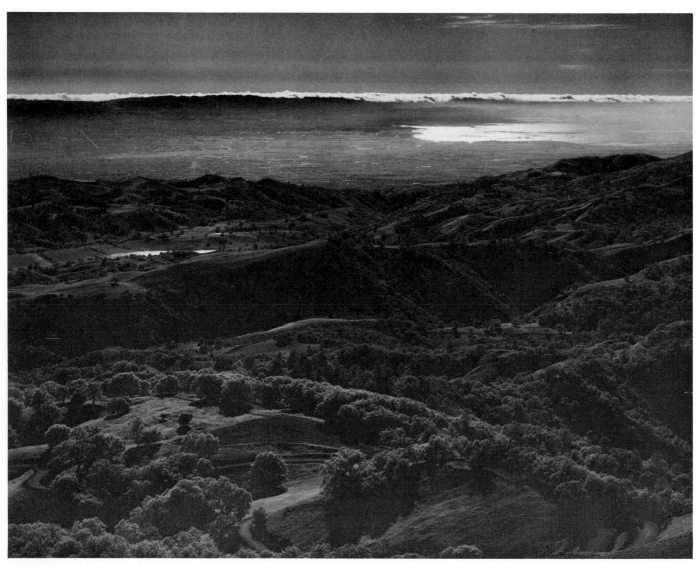

George M. Craven: Santa Clara Valley and San Francisco Bay from Mount Hamilton, California, 1968. Infrared photograph.

If yours is a simple camera, you probably haven't given much thought to its lens or how that lens forms an image. There's little to be concerned about. Focusing, if required, is straightforward and simple. The aperture may be fixed in size or have only a few possible settings. If you keep the lens clean and hold the camera still, reasonably clear images are assured.

Every passing year, however, brings more uses for photography, and many of these applications are in highly specialized fields. Some uses are quite complex; others are simple. All have steered camera design toward more specialized capabilities, modular and interchangeable construction, and increased automation of exposure, framing, and focusing. This trend toward more sophisticated design is evident in all types of cameras, but is most apparent in those for general use.

One feature that commonly separates better cameras from the simple snapshot variety is the *interchangeable lens*. Being able to remove one lens from the camera and substitute another that will form a different image increases the usefulness of the camera by a significant factor. It also demands a basis for intelligent choice, particularly with camera systems that offer lenses in wide variety. Making the best use of a camera or lens, like any other tool, requires that its fundamental properties be adequately understood and correctly applied to the situation at hand.

No other part of a fine camera is more important than its lens, nor is any other part so shrouded in mystery. The names we find on lenses today— Xenar, Tessar, Elmar, Symmar, Planar, Sekor, Rokkor, Takumar, Heliar, Nikkor (and there are scores of others) —are not very informative. How do they differ from one another? And what kinds of images are they best suited to make? One purpose of this chapter is to shed some light (if you'll pardon the pun) on the mystique of photographic lenses; another is to explain how camera filters are used with them.

How a Lens Forms an Image

The function of any camera lens is to form an image, and it does this by bending rays of light that pass through it. Back in Chapter 4 we noted that when light passes from one material to another, its waves are bent. When a ray passes from air into a denser material such as glass, for example, the ray is bent toward a line perpendicular to the surface of that material. When light leaves a dense material and enters a less dense one, the opposite occurs: thus a ray passing from glass into air is bent away from the perpendicular to the surface it passes through.

In the example just described and diagramed here, if the two glass surfaces are parallel, as in a rectangular block, the entering and emerging rays will be parallel too.

But if they are not, as with a *prism,* the rays will be *bent,* in this case toward the base of the prism.

Now visualize two identical prisms base to base; rays passing through them are all bent toward the baseline and ultimately cross one another, as shown here.

If we add more surfaces to these prisms at the correct angles, all the emerging rays will converge and cross at the same point. An infinite number of such surfaces—a spherical surface on the prisms—would cause all light rays emanating from one point and passing through the prisms to converge at another point beyond them. Now we would have a simple lens.

Positive and Negative Lenses

Lenses cause light rays to come together or spread apart. Lens elements that cause light rays to converge, or come together, are called *positive* lenses; they are thicker in the center than at the edges. Lens elements that make light rays diverge, or spread apart, are *negative* lenses. They are always thicker at the edges than in the center, and they cannot form an image by themselves as positive lenses can do. In all but the simplest lenses, positive and negative elements are combined. This helps to disperse the image evenly over the film plane, and to improve its sharpness and overall quality. Regardless of how various elements are combined, the aim is to produce a lens that will form a clear, flat, sharp image the size of the film

Light wave passing through air and glass.

Light ray being bent by a prism.

Light rays being bent by two prisms base to base.

A simple lens.

to be used with it, and to do that over a range of lens-to-subject distances for which the camera is intended.

Designing lenses today no longer requires the rare human talent it used to. Although automated cameras are a comparatively recent development, lens making began to take advantage of the electronic computer many years ago. Computers have dramatically shortened the time required for the complicated calculations of optical formulas. One result of using computers is that lenses of superb quality are now found on relatively inexpensive, mass-produced cameras, and distinctly inferior lenses for general use have virtually been banished from the market. With computer programs currently available, any optical manufacturer can produce a variety of high-quality lenses, further encouraging interchangeable designs. With such an array of lenses to choose from, then, how can we sort them out and make suitable choices?

Focal Length

The most fundamental characteristic of any lens is its focal length. Back in Chapter 3, you may recall, we said that the focal length of a lens is the distance from the center of that lens to the film plane, when the lens is focused on infinity.* With any lens, the longer the focal length, the larger

* This is an adequate but inexact explanation. The measurement is properly made from a point within the lens system called the *emerging nodal point*. All rays that travel through the optical center of the lens appear to leave the lens from that node.

the image of an object at a given distance. Focal length and image size are therefore directly proportional: if you replace a lens of 50 mm (2 in.) focal length with one of 100 mm (4 in.) focal length, the latter image will be exactly twice the size of the former.

With interchangeable lenses, then, we may vary the size of our image on the film, but not all of that image may be usable. That depends on another important characteristic of a lens—its coverage.

Lens Coverage

Light passing through a lens forms a circular image, but practically all cameras are designed to make rectangular pictures within that circle. Each lens is designed to cover a particular size field, a requirement usually dictated by the format and construction of the camera for which it is intended. Lenses designed for a 35 mm camera, for example, will have fairly narrow cylindrical mounts since the image circle they must form is less than 3 in. in diameter. A lens to be used on a 4 by 5 in. view camera, however, must form a circular image at least 6 in. (150 mm) wide. This is why different lenses of the same focal length cannot be interchanged among all types of cameras. Although a 135 mm lens for a 35 mm camera and one of identical focal length for a 4 by 5 in. camera will form images of the same magnification, the two lenses are not interchangeable since the one designed for the 35 mm camera will not cover the larger film area of the other. Thus *focal length,* which governs image size, and *angle of coverage,* determined by the film size that the lens is designed

for, are key factors in understanding what a particular lens can do.

The focal length of a lens is usually marked on its mount, as is the ratio of its maximum usable aperture. Thus a typical lens may be marked as follows: Schneider Xenar 1:3.5 f = 80mm. In this example, *Schneider* is the manufacturer, *Xenar* the trade name of the lens design, its largest aperture is f/3.5, and its focal length is 80 mm (about 3¼ in.). Lens coverage is not similarly indicated but often can be inferred from the design of the mount; as a rule that mount will readily permit its attachment only to the type of camera for which that lens is suited.

The *maximum aperture* of a lens used to be considered a key identifying feature along with its focal length. Today's highly sensitive films, however, have made this aperture designation a less important factor when selecting interchangeable lenses.

Classifying Lenses

Lenses are conveniently classified according to their focal length and covering power. Those used in general photography fall into three broad categories:

1 Medium-focal-length, normal-angle, or simply *normal* lenses. This is the type commonly found on most cameras; it is suitable for general use.
2 Long-focal-length, narrow-angle, or simply *long-focus* lenses. These lenses produce larger images than normal ones do and are therefore useful over greater distances. A *telephoto* lens is a special kind of long-focus lens.
3 Short-focal length, more commonly known as *wide-angle* lenses. They enable the camera to record a larger area while being confined to a close distance, as in a small room, and have other useful applications.

Normal Lenses

A lens is considered *normal* when its focal length is *slightly greater* than the diagonal of the film size being covered. A 50 mm (2 in.) lens, for example, is a normal or medium focal length for the 35 mm format, whose diagonal is 44 mm.* The table below gives the focal lengths of normal lenses for frequently used film formats.

The focal length and coverage of a normal lens are similar in proportion

* The 35 mm designation for format and focal length may be confusing. The *35 mm format* uses a strip of film 35 mm wide. Allowing for the two rows of sprocket holes, its typical image frame is a rectangle 24 by 36 mm with a 44 mm diagonal. A 50 mm focal length is therefore considered normal, and a *lens focal length of 35 mm* would indicate a short-focal-length or wide-angle lens for a 35 mm format.

Table of Normal Focal Lengths for Various Formats

	Format Name	Film Size Designation	Image Size	Diagonal	Normal Lens Focal Length
1	35 mm	135	24 by 36 mm	44 mm	50 mm
2	2¼ in. sq	120-12	60 by 60 mm	76 mm	80 mm
3	4 by 5 in.	4 × 5	95 by 120 mm	152 mm	150 mm
4	Pocket Instamatic	110	13 by 17 mm	21 mm	25 mm
5	Instamatic	126	28 by 28 mm	40 mm	45 to 50 mm
6	6 by 7 cm	120-10	60 by 70 mm	92 mm	105 mm

to the average focal length and visual field of the human eye.* Thus the image produced by a normal lens has a perspective within it that we find familiar. Normal lenses are suitable for most types of general photographic work, and should be used unless there is a good reason for choosing a different kind.

Long-Focus Lenses

A lens is considered to be a *long-focus* lens when its focal length is *much greater* than the diagonal of the film size being covered. Long-focus lenses produce larger images at a given subject distance than normal ones do on the same film size. In general photography they are useful for framing a smaller area or a more distant subject than a normal lens can do; although they "see" less area, they enlarge it more. Long-focus lenses are also useful to reduce distortion of the third dimension that comes from too close a point of view. For example, in head-and-shoulders portraiture, a long lens enables the camera to remain farther away from the subject, yet still fill the frame; a normal lens requires a closer camera position from which the subject's nose and ears appear disproportionate in size.

Long-focal-length lenses have their problems, though, and one of them is that image movement from a shaky or unsteady camera is magnified along

* The *visual field* of the eye is the area it can see from an immobile position. Because the eye moves, however, we usually refer to its *field of view*, a greater area describing the limits of its visual field in all orbital positions.

with the picture. A tripod may be needed to control this. Another problem is the increased distance necessary between the lens and film. This requires a more expansive bellows or a longer lens mount on the camera, and there are practical limits of space and weight to such apparatus.

Telephoto Lenses

A solution to this latter problem is the *telephoto* lens, constructed with two groups of elements separated by a substantial air space. The front group is positive, or converging; the rear group negative. This arrangement permits the lens to focus its image at a much shorter lens-to-film distance than a normal lens of equal focal length would require. For example, a 300 mm telephoto lens mounted on a 35 mm camera may require only 145 mm of space between its rear element and the film plane. This saves considerable space and makes the camera and lens easier to hold and balance.

Incidentally, all telephoto lenses are long-focus lenses, but the converse is not true. A telephoto lens must focus at a lens-to-film distance *shorter* than its actual focal length. If it doesn't, it's merely a long-focus type. The photograph of the Santa Clara Valley in California (at the head of this chapter) was made with a 380 mm telephoto lens on a 4 by 5 in. format.

Mirror Lenses

When extremely long focal lengths are needed for small-camera lenses, a *catadioptric* system may be employed. This type of lens combines reflecting mirrors with refracting elements, enabling the light rays to be bounced back and

forth within the lens system before being passed on to the film. Such a lens can save considerable space and weight in focal lengths beyond 400 mm (for a 35 mm format), but it has two troublesome features. If the view being photographed has a highly reflective background, such as the sunlit surface of a lake, the lens will produce circular, out-of-focus highlights in the image from uncontrolled reflections in its mirrors. A more serious problem with mirror optics is that they have no diaphragm (aperture) because it would obstruct the passage of light through the mirror system. Exposure must therefore be controlled entirely with shutter settings or filters, and depth of field cannot be varied. Nevertheless, mirror optics represent a compact alternative to telephoto lenses that are too long and difficult to handle.

Wide-Angle Lenses

A lens is called a *wide-angle* lens when its focal length is much *shorter* than the diagonal of the film size it covers. Examples include lenses of 35 mm focal length for a 35 mm format (see footnote on page 216), and lenses of 65 mm focal length for a 2¼ by 2¼ in. (6 by 6 cm) format. Wide-angle lenses typically will have an angle of coverage twice that of a normal lens. They are useful in confined locations where a normal lens would frame too small an area. The wide angle of coverage permits a larger area to be included. Such lenses are particularly helpful for photographing architectural interiors, and their great depth of field (compared to a normal lens) also makes them useful in reportorial photogra-

phy. Anne Noggle's photograph (page 152) and Bill Owens's photographs (pages 172, 224) are made with wide-angle lenses.

Due to their short focal length, wide-angle lenses must be placed closer than normal to the camera's film plane. In some 35 mm reflex cameras, where a mirror must move up and down in that same space, such a lens would interfere with this movement and render the mirror unworkable. A neat solution to this problem is the *retrofocus* lens, a reverse telephoto design. In a retrofocus lens, the negative group of elements precedes the positive group, resulting in an effective focal length shorter than the actual distance required between lens and film to focus the image. This design thereby lengthens the optical path to make room for the reflex mirror.

Zoom Lenses

Zoom lenses are *variable-focal-length* lenses. We're familiar with their use on television and motion-picture cameras where they permit uninterrupted changes in image size from a fixed camera position. This flexibility is less useful in still photography, where the zoom feature more commonly is a convenience providing several focal lengths in one lens. It is useful in reportorial and sequence work. Focal length, and thereby image size, are varied by moving certain components within the lens in relation to others, which are fixed. Zoom lenses are complicated and expensive, and at any given focal length cannot produce image definition and sharpness equal to that of a high-quality lens of fixed focal length.

Special-Purpose Lenses

Most ordinary camera lenses are intended to focus sharply over a range of distances, usually from 3 feet to infinity. When the circumstances under which a lens is used vary significantly from those conditions, the lens can be designed to form its highest-quality image within the special conditions of its use. Four such types of special-purpose lenses are encountered frequently enough in general photographic work to warrant some explanation of their nature here.

Enlarging Lenses

Camera subjects are generally three-dimensional in nature and are located some distance away, but an enlarger's "subject" is flat and close—a negative located just inches away from the lens. The enlarging lens is designed to form an image from a nearby flat plane, and to project that image on another flat plane not far away. In an enlarger it always functions under these conditions, and need not be concerned with any others. Enlarging lenses, therefore, are not well suited to general camera use.

Micro and Macro Lenses

These lenses are designed for closeup work—photography at very short distances to the subject, where the image produced in the camera may often be as large as the object before the lens. Although they produce their best image quality at such short object distances, some of them are also suitable for general work at longer distances. Most have features to make routine closeup work more efficient. Technical photographers will find them unsurpassed for making same-size photographs of small objects and specimens, while artists and educators find them useful to make slides of larger materials. Such lenses usually contain the prefix *micro* or *macro* in their names.

Closeup Attachments

These are not complete lenses in themselves, but rather are usually single elements designed to be added to existing lenses so that the latter may focus shorter distances. For example, a typical twin-lens reflex camera in the $2\frac{1}{4}$ by $2\frac{1}{4}$ in. format focuses down to $3\frac{1}{2}$ feet. By placing a suitable closeup attachment in front of the regular lens, it is possible to produce reasonably sharp images with that same camera as close as 12 inches. Such a camera may then be used to photograph small objects such as ceramic pottery, small drawings and paintings, and anything that a close point of view will not distort beyond useful limits. Closeup attachments represent an economical way to vary the effective focal length of fixed camera lenses for such purposes.

Closeup attachments for certain twin-lens reflex cameras come in pairs: a thin element for the lower (taking) lens, and a thick one for the upper (viewing) lens of the camera. The thicker attachment contains an optical wedge or prism, and a reference mark on its rim. This unit must be attached to the *upper* lens of the camera, with the reference mark at the *top*. In this position the prism will aim the camera viewing system at the closer lens-to-subject distances involved, conveniently eliminating most errors due to parallax.

Process Lenses

These are lenses specially designed for the ultimate in image quality and sharpness, but those conditions are attained at the expense of light-gathering ability and depth of field. Process lenses are slow; they have relatively small maximum apertures, but they evenly illuminate their focal plane. Like enlarging lenses, they are designed to reproduce a flat field, but usually over a greater range of distances such as 3 to 30 feet. If the lens is intended for color reproduction, as most process lenses are, great care is taken to insure that it focuses all colors or wavelengths of light in precisely the same plane with equal sharpness. Process lenses have long been used in photography for the printing crafts, where high orders of definition and sharpness are required. In recent years they have also seen wide application in the electronics field. There they are used to produce optical masks for microelectronic devices such as the integrated circuits which have revolutionized that industry.

How Filters Work

Filters are thin layers of transparent gelatin, plastic, or glass which contain a substance that will absorb certain wavelengths of light. Fundamentally, all filters work the same way: they *absorb* some wavelengths of light while they *transmit* others. Thus they function as selective valves, controlling the wavelengths and the quantity of light that passes through them. There are four general types: colored filters, polarizers, neutral-density filters, and interference filters. Colored filters and polarizers have numerous uses that are considered here. The other types are for specialized uses not encountered in general photographic work.

Photosensitive materials such as film and paper respond to light in different ways. We call their overall sensitivity to white light their *speed,* using ASA ratings for films and comparable data for most photographic papers. But we also noted in Chapters 5 and 6 that films and papers respond differently to various colors or wavelengths of light. To designate this kind of response we use labels such as *orthochromatic* and *panchromatic.* Whenever a photosensitive material responds to more than one color of light, we can change that response by using colored filters.

Colored Filters

How these filters work can be understood by first considering the nature of white light. We may think of it as a mixture of six colors: red, green, blue, cyan, magenta, and yellow. All except magenta are found in the natural spectrum of white light; magenta can be produced by mixing the two colors from opposite ends of the spectrum, red and blue. If we arrange these six colors of light into a circular pattern like the diagram here, we can readily see how they relate to each other. This *color wheel* is the key to understanding what any colored filter will do in any photographic application; it is also fundamental to all color photography.

Any colored filter functions by absorbing one or more colors of light and transmitting or passing the remaining

A photographic color wheel.

ones. *The basic principle applicable to all is that a filter passes or transmits its own color and absorbs its compliment,* which is opposite its own color on the wheel. Let's take the example most often used in black-and-white photography. A yellow filter freely transmits yellow light, but absorbs blue (which is opposite yellow on the wheel). A pale or medium yellow filter will transmit other colors adjacent to yellow, and will effectively block out only blue rays. Similarly, a red filter will transmit red but will absorb cyan (bluish green). Intensely colored filters will also absorb some colors adjacent to the complimentary hue on the wheel. Thus a deep red filter will not only absorb cyan but most of the blue and green light as well.

Filters, of course, are not selective of subjects: they only respond to colors of light, and will absorb not only the individual colors but also their components from mixtures as they occur. Thus a green filter will absorb the magenta component of any light containing it, and some of the adjacent red light and blue light as well.

From this behavior, then, we may infer another guiding principle of colored filters in black-and-white photography. When a filter *absorbs* a certain color of light, anything that reflects that color to the camera will be recorded weaker on the negative and therefore *darker* in the positive, or print. For example, when a yellow filter is used to photograph a clear, blue sky containing white clouds, the filter absorbs much of the blue light from the sky but little of the light reflected by the white clouds. Since the sky then is recorded lighter than the clouds on the negative, it appears darker than they do in the print. Thus a yellow filter darkens the tone of blue sky in a black-and-white photograph, and make the clouds more visible.

Similarly, a green filter will darken the rendering of magenta (reddish blue) objects in a black-and-white positive, and a red filter will darken the tone of blue and green ones. In each case, however, objects that are the same color as the filter will not be darkened, and thus will appear lighter by comparison. We may therefore more fully describe our preceding examples by noting that a yellow filter lightens the rendering of yellow objects (in the print) and darkens the appearance of blue ones; a green filter lightens green objects and darkens reddish-blue ones; and a red filter lightens red objects (by comparison) and darkens those that are green and blue.

Filter Factors

Because it absorbs some wavelengths or colors of light, a filter invariably *reduces* the total amount of light that passes through it to the lens and film. Unless the absorption is slight, an *increase in exposure* will be required. This may be accomplished by increasing the exposure time, or by opening the aperture to allow more of the filtered light through.

The amount of exposure increase necessary will vary with each filter, with the spectral sensitivity of the film (ortho or pan), and with the color content of the light itself (daylight or artificial). The increase required is usually designated as a *factor* by which the normal exposure must be multiplied. Because of the three variables just mentioned, the literature accompanying a particular kind of film will usually give two separate factors for each filter listed; one factor is for *daylight* and the other is for *artificial* (tungsten) sources. Likewise, a particular filter may require separate factors not only for daylight and tungsten sources, but also for *ortho* and *panchromatic* films. Never assume that the factor for a particular filter is the same under all conditions; it is not. Red filter factors, however, apply only to pan films; since ortho films are not sensitive to red light, red filters cannot be used with them.

The table here gives the factors for typical filters used in black-and-white photography with *panchromatic* film. Remember that these are *factors* for increasing exposure. When the red filter is used in daylight, for example, its factor of 8 may be applied to the exposure in several ways: by increasing the time 8 times (example: 1/250 to 1/30 sec), by opening the lens 3 stops (example: f/16 to f/5.6), or by any equivalent combination of these two methods.

Polarizing Filters

As a normal light wave travels outward from its source, it is considered to be vibrating *transversely* in all planes, that is, in all directions *perpendicular* to the path of its travel. Most of the light we can see is thought to behave in this manner. It is possible, however, by either natural or optical means, to eliminate most of those transverse vibrations so that the

Exposure Factors for Typical Filters Used in Black-and-White Photography with Panchromatic Film

Filter Color	Exposure Factor in	
	Daylight	Tungsten
Medium Yellow	2	1.5
Orange	3	2
Green	4	3
Red	8	4
Deep Blue	5	10

light vibrates perpendicular to its direction in only one plane. Such light is said to be *polarized*.

There are two common sources of polarized light in nature. One is the light coming from a clear blue sky, at an angle of 90° to the sun. Such light is strongly polarized, although the only indication of it to our eyes is that the sky may appear a little deeper blue than usual. At other angles, natural skylight is less strongly affected, until at 180° and near the sun itself no polarization occurs. Natural light reflected at an angle of about 35° from non-metallic surfaces such as wood, plastic, glass, paint, or water, also is polarized. Again the effect is less apparent at other angles, disappearing completely at right angles to the surface, and parallel to it.

Polarized light appears to the eye much like any other kind, but a frequently seen effect of it on glass windows, for example, is the glare that obscures our vision through them. We've seen this on our car windshield when driving toward the sun; light reflecting from a smooth, concrete roadway on a bright day can also produce such glare.

Polarizing filters provide a way to control such reflections when they would otherwise obscure something we're trying to photograph. They are also useful to darken a blue sky in outdoor photographs, without changing the appearance of other colored objects in the view. Polarizing filters contain a material that works like a louver, *absorbing light that is already polarized while polarizing any that is not.* Since polarized light looks the same as unpolarized to the eye, only the blocking of already polarized rays is noticed.

We can see the effect of a polarizing filter on already-polarized light simply by looking at such light through the filter, and rotating it until its polarizing plane is at right angles to that of the light. At that point the filter turns dark and the polarized light is blocked. To photograph the effect, slip the filter over the lens so that it is oriented *the same way.*

Small reflective objects such as glass-covered pictures may be photographed without troublesome reflections by this method. Artificial light may be used, but it is necessary to polarize the *light* before it reaches the shiny surface. Polarizing material similar to that in the filter must be used over the light fixtures, and this can be an expensive procedure. Such material will polarize the light falling on the reflective surface; a polarizing filter at the lens will then block the reflection that reaches the camera. Using the camera filter alone will not work, since the light reaching it will not be polarized and therefore cannot be filtered out.

Like other filters, the polarizer absorbs some of the light reaching it and thus affects exposure. Most types require 3 times the normal exposure for the full polarizing effect.

Filter Guidelines

Filters for use on camera lenses usually come as thin squares of dyed gelatin, lacquered on both sides; they also come as glass circles, mounted for easy attachment to the lens. *Gelatin filters* are available in many colors for general and technical work. Because they are very thin, they seldom interfere with image sharpness. Gelatin filters are also inexpensive, but easily soiled. They should be handled with great care, and only near their edges. Clean gelatin filters by whisking them lightly with a lens brush or air syringe; never rub them with anything. A scratched or soiled gelatin filter should be discarded and replaced.

Glass filters are more convenient to use than gelatin ones, but they are more expensive. Because they are thicker, they may soften the sharpness of an image when used on extremely short or long focal length lenses. If kept clean and properly positioned in front of the lens, though, glass filters can be useful camera accessories. Clean them as you would a fine lens.

Some filters, like the ones used in the enlarger with variable-contrast papers, come as thin, plastic wafers and as even thinner acetate sheets. These are not intended for use on cameras. The plastic ones can be cleaned with a mixture of water and denatured alcohol, or with lens-cleaning fluid used very sparingly. Discard soiled acetate filters.

Let's summarize this discussion of how filters work by listing three brief rules for using them. They apply to any light filter, with any black-and-white film, in any photographic situation. Perhaps the closest we come, in this book, to a recitation of holy writ:

1 *If you don't need a filter, don't use one. A filter never adds anything to a picture; it only takes something away.*
2 *Any colored filter renders its own color lighter (in the print) and its complement darker. Refer again to the color wheel.*
3 *Increase the exposure by the appropriate filter factor.*

Bill Owens: Party for Children's Home Society, 1972. From Suburbia.

In Chapter 4 we defined natural light as coming from the sun. Daylight, of course, is its most familiar form. From that simple definition we may argue that any light not so produced is not natural, and therefore artificial. What matters here, however, is that light is a tool, a designing element in picture making. A functional definition, then, may be more useful to photographers than a physical one: photography, like politics, is an art of the possible.

To a photographer, *artificial light is light that he can control at its source.* Other light, though it may not come from the sun and may be produced artificially, may be functionally regarded as natural light by the photographer if he cannot control it before it reaches his camera. Admittedly these definitions are arbitrary, but they are also useful.

Broadly considered, two types of artificial light are of particular interest to photographers. One type emits its rays *continuously:* this includes most forms of electric lighting that are part of our daily life. The other type is *intermittent,* producing its light in brief pulses or flashes. We're familiar with two such forms, the flashbulb and electronic flash lamp used by photographers everywhere.

Continuous light offers several advantages over the intermittent type, and some of these are particularly valuable to anyone not familiar with its use in camerawork. We'll therefore consider it first, and later apply the rationale behind its use to photoflash. Flash may be a more convenient photographic light source, but its brief duration makes it difficult for an inexperienced photographer to study its behavior.

Continuous Light

Continuous artificial light is readily available anywhere that electricity is. Its most familiar forms, the *tungsten filament lamp* and the *fluorescent tube,* are usable just as they come. Thanks largely to modern, high-speed films, intense photoflood lamps on which photographers so heavily relied not long ago are no longer essential: for black-and-white still photography, ordinary household lights will do. Artificial light sources come in a variety of intensities and colors; this is no problem for photographers using black-and-white materials, but does require special attention when using color films.

Most uses of artificial light tend to imitate its common natural form. That's daylight: on a clear day, a mixture of direct sunlight and diffuse light from the sky overhead. Overcast daylight is also familiar: the diffused skylight dominates, and may even obscure the sun's rays altogether. Since each has advantages for the photographer who can use it well, let's consider how these two light conditions can be duplicated indoors.

Light Functions

The key to using artificial light is to *consider its function before its source.* Although some lamps are more useful than others in a particular role, almost any kind of light source can perform several tasks equally well.* Four functions are fundamental:

1 **Key light** This is the main source of illumination; it dominates all other lights wherever it is used. It's the artificial equivalent of direct sunlight in nature. Being the most important light, it casts the most important shadow; its directional quality unifies a picture and determines the mood of a scene.

2 **Fill light** A fill light illuminates the shadows cast by the key light, replacing their inky darkness with enough light to record detail and tone. Thus it functions like skylight on a clear, sunny day. It must never equal the key light in intensity on the subject, for then it would be another key light and not a fill. Equally important, it should cast no significant shadows of its own.

3 **Accent light** As its name implies, this one adds small, local highlights to an otherwise evenly lit area. It is commonly used in portraiture, for example, to highlight the hair, and in commercial photography to make details of objects more visible. An accent light may appear as bright as the key light or even brighter, but it never dominates a picture as the key light does. It's strictly a local touch, never

the main show. The highlights it makes, when carefully placed and sparingly used, will add brilliance to the finished print.

4 **Background light** This light illuminates the background, that is, *the space beyond the subject* being photographed, and not the subject itself. Its purpose is to provide tonal separation in the print between the subject and the space around it.

Shadowless Lighting

Some photographers regard an indirect type of illumination called a *bounce light* as a fifth major function. It actually combines key and fill functions to produce a larger, more diffused light source than a comparable direct light could do. This is accomplished by aiming the light source at a large reflecting surface such as a white board, sheet, or a milky plastic umbrella. If several such indirect lights are positioned around a subject, they will provide an aura of light that is essentially directionless, and therefore shadowless. They effectively simulate diffused skylight of overcast days.

Shadowless light, as this is sometimes called, illuminates an *area* rather than an object within it. It is ideal for photographing shiny-surfaced objects and things that have important black parts. It minimizes contrast between black and chrome, for example, on small appliances and similar objects. Indirect lighting is also useful when a small object must be photographed from an extremely close viewpoint. If there isn't enough space between the object and the camera for direct light placement, indirect light may fill the bill.

* We shall not discuss *floodlights* or *spotlights* here because these terms are more descriptive of a light source than of its function.

Once set up, shadowless or indirect light is easy and efficient to use, requiring very little adjustment for various kinds of objects placed in it. But it is not well suited to render the shape of objects or the texture of surfaces; direct light can perform those tasks much better.

Direct Lighting

For good results with direct lighting, two principles overshadow all others: *keep the lighting simple,* and *build the lighting one function at a time.* Check the lighting as you go, always from the camera position. It will look slightly different from any other angle, but the way it appears at the camera, of course, is the way it will look in your photograph. Suggested procedures for photographing people and inanimate objects are given elsewhere in this chapter. They should not be considered rules but simply starting points for your own further experimenting.

Photographic Lamps

A word about continuous photographic lamps, usually referred to as *photofloods.* They are simply regular light bulbs whose tungsten filaments burn at an abnormally high rate. They give more light than regular bulbs, but burn out much sooner.

Photographic light bulbs have ASA code designations for easy identification. The two most popular are the No. 1 Photoflood (code BBA), a 250 watt, screw-base lamp with about a three-hour life, and the No. 2 Photoflood (EBV), a similar 500 watt lamp

lasting six hours. Two other lamps preferred by photographic studios are also available from many photo dealers. These are the 250 watt ECA lamp and the 500 watt ECT. Although not quite as bright as the first pair mentioned, these have much longer lives and are suitable for color photography as well as black-and-white. All four lamps fit regular screw-base sockets but should be used with good reflectors. Do not use more than three 500 watt lamps on a single electrical circuit.

Some photographic lamps are available with their own reflector built into the bulb. They are more expensive than ordinary lamps but more convenient: they need only be screwed into simple, clamp-on sockets. The 500 watt EAL lamp is recommended.

Many varieties of *tungsten-halogen* lamps also are used in photographic work. These lamps are compact and operate at very high temperatures. They have a high, stable light output over a long, useful life, and do not darken with age as regular tungsten lamps do. Tungsten-halogen lamps must be used in equipment designed for them; adequate ventilation is essential. These lamps require extremely careful handling: *the quartz tube must not be touched by the skin under any circumstances.* Mere traces of skin oils or perspiration on the lamp will cause it to heat unevenly and fail.

Simple Portrait Lighting

Here is a suggested procedure for simple portraits. It will work equally well with floor and table lamps at home, with portable floodlamps of any kind, or with studio lamps designed for professional use. The kind of lamp

you have is less important than how you use it. You may have to remove the shades from home lamps or equip them with brighter bulbs (150 and 200 watt bulbs are available wherever housewares are sold; or the screw-base photoflood lamps described earlier may be used). In any case, be sure that no part of the lampshade touches any of these bulbs, for they get quite hot.

1 Begin with the *key light,* regardless of where you place it. Generally, it should be a few feet higher than the face, and to one side of the camera. When you have the effect you want on the face, check the shadow to see that it doesn't dominate the picture frame or call attention to itself.

2 Next, add the *fill light.* Usually this should be on the opposite side of the camera from the key light. Keep it at about your subject's eye level. It should be much less intense than the key light; use a dimmer light or move it back from the subject until the balance of shadow to highlight is to your liking. Another technique that usually helps is to *feather* the light—that is, to swing it away from the subject's face so that only part of its beam falls there. This is useful with reflector-type lights, and if you swing the light toward the camera (where it may illuminate the camera more than the subject), it usually will not spill onto the background as it fills the shadows of the key light.

3 Third, try using an *accent light* to add a highlight to the hair. This can be from a gooseneck desk lamp, a reading light, or any small lamp designed for such use. Place it opposite the key light, somewhat behind and above the subject, and aim it toward the hair. Check it very carefully from the camera position, preferably through the viewfinder, and adjust it until it gives a suitable highlight. Remember, it must not dominate the lighting on your subject; it only adds an accent.

4 The *background light* is optional; not necessary, but usually helpful. Keep in mind that your picture is a two-dimensional frame. The background light helps give your image a stronger feeling of depth within that frame, and makes your subject appear to be in three-dimensional space. Try making a pair of otherwise identical exposures, with and without the background light, to see its effect. This light may be placed low, behind the subject, or well off to one side. Aim it at the background. Its effect should be seen just over the subject's shoulders. Keep it subdued; it must not be brighter than the key light, and in fact should not call attention to itself at all.

Try angling one shoulder of your subject slightly toward the camera. This will give the picture more depth and a less mechanical appearance. Allow enough space between your subject and the background—at least 4 feet—for shadows to fall outside the frame of your picture and for a background light to do its job. Use a light meter if possible to calculate the exposure, and take care that a strong accent light doesn't fall directly on the cell of the meter when you take your reading. Remember that the face you are photographing may not be medium gray (review the section on using

exposure meters in Chapter 3 for more suggestions). Work as briskly as you can; remember that you have a live, warm human being under those lights. Don't bake the last traces of emotion out of your sitter! Once again, don't forget our first thought: keep it simple.

Inanimate Objects

The procedure with these is basically the same as with portraits, although we now must consider a couple of additional shapes. People's heads are basically *spherical;* inanimate things may be *cubic* or *cylindrical* as well. Regardless of their actual structure, most such objects may be regarded as having one of those three basic shapes. The major difference in lighting them has to do with where the key light is placed.

Cubes

For things that are fundamentally cubes, try placing the key light behind the object, high and off to one side, so that it throws a shadow of the object toward a lower corner of the picture as you view it in the camera. The fill light can now be directed at the side of the object facing the camera. Use enough illumination here so that details can be clearly seen, but not so much that this side becomes as bright as the key-lit top. A second fill light, less intense than the first, or an accent light, should illuminate the third side of the object visible to the camera. Keep this third side less bright than the other two.

A background light may be added for separation just as in portraiture. Its effect should be visible in the viewfinder just over the profile of the object and not on the object itself. Because the key light in this suggested arrangement comes from behind the object, however, a background light may not be needed.

Cylinders and Spheres

Cylindrical objects are easier to light. The key and fill lights should generally be opposite each other, but both slightly toward the camera position. There's no point in illuminating what is not visible to the camera. For example, if you first place the key light at two o'clock and the fill at eight (in relation to the object being photographed), try moving the key to the two-thirty or three o'clock position. Other arrangements of these two lights, of course, are possible; a little experimenting will show you the possibilities. Keep the key and fill lights more or less level with the object so that the round side is evenly lit. Add an accent light to the top of the cylinder, if needed, and perhaps place the background light as before.

Lighting of spheres is much the same. Key and fill lights at opposite sides of the object and camera usually are adequate, although a background light may help reveal the form. With both spheres and cylinders, a terminator or "day-night" line may be visible on the rounded surface. As a rule, this will not call attention to itself if the key and fill lights are placed so that this line appears off-center and does not bisect the object. Of course, you can easily emphasize this shadow line if you wish by centering it.

Shadowless and Key Light Combined

This apparent contradiction of terms offers yet another solution to the problem of photographing small objects with a minimum of time and trouble. It is particularly useful for objects whose shape is important to the purpose of the picture, but whose surfaces are highly reflective and therefore troublesome with direct lights. The basic lighting setup is a *shadowless* or bounce one, described earlier in this chapter. Three or four lights may be needed to create the bright, diffused environment. A white table or background paper under the object may also be helpful.

Position the object so that three planes of it (if a cube) are visible to the camera, and then add a weak key light from a position above and to the rear of the object, a bit off to one side, as if you were lighting the object directly. Note that the key light this time should be added *after* the bounce or shadowless lighting aura is arranged, and it should not destroy the shadowless effect. The key light, in effect, is a strong accent light. It will cast a shadow, but it should be a very soft one. Reduce its intensity, or increase its distance from the object until the desired balance is obtained.

For calculating exposure, a gray card may be helpful. Place the card in the bounce-lit area, and carefully read it with the meter held on the lens axis about a foot in front of the card.

Intermittent Light: Photoflash

Photoflash has become a popular source of artificial light that has made photography possible almost anywhere. That is one of its two great advantages over the continuous light just described: flash is *portable*—it goes wherever the camera does. But equally important, the flash of modern photographic lamps is *brief* enough to stop or "freeze" movement in a wide variety of picture situations. These two significant advantages far outweigh the minor drawbacks that any resourceful photographer easily can overcome.

There are two popular sources of photoflash illumination. One is the *chemical flashbulb,* a modern, safe version of a photographic light that was invented nearly a century ago. The other source is the repeating *electronic flash* lamp invented by Dr. Harold E. Edgerton of the Massachusetts Institute of Technology in 1931.

The most convenient and popular form of flashbulb today is the *flashcube*. It contains four separate flashlamps grouped around a common core with a multi-sided reflector. The entire unit is packaged in a housing of transparent blue plastic that acts as a filter to match its light to the spectral response of daylight color film.

Each segment of a flashcube produces a sudden flash of light by the precise burning of zirconium wire in an atmosphere of oxygen. Firing an ordinary flashcube or bulb involves a chain reaction that begins when a voltage is applied to the bulb by a synchronizing circuit in the camera shutter. This heats a tiny filament, thinner than a human hair, to touch off a bit of explosive primer built into the bulb. The primer, in turn, ignites the zirconium wire, which quickly oxidizes to produce the flash of light we see.

Synchronization

All this takes time—about $1\%_{1000}$ to $15\!/_{1000}$ second, so the camera shutter must delay its opening that long for the firing sequence to be completed. A *synchronizer,* built into the shutter, provides that delay. If the camera is designed for only one type of flashbulb, the proper delay is automatic. Other cameras are equipped with a two-position switch, usually labeled X–M, that controls this feature. In the X position the flash circuit is fired as soon as the shutter blades open; switching to the M position delays the shutter for about 20 milliseconds, allowing the flashbulb ignition sequence to run its course first.

The flashcube is a more convenient version of a fingernail-sized flashbulb, the AG-1. This all-glass bulb was introduced in 1958 to replace a variety of older, larger lamps. Some of these older flashbulbs are still in use with obsolete snapshot cameras and with portable lighting equipment used by commercial and industrial photographers in situations where other illumination is less practical.

Ordinary flashcubes and all-glass (AG-1) bulbs, like older types, are ignited by low voltage from a battery. This gives rise to the most common cause of flashbulb failure—weak batteries. Recently, however, flashbulb manufacturers have come up with an ingenious solution to this chronic problem. A new cube designated *Type X* or *"Magicube"* eliminates the battery problem by substituting a *mechanical* ignition system for the electric one. Each of the four lamps in a Type X cube has a percussive primer in its base. That primer is fired when struck by a small, tensioned spring,

much like a child's toy cap pistol. No electricity is used. The primer blast ignites the shredded zirconium just as in other flashcubes.

Because the firing system is a simple mechanical one, these cubes can be used only on cameras with synchronized mechanical triggers in them. Operating the shutter of such a camera momentarily pushes a small probe up into the base of the Magicube, tripping one impact spring. An added dividend: a spent cube with all of its springs released can signal the camera mechanism that it needs replacement. Type X Magicubes and regular flashcubes are not interchangeable. Although they look very much alike, neither will fit equipment designed for the other.

Electronic Flash

Although the electronic flash lamp was invented as a scientific tool to analyze motion, it was soon adapted as a repeatable source of photoflash illumination. Using an electric flash to arrest motion so that it might be photographed was not new in the thirties: William Henry Fox Talbot, again a pioneer, was granted a patent for such a device in 1851. Where Talbot had used an open-air spark, however, Edgerton's device substituted a charge of alternating current in a glass tube full of inert gas.

In modern units, a high-voltage electric charge is applied to electrodes in each end of a helical glass tube filled with xenon gas. Triggering the unit ionizes the xenon, and in this state it conducts the high voltage charge across it with a brilliant flash of light. The gas is not consumed in the pro-

cess, and as soon as another electric charge can be placed on the tube, another flash is possible.

This feature alone suffices to make the electronic flash an attractive alternative to the chemical flashbulb. Although its initial cost is higher than that of conventional bulb equipment, an electronic flash unit is much less expensive to operate. But the electronic unit has another advantage that is even more valuable: its flash has an extremely short duration. Typical times range from $\frac{1}{500}$ to $\frac{1}{70.000}$ second in modern units, short enough to "freeze" virtually any action taking place while the film is exposed.

Electronic flash units need no shutter delay to synchronize their light, and leaf shutters that are compatible with them will fire the flash as soon as their blades are fully opened. If a shutter is synchronized for both electronic and chemical flash, the "X" position of the M–X lever will give correct electronic response. But focal-plane shutters, found on many 35 mm cameras, present a special problem: the flash duration is much shorter than the time required for the shutter opening to travel across the film frame. To avoid the partial frame exposure that would result, the flash must be used only with shutter settings that expose all of the frame simultaneously. Usually this means times of $\frac{1}{45}$ second or longer, and many shutter dials indicate the shortest time setting where the frame is entirely open.

Exposures with Flash

Exposures with flash are affected by the same factors we noted for natural

light: intensity, film sensitivity, aperture, and shutter time.* But other factors also apply: with older equipment, the shape of the reflector may alter the light output of the bulb, and since the light source is usually used indoors, the proximity of reflecting surfaces such as light-colored walls and ceilings must be accounted for.

Most important, however, is the *distance from the light to the subject.* The inverse square law, a basic principle of physics, states that as light spreads out from a source, its intensity diminishes as the *square* of the distance increases. In other words, at twice the distance from a source of light there is only one-fourth of the intensity. Small changes in light-to-subject distance, then, will produce large changes in illumination on that subject. Since this distance has a significant effect on exposure, it should be estimated with care.

Most modern flash units contain a simple calculator that correlates the *light distance with the aperture.* This is the critical relationship. Users of older units that do not have such devices on them must refer to a *guide number.* This will be found in the instructions supplied with electronic units or on the packages of larger conventional flashbulbs. *Divide the lamp-to-subject distance (in feet) into this guide number to obtain the correct aperture setting.* For example, if your

subject is 15 ft. away from the lamp and the guide number is 165, set the aperture at f/11.

Automatic Exposure Controls

Two recent developments in the evolution of electronic flash units have addressed themselves to this exposure problem. The first was the automatic electronic flash unit, a development of the mid 1960s. Such units contain a small sensor that measures the brightness of the flash reflected by the subject in the same manner that a conventional exposure meter does. The sensor is connected through a transistorized circuit to the charge on the xenon tube, and when enough light has been reflected to the sensor (according to the ASA film rating for which it has been preset), the remaining flash charge is sidetracked to a "quenching" tube where it is dissipated. The closer to such a unit the subject is, the shorter the duration of the flash. Exposures as brief as $\frac{1}{70,000}$ second are reported to be possible.

Such units expend the entire charge with each release, regardless of how much is used to produce light; a full recharging cycle is therefore necessary. A subsequent improvement in electronic flash design has allowed the unneeded charge to be stored rather than wasted. At close distances between light and subject, where only partial discharging capacity is needed, the newer circuit cuts off the light at the proper instant and retains the remaining charge for the next use. Recycling time is thus shortened, and battery life is increased.

* Shutter settings do not affect *flash* exposures in the same direct way they do other light. Flash illumination rises to a peak and then falls; it does not maintain even intensity. Increasing the time that the shutter stays open will therefore not increase exposure by the same amount.

Harold E. Edgerton: Swirls and Eddies of a Tennis Stroke, 1939.

Stroboscopic Light

Over the years some electronic flash units have been designed to recycle and reflash with great rapidity, making it possible to capture numerous flashes by a single time exposure with the camera. Dr. Harold E. Edgerton's experimental photograph of a tennis player demonstrated this effect in 1939. Such a light is called *stroboscopic;* today it is used in engineering, photography, and other applications.

The stroboscopic light makes possible illustrations of great utility and beauty. Berenice Abbott's photograph here was one of a series done in 1961 for the Physical Science Study Committee. Two such lights were used to repeatedly show the positions of the two balls at a constant time interval. As electronic circuits became more sophisticated, with greater ability to recycle at ultra-fast rates of speed, photographs made in a millionth of a second became possible.

Berenice Abbott: Collision of Two Balls of Unequal Mass, 1961.

Dorothea Lange: F. S. A. Camp, Farmersville, California, 1939. The Library of Congress.

Flash Techniques

Because photoflash is often chosen over other forms of lighting for its simple convenience, it follows that techniques for using it should be simple, too. The most obvious and convenient methods, unfortunately, are not always the best from a photographic standpoint. But a resourceful photographer can alter them to get superior results with a minimum of effort.

Single Flash

A guiding thought we mentioned for continuous light deserves to be echoed here: *keep it simple.* And what is less complicated than a single flash placed on the camera? This, of course, is where the vast majority of flash units are used, and for sheer convenience, you can't beat it. But for photographic effectiveness, it's hard to imagine a poorer location: the light is so close to the lens axis that faces and objects flatten out under its even saturation, and shadows, as we see in Dorothea Lange's photograph here, add a grotesque dimension to the figures. With a single flash, your only light is a key light, so careful placement of it will make all the difference.

If the situation demands quick recording, as fast-breaking news events

(like Oswald's assassination pictured in Chapter 1) often do, convenience and quick response outweigh all else. And with many simple cameras it isn't possible to move the flashcube to another location. But in most other situations the picture will be greatly improved if the lamp is lifted a foot or two above the camera and slightly to either side. Bill Owens used this technique to make many photographs for his penetrating glimpse of middle-class American life, *Suburbia*. In his photograph from a cocktail party (reproduced at the beginning of this chapter), the women nearest the camera are not washed out as they would be had the flash been on the camera instead of several feet away. Illumination, and therefore exposure, is nearly equal on all four figures because the light is off to the left, almost equidistant from each of them.

Many flash units have a connecting cord that will permit them to be held a few feet off the camera and fired by the shutter release. Watch out for mirrors, windows, or shiny surfaces that will kick the flash right back to the camera lens. Place the light so that its reflection will go somewhere else. People with eyeglasses present a similar problem: ask them to tilt their head downward ever so slightly; reflections will then be directed below the camera instead of into it. Finally, an important point about exposure: always figure the exposure on the subject's distance from the *light,* not the camera.

Bounce Flash

Another technique for using a single flash, and one that is particularly ef-

fective in rooms with light-colored ceilings, is *bounce flash.* Instead of aiming it directly at your subject, hold the flash above the camera or over your shoulder, and bounce its light off the ceiling as Bill Owens has done to create a large, diffused source of light in a very natural position. We see Owens at work here: his light falls softly on the dressing table and is not blasted back to the camera by the mirror.

Bounce flash is well suited to close-ups of people and interior details: its soft light from above avoids the unpleasant shadows and risk of overexposure that accompany direct flash at close range. And bounce flash often is the only way to illuminate the entire field of a wide-angle lens with a single lighting unit. Similar effects may be obtained with some older flash units by removing the reflector and using the flashbulb "bare."

Bounce flash requires an adjustment in exposure due to the longer distance that the light must travel, and because the reflecting surface always absorbs and scatters some light. *Two or three f/ stops more exposure* should suffice in most indoor situations, but it's wise to *bracket* your exposure until experience indicates the proper increase. Newer electronic flash units with built-in exposure sensors will not require this adjustment.

Multiple Flash

Just as better pictures usually result from using several continuous lights for different functions, better flash pictures can often be made with more than one light source. Multiple flash takes more time to prepare than single

Bill Owens: Self Portrait with a Friend, 1970. From Suburbia.

flash, but it is a portable equivalent of the functional lighting we discussed earlier with regard to continuous sources. As with that type, a second unit allows you to use *key* and *fill* lights for better modeling and more even illumination.

A simple yet effective setup is to use one flash well off the camera to either side. From there it serves as a *key* light, shaping forms and creating shadows. A second flash, on or near the camera, is used as a *fill* light to soften the harsh shadows from the off-camera key. This on-camera fill light should be less intense than the key, as Russell Lee's photograph demonstrates. If a smaller flashbulb or electronic unit is not available, drape a single thickness of a white linen handkerchief over the fill light. That will cut its intensity about in half. Another method that works well, especially at close range, is to use a standard lamp with a reflector for the off-camera key, but a bare bulb for the fill light near the camera. Caution: don't place a bare bulb close to anyone's face (including the photographer's)—they have been known to shatter in rare circumstances.

Exposures in multiple flash are no different than with a single light, so long as each light performs a different function. As with continuous light, *exposure is based on the key light,* not the fill. Use the distance between the off-camera lamp and your subject to calculate the proper aperture.

Lamps used in multiple flash setups should be connected electrically so that they fire simultaneously. Most larger electronic units and many older flashbulb holders provide for such circuits. Where distances do not exceed 25 feet or so, ordinary lampcord wire makes a suitable connection. For longer distances, photoelectric *"slave" units* are more practical.

A "slave" unit catches the *light* from the "master" flash connected to the camera, and trips its own flash in response. No delay occurs with electronic units, but those designed for flashbulbs produce a time lag caused by the firing sequence in the remote lamp. Slow shutter times, such as $\frac{1}{30}$ second, must be used to catch both flashbulbs.

Another firing method that works well with multiple flash is the time-honored *open-flash* technique. No synchronizers or wires are needed for this. There are three steps: *open* the shutter (it should be set on "Bulb" or "Time"), *fire* the flashbulbs, and then *close* the shutter. It's not the best method for stopping action, but it is an easy way to fire a multiple-lamp setup without synchronizing problems.

Synchro-Sunlight

Photoflash can also be effectively used as a fill light to soften shadows cast by the sun. When people are posed outdoors, for example, they can turn their backs to the sun so that their faces are in the shade. This eliminates squinting. A flash on the camera then lightens the facial shadows.

Exposure with this technique is based on sunlight, just as it is with other natural light situations. Once the shutter time and aperture have been determined, use the guide number or the flash unit's exposure calculator to find the correct light-to-subject distance. For example, imagine that you're photographing a group of people outdoors, and you've arranged

Russell Lee: Lunch Time at the Nursery School. F. S. A. Mobile Camp, Odell, Oregon, 1941. The Library of Congress.

them with their backs to the sun. Let's say your daylight exposure would be $\frac{1}{125}$ at f/16, and the guide number for your flash unit is 120. Dividing 16 into 120 gives a lamp-to-subject distance of 7½ feet; at that distance, the flash would balance the sunlight. But you only want the flash to *fill shadows,* not be a second key light (like the sun). Moving it back a couple of addi-

tional feet (from the subject) will give you the desired balance.

If the light cannot be moved from the camera, or if you wish to keep the camera in close for tighter framing, try a handkerchief over the bulb or remove its reflector. Either method will help preserve a proper, natural-looking balance between the flash unit and the sun.

Rulon E. Watson: The Whirlpool Galaxy in Canes Venatici, 1960. Courtesy Lick Observatory, University of California, Santa Cruz.

Photography touches our lives in so many ways that we'd be hard put to describe all of the opportunities it presents to someone seeking a career. In a society that makes such widespread use of visual communication, the opportunity for employment in some form of photographic activity is limited only by how willing we are to seek it out. Here, as in other fields, new careers continue to grow from new technological developments, and although more people than ever before are now employed in photographic work, there's opportunity and variety enough for all.

Photography as a Career

Taken as a whole, the photographic career field is primarily a *service business,* although an important manufacturing one lies at its heart and makes that service possible. Photography is the keystone of other major industries too. Printing, electronics, and information storage systems, for example, rely heavily on it for their manufacturing processes, and photographic skills are a valuable asset to many people in other fields such as medicine, education, and engineering. But as a service business, photography is fundamentally oriented to *people* and their needs; it aims to satisfy their desires to express themselves, to learn, to communicate with others, and to get more enjoyment out of life. Certain areas of photographic work have become well defined by practice, and it may be helpful to one considering such a career to describe some of the more important ones here.

Industrial Photography

An industrial photographer's work generally supports that of his colleagues in the research and development, production, marketing, and public relations areas of a corporation's activity. Thus he is an important member of a team, a communications specialist whose assignments vary from routine reproduction to imaginative problem-solving. Some of the photographic services he renders may represent the best way to gather certain data; others may be the only way to accomplish a particular task.

Scientists and engineers use photography constantly. When allied with the proper devices, the camera can reveal things too small for the human eye to see and events too brief for it to observe. Through time-lapse techniques, an event that occurs too slowly for humans to perceive can be seen in its true relationship. The nature of industrial and corporate photography, then, is as varied as the businesses themselves are. In recent years this has been one of the fastest-growing segments of the field, supporting the rapid and imaginative ex-

Photomosaic of cross-section of irradiated uranium dioxide fuel pellet for nuclear reactor, 1962. U. S. Atomic Energy Commission.

Lunar breccia section, 1 to 3 microns thick, magnified 700 times, 1971. From Apollo 14. Photograph courtesy Battelle Northwest Photography.

pansion of our technological society. Frequently this type of work offers the additional benefits of employment with a large and well-established concern.

Commercial Photography

This is another wide-ranging category of photographic work. Generally the commercial photographer serves the needs of other businesses much like the industrial photographer serves his own corporate or governmental employer. The typical commercial studio business is small by corporate standards, and specialization is common in this area: architectural views, advertising illustrations, product photographs (for instruction booklets, service manuals, and catalogs), educational and training materials, photographs to support legal proceedings—these all are examples of work loosely categorized as commercial photography. In recent years a concerted effort by photographers and photographic manufacturers to keep business management aware of photography's usefulness has made this a steadily expanding market. But it is also a highly competitive one, difficult for a new person to break into without an apprenticeship to gain the relevant experience.

Alexander-Wyatt Photography: Transamerica Pyramid, 1973.

Darius Kinsey: Index, Washington, 1907. The Library of Congress.

Success in commercial photography, as in portraiture (described below), rests heavily on a number of factors, but three broad ones seem crucial. First, a successful photographer must be able to *empathize with his client and understand his client's needs.* Second, the photographer must have *imagination,* and the artistic and technical ability to produce pictures that communicate his client's ideas, or show his products, to the client's best advantage. The photographer must be able to work under *external* as well as internal direction, and of course he must be able to deliver the goods. What a commercial photographer sells, then, is primarily *service,* not merchandise; if he can build and maintain a good working relationship with his clients (who are businessmen themselves), he should be able to capture an impressive part of the action.

A third critically important factor in the success of a commercial or portrait studio is the *owner's profit motivation.* He must possess this driving business incentive in order to *remain in business,* and it is particularly relevant to a photographer who frequently will be tempted to sacrifice good business practice for artistic excellence. A balance between these critical factors is necessary to survive, and since a new commercial or portrait photographer can rarely afford to hire a business manager, he should possess this crucial skill himself.

Walker Evans: Penny Portraits in Photographer's Window, Birmingham, Alabama, 1936. The Library of Congress.

Portrait Photography

Because they are oriented toward a local consumer market, portrait studios represent a highly visible segment of photographic work. They are also one of the most traditional. Portraiture, of course, means dealing with people, and a high percentage of successful portrait studios are so because they cater to the wants and life styles of their local communities. Portraiture includes the photography of weddings and school groups, the latter a lucrative segment that neatly introduces the studio product to the community.

More than 80% of portrait establishments are individual proprietorships, and few have more than two employees. The field therefore offers a career opportunity only to one going into business for himself, but because the portrait trade is easily entered it is fiercely competitive and rarely lucrative to a newcomer. A knack for dealing with people in a friendly manner is vital to success.

Graphic Arts Photography

This field is part and parcel of the printing trade, where offset lithography now dominates all other ink-on-paper processes. Offset uses photography for its basic production methods, and wherever printing is done, graphic arts photography will be found. Some segments of this area, such as newspaper, magazine, and book production, are well established, and the manufacture of printed packaging is one of the most rapidly expanding segments of the field. Precision applications such as map making and the reproduction of engineering drawings are also included.

Graphic arts photography is exacting mechanical work. Recent advances in printing technology have required greater skill of technicians in this field, especially in those aspects of the work that precede camera operations. Computers are being widely employed, so prospective entrants to the field should have some knowledge of their use.

Publications and Media Photography

What was once a well-defined career field in newspaper and magazine photography has been reshaped by television. Motion picture production accounts for a large share of this market, and publications now rely heavily on free-lance photographers who sell their work to any media that will buy it. Although easily entered, free-lancing is a highly speculative business, often conducted part-time by people who are otherwise employed. Photographic ability in these fields is almost always more salable if it is coupled with reportorial skills and the ability to put a story together. Entry opportunities are better on small-town and weekly publications and in public relations work; there is little turnover on the staffs of metropolitan dailies. Media photography today includes the production of stills, films, and videotapes for television and motion-picture use. This is another highly competitive area requiring specialized training and usually an apprenticeship as well.

Photographic Retailing

This field is part of a rapidly expanding consumer market that is directly related to a growing middle class, its shorter work week, and the mushrooming popularity of recreational activities. The retailing scene for photographic goods, like many other consumer products, is moving to the mass-merchandising operations with their familiar chain and "discount" stores. A few independent dealers are organized to sell service and advice along with their merchandise, but the large majority are geared to reach a product-oriented market built by heavy consumer advertising in TV and print media. A pleasant personality and an effective selling technique are prime requirements for this work. Photographic knowledge is helpful, of course, but it is not always found behind retail counters. There your ability to sell will be valued more than your knowledge of products and their uses. The field is often used as a step to other kinds of work.

Photofinishing

This highly automated area of photographic work has two major segments. One is closely related to the retailing business just described, and is geared to process the thousands of rolls of film dropped in mailboxes and left each week at drug stores, photo shops, and other retail counters everywhere. *This field is almost exclusively color.* Competition for both new and repeat business is very keen, and much of the work is profitable only in large volume with highly mechanized handling. What manual work remains is done largely by unskilled people trained on the job. Skilled openings in photofinishing go to people with demonstrated managerial ability and a working knowledge of color photographic processes, chemistry, and electronics. The retail finishing business is highly seasonal, although consumer advertising is helping to spread its load over more of the winter months.

The other segment of this important field is related to the commercial and portrait studio businesses discussed earlier. This aspect is known as *trade,* or *custom finishing.* Here the emphasis is on a quality product that will be resold under a photographer's own name. Such clients demand salable quality and prompt service at fair prices. Trade finishers tend to employ more skilled people than other finishers do. They are located in every metropolitan area of the country, and the field is still expanding.

Photographic Manufacturing

This industry, of course, lies at the base of all others mentioned here. If it seems less accessible than others, it may be because it is not as widely located as the photographic businesses and industries it serves. For years, most photographic manufacturing was located in Rochester, New York, and in a few other northeastern cities. While a great deal of it still is concentrated there, it has recently spread to the midwest and west coast as well.

As every photographer soon discovers, many of the products he uses come from abroad. American manufacturing is concentrated most heavily on sensitized goods (film and paper), processing supplies, snapshot cameras, and some highly specialized and sophisticated photographic apparatus used in commercial, industrial, and photofinishing work. Other products are most often imported.

Relatively few jobs in this manufacturing industry require photographic skills; various technical abilities common to many other industries are needed by photographic manufacturers too. Photographic skills *are* needed, however, by people who represent the industry to its ultimate customers, especially to the commercial, industrial, and media segments of the field. These manufacturer's representatives—"tech reps," as they are called—must thoroughly know their company's products and also how those products can solve a studio's or client's problem. Much of the work these tech reps do is educational, showing photographers how to get better results for their customers. Other requirements are similar to sales work.

Photography in Education

A major premise of this book is that photographic images have an unparalleled power to convey information and

Construction of a photomosaic. Courtesy Battelle Northwest Photography.

ideas. In education they are indispensable tools. Yesterday's *visual aids* have become today's *visual language,* vital to the instructional process at every level. The recent expansion of educational opportunities beyond the high school, marked by the opening of new community colleges or university branches in every state, has meant a corresponding growth in this important field. Opportunities exist for both academically and technically trained personnel, and the stimulation of working with younger people, which is the lifeblood of education, is a major factor for many who choose this area for a career.

Our brief look at the photographic career field is by no means complete; only its major segments are described. Relatively few people engaged in photographic work are *photographers* in

the sense of creating original images. Many, many more are technicians, variously trained and qualified in one or more aspects of this field. The final chapter of this book, in fact, is addressed primarily to those who will have more occasion to look at photographs than to make them. But because photography plays such an important part in so many different areas of human endeavor, it deserves serious consideration by anyone who is planning his future, whether or not he intends to make it a career.

Photography has opportunities for the physically handicapped too, particularly for the blind. Some operations demanding varied levels of skill must be performed in total darkness, where lack of sight is no obstacle. Manual dexterity, however, is necessary, but many people otherwise handicapped can find rewarding work in a photographic career.

Although some segments of photographic work are covered by organized labor contracts, the field as a whole is not. Some industrial photographic technicians may be included in agreements that also apply to workers in other skills. But because the photographic industry is populated by a large number of very small businesses, compensation generally reflects the usual factors of supply and demand, education and experience. As a rule, people who have specialized training and some college education begin at higher levels of compensation and tend to advance more rapidly than those who do not. And many opportunities in mid-management positions of industry require at least a two-year college degree.

Photographic Instruction in Colleges and Universities

Photographic instruction is offered by more than 600 American colleges and universities. It tends to be concentrated in art and journalism departments, reflecting its major expressive and communicative functions. Some programs and many individual courses also are found in departments of industrial arts, physical science, and photography or motion pictures alone. In 1971 more than 200 college and university departments offered a major photography program leading to a bachelor's degree, and there is every indication that the number has grown since then. Scores of community colleges offer an associate (two-year) degree; about an equal number of universities have graduate programs leading to master's degrees in art, fine arts, and science.

A closer look at the programs in these institutions shows that they vary widely in aims and means: like the career field itself, photographic instruction has no standardized content in the United States. Even at the entry level, courses with such common titles as "basic photography" differ markedly in objectives, content, and means of evaluation. This is healthy for a student willing to shop around before applying for admission; he'll be much more likely to find a program suited to his own particular interests and needs. But it also makes evaluation of programs on any basis other than individual achievement rather difficult.

At the community-college level, programs in photography tend to be closely related to local and regional

employment opportunities, although many of them also offer extensive instructional work in fine arts as well. Numerous community colleges offer one the chance to begin his academic study there and then transfer the work completed to a university for credit toward a four-year degree. Again there is no standard pattern, and *transferability should not be assumed, but ascertained in advance.*

Programs at four-year colleges and universities show the greatest variety of both objectives and resources. Most reflect the expertise of their instructional staffs and the capabilities of their equipment and facilities. In still photography, art-department programs dominate this undergraduate level, with communications and journalism-related ones a close second. Numerous programs are related to educational technology and the development of instructional materials, while in recent years both still photography and filmmaking have become important units of broadly conceived curriculums in the humanities and interdisciplinary studies.

Graduate programs in photography, according to a recent survey, are primarily centered in the fine arts, but many are offered in motion-picture production and graphic arts as well. Some are intended to prepare candidates for teaching and other academic careers, and entrance to these programs, as a rule, is limited.

Further Information

Two publications on careers and educational opportunities in the areas of still and motion-picture photography are recommended for additional information. *Photography as a Career* describes the various aspects of this field in somewhat greater detail than space permits here. It is available without charge from the Photographic Art and Science Foundation, Inc., 1090 Executive Way, Des Plaines, Illinois 60018.

A Survey of Motion Picture, Still Photography, and Graphic Arts Instruction lists more than 600 American and Canadian colleges, universities, and technical institutes which offer some kind of photographic instruction beyond the high-school level. It notes the general types of courses offered by each responding school, and extracts various tabular data from the survey replies. Copies of this 56-page publication are available at 50 cents each from Eastman Kodak Company, Department 454, Rochester, New York 14650. Ask for pamphlet T-17.

The best way to determine whether a particular program is what you are looking for, of course, is to visit the department where it is offered. Talk to the staff and the students, look at the work being done, and ask what the graduates of that department are doing. Also ask about entry requirements, openings (many departments have limited space), and costs. These vary widely, and in most programs students must furnish part of their equipment and materials in addition to meeting tuition and fees. The more firsthand information you can obtain in this manner, the better equipped you will be to choose the best opportunity available to you.

Good hunting, and good luck!

Minor White: Snow on Garage Door, 1960.

We began this book by describing how the photographic image differs from other types of pictures, and how making a photograph can be quite an uncommon experience. Usually we create a photograph by perceiving what is before us with the help of what is within us, and then by gradually limiting our response to that entire, constantly changing experience. When empathy and distillation have functioned in full measure, we select a moment and record the image. Postvisualization, with its additional synthesis and selection processes, may follow, but at some point or other the image is cast free: it begins a life of its own. Exit now the photographer, the image maker. Enter here the viewer and the critic.

How We Look at Photographs

We make a photograph one way, but we look at it another. The image comes on all at once, not step by step. Minor White's photograph here, for example, does not evolve before us but confronts us instantly. We don't have to wait for it to appear in a developer tray or unreel like a movie: it's there to be seen and appreciated all at the same time.

We come to know the picture, however, more slowly. It contains more than we can grasp in a single glance, so we need time to perceive it. The still photograph, of course, has an advantage in this respect over the moving one: it isn't fleeting, it doesn't go away.

If the image states its theme vigorously, if it has sufficient *impact,* it will compel our attention. And if the picture presents itself in an expressive manner, it usually will retain our interest. Walker Evans's Bethlehem scene has these qualities. We can imagine the lives of people within the walls of these houses, lives sustained by the products of those blast furnaces in the valley beyond, and ending in the foreground to overlook the places where they lived and toiled. Similarly, we may enjoy poring over Joseph Pennell's richly detailed photograph of the Junction City Veterinary Hospital, but perhaps we can also share some of Doc Hopkins's admiration and apprehension for the automobile. On this summer day in Kansas the young doctor shares top billing with a comely lass in a wagon, and with a motor car parked prophetically by his door.

Reading these rich images for the stories they contain can be rewarding in the same way that a good literary narrative is absorbing. Many other photographs in this book likewise have been chosen for the quality of visual experience they offer. Not all of these photographs tell a story, but each has something to say to us if only we can see it.

Walker Evans: Bethlehem, Pennsylvania, 1935. The Library of Congress.

Joseph J. Pennell: Veterinary Hospital, Junction City, Kansas, 1909. J. J. Pennell Collection, Kansas Collection, University of Kansas Libraries.

Douglas Prince: Calf in Enclosure, 1972. Courtesy Light Gallery, New York.

What We See in Photographs

New photographers are often surprised to learn that what people see in a photograph may bear little resemblance to what the image maker thinks he is showing them. People, being human, *see what they want to see* in a photograph, as in anything else they experience. This may or may not be what actually is there, for what people will allow themselves to see in a photograph is conditioned by numerous external and internal factors.

Sometimes our response is automatic: if three or more dissimilar sounds reach us simultaneously, for example, we tend to respond to the loudest and screen out the others. Likewise, we tend to see moving objects more readily than static ones, and bright reflections in a picture more easily than darker values. Douglas Prince's calf and his turbulent sky, for example, arrest our attention before we can explore the rest of his rich, romantic image. But in other respects, the experiences we have and the sensations to which we respond are largely ones of our own choosing. We're forever comparing what we see with what we know, assimilating the external experience of a picture with everything that has meaning in our life. This process is different for each one of us, and tends to explain why two people can look at the same picture and get completely different messages from it.

Obstacles to Seeing Photographs

If we approach a photographer's statement fairly, we will try to be receptive to his message. Such awareness does not come easily: too many things get

in the way. A few of these obstacles are familiar photographic ones, technical flaws that obscure the photographer's intentions before anyone else can encounter his image. But the great majority of these obstructions lie with us as viewers, not with the photographs, and are therefore harder to recognize.

Some people, for example, have trouble responding to a photograph in an appropriate emotional way. They may be sentimental and miss the deep sense of mystery that a photograph like Prince's evokes. Or they may be unable to get beyond a literal interpretation of subject matter, and thereby miss an important part of the message. We must be able to feel whatever stimulation to our senses a photograph offers. If we try to empathize with the image, and feel our way into its tonal recesses, its rhythms, and similar elements, a good deal more of the photographer's message will likely come across to us.

What we think a photograph should look like—a generalized preconception of the image—may not square with the example before us. Another related problem stems from personal experiences that are vivid in our mind: they may steer us sharply to one interpretation of a picture that inadvertently excludes other, equally valid ones. Perfectly human shortcomings, but obstacles nonetheless.

Undoubtedly one of the most persistent obstacles to seeing what is in such images is our insistence that a photograph should resemble something *real*, that it should present such a convincing illusion of reality that we need not consider it an illusion at all. *Identity* is a very pervasive element in photography, one that isn't easily set aside. Yet we must be pre-

pared to do this on occasion if we are going to see photographs with open eyes and allow ourselves to be touched by them. Whenever we are confronted with a non-representational image, or with one whose identity may be obscure, we must be able to get beyond the "picture of" syndrome and see what else is there. Resemblance is a useful criterion in a great deal of photographic work, but it is not an absolutely essential characteristic. Many photographs function well without it. Discarding such a visual and mental constraint at the outset, then, will let us explore beyond it.

Conceptual Approaches

Once we establish rapport with an image, the concept of approaches presented in this book may help us understand what a photograph seems to be doing, and to judge how well it succeeds. Any such concept, of course, is only a guide. Many images will appear to fit several approaches because they function on different levels for different people. Criteria that we established for the symbolistic approach in Chapter 9, for instance, can be applied to numerous photographs elsewhere in the book. Charles Sheeler's approach to the barn (on page 258) was almost reportorial. Compare this image with his directly visualized photograph in Chapter 4. Similar subject matter, but altogether different interpretations.

Margaret Bourke-White's photograph in Chapter 1 illustrates another important point: a photograph removed from the context of its origin may convey an entirely different meaning. That picture was made in Louis-

Charles Sheeler: Barn, c. 1915. Collection: Philadelphia Museum of Art: Bequest of Fiske and Marie Kimball.

ville during the great Ohio River flood of 1937. Three-fourths of the city was inundated. Bourke-White realized that the wreckage of human lives wrought by a major flood is felt far longer than the toll of washed-out bridges and submerged property. While photographing refugees from the flooded Negro quarter queued at a food-distribution point, however, she undoubtedly sensed the cutting social comment injected by the billboard. Today it is the latter message that the photograph so strongly conveys.

Documents such as this refugee picture easily fit a concept of approaches, but much contemporary work is difficult to categorize. Photography is now going through a period of intensive experiment in the United States. Such activity is bound to produce images that challenge traditional values and even question the very nature of photography itself. Photographers and viewers alike are nourished by such ferment, and conceptual definitions of photography must remain open-ended to deal with it.

Aaron Siskind: Corfu, 1970.

Viewing Photographs

The only way to experience what photographic images have to offer, of course, is to look at them. Ink-on-paper reproductions such as those in this book are a useful step in that direction, and well-made photographic copies, such as properly projected slides, are even better. But *original prints* are the best of all. What a photographer tries to convey can often be communicated best through the subtle detail, color, and tones that are possible only in a fine print.

A growing number of museums and galleries in the United States and Canada display fine photographs on a continual basis, and many others do so intermittently. Foremost in this regard are the International Museum of Photography at George Eastman House in Rochester, New York (where working exhibits of equipment also are on display); The Museum of Modern Art in New York City; the Art Institute of Chicago; the University of New Mexico Art Museum in Albuquerque; and the Smithsonian Institution in Washington, D.C. The Witkin Gallery and Light Gallery in New York, and the Focus Gallery in San Francisco have been exhibiting fine photographs for several years. Other galleries where original photographs may frequently be seen are located in most metropolitan and many suburban communities.

Traveling exhibitions of historic and contemporary work are circulated by the International Museum of Photography, the Smithsonian, the Visual Studies Workshop in Rochester, and a few other organizations with similar print collections. These, together with locally originated shows, often may be seen in college and university galleries and museums across the country. Additional public collections of fine photographic prints are indicated in the sources of some illustrations in this book. Go to these galleries and museums, and look for photographs that are meaningful to *you.*

If there is a better way to experience fine photographs than on the gallery walls, it is living with them at home. Galleries exist primarily to sell work by the artists who exhibit in them. Fine photographic prints are no more expensive than similar-size prints by artists of equivalent ability and reputation in other media. The extent of a gallery's patronage (in sales, not merely traffic) will largely determine how long and how well it is able to present art for public enjoyment. But our reasons for displaying photographs in our homes should be personal ones: what we hang there reflects our feelings as well as our taste, and quality photographs, along with other works of art, should be accorded this honor.

Reviewers and Critics

People who go to museums and galleries comprise only a part of the photographer's audience. There are others living far from metropolitan areas, for instance, who depend on someone else to see the photographs for them, and then to report on and react to what they have seen. Serving the needs of those people, as well as the gallery-goers, are the reviewer and the critic.

It may be useful at this point to draw a distinction between *reviewing* and *criticism.* Constructive criticism must review the work at hand, but not all reviews need be critical. *Reviews,* in fact, are largely informational.

Oliver Gagliani: Crockett, California, 1970.

They describe the exhibition or event, add some background information about the artist, and tell where and when the work may be seen. Reviewers often comment on what they believe are the photographer's intentions, but such remarks should be labeled what they are—opinion and comment rather than fact. Informational reviews should be written for the viewer; they aid the photographer being reviewed to whatever extent they enlarge the size and sharpen the interest of his audience.

Once a reviewer makes a *judgment* or *evaluation* about an image or exhibitor, however, he crosses a thin line and becomes a *critic*. The distinction is an important one, because with that step a reviewer claims the privilege of publicly expressing his own opinion about a photographer's work or worth. Equally important, the critic also assumes certain responsibilities to his

audience or readers, to the photographer or artist, and to himself.

First, he has a responsibility to the artist and the reader to demonstrate that he knows what he is talking about. Both may expect him to be familiar with major images from the past, to recognize and relate the important styles and approaches that photographers have used over the years, and to understand the major directions of contemporary photographic work. He will call the viewer's attention to the strengths of a work as well as its weaknesses, and he will refrain from taking issue with a photographer's point of view merely because it differs from his own. A conscientious critic should attempt to understand the photographer and his images, even though he may personally feel little rapport with them. He is entitled to be subjective as long as he is honest, but he has an obligation to define and defend his critical standards, and to explain his conclusions to both artist and audience alike.

The art of criticism is a different kind of exercise than the arts it examines. It has always been a difficult task. François Arago had trouble reviewing daguerreotypes in 1839 because he had only the language of painting to rely on, and he found it quite inadequate to describe those novel images. P. H. Emerson fared better half a century later, and Alfred Stieglitz provided a model that many others since have tried to emulate. Today's commentators can still read Stieglitz with profit.

Critics are challenged today as much as ever. The most inventive work in any medium is always ahead of what people say about it, and photography is no exception. All the obstacles to seeing a photographic image that we mentioned earlier in this chapter can ambush the unwary critic. Avoiding these obstacles is only a small part of his obligation.

Critics of photography are in a suitable position to help photographers recognize and exceed their own best efforts. This, too, should be part of a responsible critic's role. Such encouragement can be nourished by what the reviewer brings to his writing from the carefully considered thoughts of others, and from his own sensitivity as a human being. His response can draw on collective thinking, yet be a strongly personal one that makes constructive criticism, enjoyable reading, and perceptive viewing.

The critic of photography also has an obligation to his readers to speak to them clearly. Lucid, responsible assessment attracts a discriminating audience; obscure and irresponsible criticism turns such people away.

Finally, each one of us who looks at pictures, for *we* are the photographer's audience, has a duty to both the artist and the critic to see the work for ourselves. Our rejoinder to the critic, regardless of whether we endorse or reject his views, must begin like our response to the artist, from a firsthand appraisal of the latter's images. Only then can the critic, the photographer, and the audience contribute to the maturity of each other.

Looking at fine photographs in such a light, like good conversation after dinner, can be a rare and exhilarating experience, and a stimulating contribution to creative and joyous living. Isn't such a life, after all, the ultimate purpose of education and of art? And isn't it the affirmation of all that we value most highly in our fellow man?

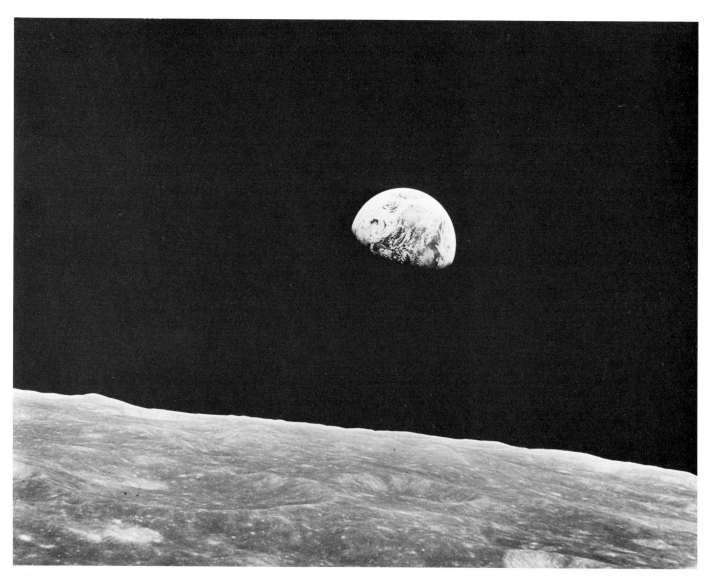

The Earth from Lunar Orbit, Apollo 8, 1968. NASA.

Any used camera should be thoroughly checked by the buyer before final purchase arrangements are made. Many dealers will permit such a customer test within a few days, with full credit or refund if the camera proves unsatisfactory but is returned in the same condition that it was obtained. The main things to check are these:

1 The lens should be tested for image sharpness.
2 The shutter should be checked for proper mechanical operation and for the relative accuracy of its settings.
3 The camera body should be checked for light leaks, particularly around the back and bottom.
4 If the camera has a rangefinder, this must be checked for accuracy.
5 While it is desirable to check internal flash synchronizers and exposure meters, these devices vary according to the type of camera and are best examined by a dealer or technician who knows the equipment and has the proper testing aids. Most larger dealers can perform or refer you to this service.

Testing Procedure

The following procedure is devised to test a camera for the first four points above with a minimum of time, trouble, and expense. Although especially appropriate to used cameras, the procedure obviously can be applied to new ones as well. In addition to the camera, you'll need a tripod, cable release, slow film (ASA 32 to 50), an 18% gray card, a good 8X magnifier, a black crayon or marking pen, and a couple of sheets of newspaper. Here's the procedure:

1 Examine the camera body for dents or scrapes that impair the movement of any adjustable part. Cock and release the shutter on each of its settings; watch particularly for failure to close on longer time settings such as $\frac{1}{2}$ and 1 second. The release on the camera body should work smoothly without binding. Clean the lens and film chamber, and load the camera with Kodak Panatomic-X, Ilford Pan-F, or a similar ASA 32 to 50 film.
2 Secure the camera on a rigid tripod or stand, and use a cable release for all exposures.
3 In *overcast daylight* or *open shade,* tack or tape a double-paged sheet of classified ads from a newspaper to a wall or other flat surface, and frame this in the camera so that it fills the finder and so that the camera back and the newspaper are parallel. The camera's lens should be pointed squarely at the center of the newspaper target. Focus carefully on the sheet.
4 Expose frame No. 1 at the *maximum* aperture. Use a meter for correct exposure, or carefully apply the table in Chapter 3.
5 Expose frame No. 2 at the *critical* aperture, two stops smaller than the maximum. Again, use correct exposure.

6 Expose frame No. 3 at the *smallest* marked aperture. Correct the exposure for this reduced amount of light.

7 Replace the newspaper with an 18% gray card. Move the camera in close, filling the frame with the gray tone. The image need not be in focus; the lens, in fact, should be *focused on infinity.* Expose frames No. 4 through No. 12 at shutter times of $1/4$, $1/8$, $1/15$, $1/30$, $1/60$, $1/125$, $1/250$, $1/500$, and $1/1000$ second respectively, *adjusting the aperture to give each frame a correct equivalent exposure.* This should be done under the light conditions indicated; avoid early or late daylight hours as the light intensity rapidly changes at those times.

8 If the camera has a rangefinder, perform the following test on an additional frame or on a separate roll of film if necessary. Take a newspaper page with a bold headline or advertising banner that runs all the way across the page (rather than over a column or two). Mark a heavy black line with the crayon or pen vertically through the headline near its center. Tack it up as before, but this time place the camera tripod so that it is about 3 or 4 feet from the page, with the lens axis at about a 45° angle to it. Focus *carefully* on the crayon mark with the rangefinder, and expose a frame with meter and cable release as before, *using the maximum aperture.* For greater accuracy, repeat this test using a picket fence (mark one central picket) about 25 feet away, in fading daylight. Again, the maximum aperture *must* be used.

9 Develop the exposed film as recommended by the manufacturer or by your usual procedure for this material.

Evaluating the Test

Examine the dry negatives by transmitted light (against a window or on a light table) with an 8X magnifier. Be sure that the film is held flat.

Irregular black patchy areas or streaks at random locations on the film are evidence of light leaks in the camera body. These marks along the top of the negative strip, for example, indicate leaks along the bottom of the camera.

Frame No. 1 should be examined carefully for sharpness, especially in the corners of the negative. The central area should be acceptably sharp; corners, however, may be less so. Many lenses produce an image that is sharpest in a slightly concave, saucer-shaped plane, rather than a flat plane like the film is. If the corners are sharp but the center of the frame is fuzzy, the lens focusing scale or rangefinder should be checked for mechanical error.

Frame No. 2 should be acceptably sharp all over the frame. If this image is unsharp in places, reject the lens.

Frame No. 3 should be slightly less sharp than No. 2 overall, but better than No. 1. Corners should be sharp.

Frames No. 4 through No. 12 should have the same apparent grayness in the negatives. Serious unevenness usually can be spotted visually, but a densitometer, if available, will provide a more precise evaluation.* It is not

* Densitometer readings from all adjacent frames (except 1/8 and 1/15 second) should be the same; a variance of .1 in the reading indicates a 33% error in shutter time.

essential that each shutter setting give the actual indicated time; what *is* important is that each be correct *relative* to the others. Actual times, if desired, can be ascertained by a repair technician with appropriate equipment, but most camera shops are not equipped to provide this service.

If the rangefinder test was made, examine that negative with the magnifier. If the letter with the crayon mark through it is the sharpest point in the headline, the rangefinder is correctly adjusted. If the crayon mark is not sharp but another point on the headline is, the rangefinder is out of adjustment and should be corrected by a competent serviceman.

In 35 mm cameras with removable takeup spools (such as the Leica III Series), make sure the film actually is being transported when the advance lever or knob is operated. To do this, load the camera in the usual manner and position the film for the first exposure. Then turn the *rewind* knob or crank gently to take up the slack film in the cartridge. Thereafter, when the film is advanced, the rewind control should move also. If it does not, the film is not advancing and the takeup spool may be slipping on its core. The effect is noticed, as a rule, only with 36-exposure loads. The spool may require shimming to correct this fault and insure proper transport.

One final note: insist on *written* estimates before ordering extensive repairs to older, used cameras. Skilled labor, of course, is the major factor in the cost of such work, and the charge may be too great considering the value of the camera. *You* be the judge, *before* the work is done.

Polaroid materials

Polaroid picture materials are all negative-positive in nature but are otherwise fundamentally different from conventional films. Each Polaroid Land film unit consists of four essential parts: a negative emulsion, usually coated on paper, which is exposed in the camera; a positive paper sheet on which the print is produced; a pod of chemicals that process the image when spread between the negative and print; and an opaque paper roll, envelope, or similar container that protects the other parts from premature exposure to light. With a single exception, only the positive print is retained as a usable, permanent image.

After exposure in the usual manner, the negative and positive materials are simultaneously pulled between two steel rollers that press against them. These rollers spread a viscous developing solution from a bursting pod between the materials and squeeze them tightly together,
face to face. As the negative image develops, unexposed silver ions are delivered to the specially prepared print paper through an ingenious chemical transfer system that takes place in the syrupy reagent. When separated from the negative 15 seconds later, a relatively stable print is obtained. Coating it with lacquer makes it permanent.

A guiding premise behind the development of Polaroid Land materials prior to their introduction in 1948 and throughout their subsequent improvement was and still is an esthetic one. The aim has been to place nothing between the photographer and his image except a quick process that would deliver a positive print while the original motivation for the picture was still fresh in his mind. Instant feedback from the image to its maker was the primary goal; instant processing in the camera helped insure it. The value of this feedback in teaching people of all
ages to be more perceptive has been amply demonstrated over the last quarter century. Many other uses for the process in business and industry have been discovered, and most, like scientific recording, have been suggested by its rapid-access feature.

Film Types

Black-and-white Polaroid materials are available as rollfilms, film packs, and individual sheets. All must be used in Polaroid Land cameras or in devices that adapt other cameras to these films. The primary designations given below are for 4 by 5 in. sheet film units, but similar materials in other formats are noted.

Type 52 material yields a high-quality, long-scale print 15 to 20 seconds after removal from the filmholder. It has an ASA rating of 400 and is panchromatic, making it superb for general photographic use.

A similar material for Polaroid roll cameras is designated Type 42 and has an ASA rating of 200.

Type 57 material yields a medium-contrast print with 15 seconds development. It has an ASA rating of 3000, but its images are somewhat less brilliant than those on Type 52 film. An identical material is available in rolls as Type 47 and in film packs as Type 107. The CB-100 Land Camera Back permits these packs to be used with several conventional camera systems in the 120 square and 60 by 70 mm formats; the Model 405 Pack Film Holder adapts the packs to 4 × 5 cameras.

Type 51 material produces a high-contrast print, similar to those from lithographic negatives, with 15 seconds development. It is a blue-sensitive material that has an ASA rating of 320 in daylight or 100 with tungsten lamps. It is available only as individual 4 × 5 sheets.

Type 55 P/N produces the only usable negative among Polaroid materials, but what a superb negative it is! Image quality is comparable to that obtainable with the best thin-emulsion conventional films, grain is virtually indistinguishable, and the image can be enlarged as much as 25 times. A medium-contrast print is also produced along with the negative. Type 55 P/N material has an ASA rating of 50; a similar material rated 75 ASA is available in film packs as Type 105.

After exposure and processing for 30 seconds in the usual Polaroid way, the material is separated to yield a print and a film-base negative that is fully developed and fixed. Within a few minutes of its removal from the film pack, however, this negative must be cleared, washed, and dried. Clearing is accomplished by immersing the film for 30 seconds, with continuous agitation, in an 18% solution of sodium sulfite. The solution can be conveniently prepared by dissolving 1 pound (454 grams) of anhydrous (dessicated) sodium sulfite in 68 fl oz (2 liters) of water at 70° F (21° C). After clearing, the negative is washed for 1 or 2 minutes in running water, then rinsed in a wetting agent like ordinary film, and dried.*

All Polaroid black-and-white prints must be coated with a lacquer after processing. This cleanses their surface of chemicals that would later discolor them and protects their images from deterioration by air. A single wipe with a lacquer-soaked coater supplied with the film makes this final operation a simple one.

* Type 105 film is treated in a 12% sodium sulfite solution (300 grams per liter) for 30 seconds, then washed 5 minutes.

Stabilization processing materials provide a convenient way to make black-and-white photographic prints that are needed quickly. The process is identical to conventional methods of making prints through exposure, but replaces the customary wet-processing sequence with a damp-dry one that takes as little as ten seconds. Photographers have found many applications for these quick prints in publication work where they are needed only long enough to make a halftone copy, and in experimental work where the print, once made, will soon be discarded.

A *stabilized* print is dry to the touch and is usable immediately, but is *not permanent*. How long it will last depends on how it is stored. A print kept in darkness at normal room temperature and humidity can last as long as three years, but that time is shortened by higher-than-normal humidity, and deterioration of the print is rapidly accelerated by prolonged exposure to light. Even under severe exposure conditions, however, the image should remain useful for about a month.

If a permanent image is desired after an immediate use such as photomechanical reproduction, a stabilized print may subsequently be fixed, washed, and dried by conventional methods at any time before image deterioration has begun.

Papers

Stabilization papers are supplied by Eastman Kodak (Ektamatic), Ilford (Ilfoprint), Agfa-Gevaert (Rapidoprint), and a few other manufacturers, who also supply processing machines for them. Most of these papers expose just like conventional graded paper. The Kodak Ektamatic SC paper, however, permits contrast control with filters just like Polycontrast papers do. Kodak also supplies a high-contrast paper, Grade T, for phototypesetting and other photomechanical work. It handles like regular enlarging paper; no filters are needed.

All of these papers are exposed in the usual manner, although exposure time is more critical than it is with conventional materials since the print cannot be manipulated during development. Any local exposure control such as burning or dodging, of course, may be used.

Processing

Rapid processing of stabilization prints is made possible by incorporating the developing agent (typically hydroquinone) in the paper emulsion. After the silver halides of this emulsion have been exposed in the normal manner, the emulsion needs only to be brought into contact with a powerful alkali for development to

occur. Such an alkaline solution is called an *activator,* and the paper emulsion is formulated for quick penetration by it. Since no development (and therefore no oxidation of the developing agent) occurs except in the emulsion, a strong reducing agent and a strong alkali can be used. This combination produces extremely rapid development without spoilage.

When conventional papers are processed, the unexposed and undeveloped silver halides remaining in the emulsion after development are dissolved in the fixing bath, making the image permanent. In a stabilization process these halides are not dissolved but are *converted* to a colorless, relatively stable compound that remains in the emulsion. Ammonium thiocyanate typically is used as a stabilizing agent. A slight fixation may occur, but most of the halides are simply converted to a more or less stable form.

Because development and stabilizing both occur rapidly and must be carefully controlled, manual (tray) processing is not practical. The entire process is conveniently performed in a table-top machine that sits in the darkroom. These self-contained units use motor-driven rollers to transport the exposed paper and to bring the emulsion in contact with each solution, all with precise timing.

The paper is fed into the processor *face down.* The activator solution contacts only the emulsion side, and after a quick immersion in the stabilizer to stop development and arrest the image, the print is automatically squeegeed front and back and delivered from the machine in a damp-dry state. *The whole process takes only 10 to 15 seconds.* Activator and stabilizer solutions are automatically fed into the machine from their storage bottles at the proper rate.

Use and Storage of Stabilized Prints

Stabilized prints depend on chemicals retained in the emulsion for stability over their useful life. Any aftertreatment such as toning or local reduction that introduces water to the paper will wash out some of these chemicals and affect the print's stability. Before any such treatment is given it, then, a stabilized print must be fixed and washed by conventional means. Stabilized prints can be dry mounted, but no water-based adhesives should be used.

Because these prints contain stabilizing chemicals, they should *not* be left in *prolonged* contact with other conventional films and papers. Neither should they contact metal objects such as paper clips and staples; the metal might corrode and stain the print. Once a stabilized print is fixed and washed by conventional methods, however, it may be treated as any ordinary photographic print. Any of these papers, incidentally, may be processed after exposure by conventional methods and chemicals outlined in Chapter 6, although the rapid-access feature will then be lost.

These selections from the extensive literature of photography and related topics are recommended for additional study, general reading, and stimulating picture viewing. The Newhall *History* and Lyons anthology contain valuable and extensive bibliographies through 1965; the Time-Life volumes likewise list many sources from more recent years. A few older books, although out of print, are included here because they continue to be outstanding references to topics of current interest, and are available in many libraries. So is the Boni bibliography (see reference tools), the most comprehensive listing of photographic literature to date. Titles marked with an asterisk (*) are available in paperback.

General Works

* Arnheim, Rudolph. *Art and Visual Perception*. Berkeley: University of California Press, 1966. A standard reference on the perception of visual experiences by a noted psychologist. His more recent thesis, that *all* thinking is perceptual in nature, is set forth in *Visual Thinking* (Berkeley: University of California Press, 1969).*

*Boorstin, Daniel J. *The Image*. New York: Harper Colophon Books, 1964. This vigorous, stimulating essay on the art of self-deception in America includes an excellent discussion of how photography has affected our taste and culture.

Eaton, George T. *Photographic Chemistry*. Hastings-on-Hudson, N.Y.: Morgan & Morgan, Inc., 1965. A lucid explanation of photographic chemistry for the general reader.

Frontiers of Photography. New York: Time-Life Books, 1972. A suggestion of where photographic images and equipment seem to be headed. Contains step-by-step directions for tone-line, posterization, and photo screen printing. Well illustrated. Bibliography.

* Gassan, Arnold. *A Handbook for Contemporary Photography*. 2nd ed. Athens, Ohio: Handbook Company, 1971. A good reference to the Zone System and non-silver processes. Not illustrated.

Gernsheim, Helmut in collaboration with Gernsheim, Alison. *The History of Photography from the camera obscura to the beginning of the modern era*. New York: McGraw-Hill, 1969. The best reference to nineteenth-century photography in Europe, especially in England and Scotland. 599 pages, 390 illustrations. An expanded revision of the 1955 edition by Oxford University Press.

* Ivins, William M., Jr. *Prints and Visual Communication*. Cambridge, Mass.: The M.I.T. Press, 1969. A lucid, scholarly analysis of how *reproduced* images have affected hu-

man perception and learning, and how the advent of photography has changed our *cultural* vision. Engagingly written. Republication of the 1953 edition by Harvard University Press.

* Lyons, Nathan, ed. *Photographers on Photography*. Englewood Cliffs, N.J.: Prentice-Hall, Inc., 1966. A superb anthology of writings by 23 photographers on their vision and their craft. Extensive biographical and bibliographical data.

Neblette, C. B. *Photographic Lenses*. Hastings-on-Hudson, N.Y.: Morgan & Morgan, Inc., 1972. An excellent guide to modern photographic lenses. Many diagrams.

Neblette, C. B. *Photography, Its Materials and Processes*. 6th ed. New York: Van Nostrand Reinhold Company, 1962. The best general reference to photographic technology. Revised to December, 1961.

* Newhall, Beaumont. *The History of Photography from 1839 to the present day*. 4th edition, hard cover, 1964; 2nd printing, paperback, 1971. New York: The Museum of Modern Art. Still the best illustrated and most readable general history of photography up to the mid-twentieth century. This is the standard against which other histories continue to be measured. Superb bibliography and notes.

* Newhall, Beaumont. *Latent Image*. Garden City, N.Y.: Doubleday & Company, Inc., 1967. A readable account of the discovery of photography. Bibliography and source notes.

Photography as a Tool. New York: Time-Life Books, 1970. A good description of how photography is used to reveal things too fast, too slow, too far, and too small for humans to see otherwise. Illustrated.

Schuneman, R. Smith, ed. *Photographic Commmunication*. New York: Hastings House, 1972. The best contemporary overview of photojournalism, edited from conference tapes by 53 leading photographers, editors, and art directors.

*Taft, Robert. *Photography and the American Scene*. New York: Dover Publications, Inc., 1964. Still the best general history of how the camera was used in nineteenth-century America. Superb notes. An unaltered reprint of the 1938 Macmillan edition.

Wall, E. J., and Jordan, Franklin I. *Photographic Facts and Formulas*. Boston: American Photographic Publishing Co., 1947. This remains a useful technical reference for many older print processes of contemporary interest. A Xerox facsimile of the 1940 edition is available from University Microfilms, Ann Arbor, Michigan.

*White, Minor. *Zone System Manual*. 3rd ed. Hastings-on-Hudson, N.Y.: Morgan & Morgan, Inc., 1965. The standard reference for using the Zone System with contemporary materials.

Picture Books

Adams, Ansel, and Newhall, Nancy. *This Is the American Earth*. San Francisco: The Sierra Club, 1960. A landmark exhibition in book form that is still a definitive ecological statement. Reprinted 1968 by The Sierra Club and Ballantine Books.*

* Conrat, Maisie and Richard. *Executive Order 9066*. San Francisco: California Historical Society, 1972. A fine example of picture *selection* to portray the story of this ugly scar on the American conscience.

The Family of Man. New York: The Museum of Modern Art, 1955. The classic photographic theme-show seen around the world, here in book form. More than 500 pictures.

The Great Themes. New York: Time-Life Books, 1970. Six basic ideas that have occupied photographers over the years.

Jensen, Oliver; Kerr, Joan Paterson; and Belsky, Murray. *American Album*. New York: American Heritage Publishing Co., Inc., 1968. A good reference to sources of nineteenth- and early twentieth-century photographs of American life. Engaging introduction and captions, 326 photographs. An abridged edition was published by Ballantine Books, 1970.*

Lyons, Nathan. *Photography in the Twentieth Century*. New York: Horizon Press, 1967. See next entry.

Lyons, Nathan, ed. *Vision and Expression*. New York: Horizon Press, 1969. This and the preceding book are useful as contemporary pictorial extensions of the Newhall *History*. Edited by the former Associate Director of George Eastman House.

*Owens, Bill. *Suburbia*. San Francisco: Straight Arrow Books, 1973. Middle-class California looks at itself from the comfort of its two-car garage. A fine example of contemporary photographic book publishing.

Scherman, David E., ed. *The Best of Life*. New York: Time-Life Books, 1973. Selected photographic essays from the magazine that defined the concept of photojournalism.

Stryker, Roy Emerson, and Wood, Nancy. *In This Proud Land.* Greenwich, Conn.: New York Graphic Society Ltd., 1973. From the huge Farm Security Administration collection, its director has chosen nearly 200 photographs to show the dignity and spirit of Americans who survived a historic depression only to face an epochal war. Bibliography.

*Szarkowski, John. *Looking at Photographs*. New York: The Museum of Modern Art. 1973. One hundred photographs from the Museum's outstanding collection, each discussed with perceptive insight by one who wears his considerable scholarship as lightly as a miniature camera.

*Szarkowski, John. *The Photographer's Eye*. New York: The Museum of Modern Art. 1966. A superb collection of pictures to study, with a stimulating introduction on why they look the way they do.

Periodical

Aperture. Quarterly of Photography. Millerton, N.Y. 12546: Aperture, Inc. Articles and photographs that deal with the entire spectrum of photographic imagery and thought. Occasionally controversial, usually stimulating, and always beautifully printed.

Reference Tools

Boni, Albert, ed. *Photographic Literature* (1727–1960). New York: Morgan & Morgan, Inc., 1962. 333 pp.

Boni, Albert, ed. *Photographic Literature 1960–1970*. Hastings-on-Hudson, N. Y.: Morgan & Morgan, Inc., 1972. 535 pp. Some idea of how rapidly photographic literature is mushrooming can be gained from these comprehensive bibliographies. The second volume (covering only the 1960s) contains more entries than the first, which spans the preceding 233 years.

Pittaro, Ernest M., ed. *Photo-Lab Index 1972*. Hastings-on-Hudson, N.Y.: Morgan & Morgan, Inc., 1972. The standard manual of collected data on current photographic materials, formulas, and processes from most foreign and domestic manufacturers. Quarterly supplements available by annual subscription update the basic loose-leaf manual. A microfiche version of the 1968 edition also is available.

* Available in paperback.

Index

° Page numbers in italics refer to illustrations.